S0-AUX-808

the big book of
graphic design

general editor **Roger Walton**

of phic sign

COLLINS | DESIGN

An Imprint of HarperCollins Publishers

foreword

This book is a snapshot, a point in time frozen and fixed, and you should take notice. Actually, I'd advise you to buy it and keep it. Enjoy and use it now, but don't throw it away. I think you'll need it as a reminder.

I went to the optician recently. He told me my far sight was improving, while my near sight was getting worse. Not dramatically, he reassured me, although I didn't find this terribly comforting. However, my perception of the world is demonstrably shifting and probably in some way yours may be, too, as the world itself quickly changes around us.

This collection of work shows some of these changes in clear relief. Ten years ago if I'd said, "In 2007 we'll put together a collection of graphic design work from around the world. The work will include typography, photography, illustration work, page design, website design, writing, magazine design and publishing, installations, and clothes design.

And all of this work will be done by people who, for want of a better word, might call themselves 'graphic designers'"... if I'd said all this, you might have said that isn't a collection of graphic design. But today, it is.

The remit of the designer now is dramatically broadened to include many activities that the title "graphic designer" in the past excluded. And, along with that greater freedom, the passion and enthusiasm for communication seem as undimmed and provocative as ever—as does the imagination and resourcefulness of the designers whose work appears here.

So, take note of this snapshot of the landscape of graphic design. This is a point of view of what this activity encompasses today. In a few years' time it may be a very different view altogether.

ROGER WALTON
General Editor

1 copp

this page and overleaf
Adelaide Symphony Orchestra
Season 2006 brochure
dimensions 8 1/4 x 11 3/4 in 210 x 297 mm
description Subscription brochure and
seasonal identity created for the Adelaide
Symphony Orchestra.
designers Anthony Deleo, Scott Carslake
photographer Toby Richardson
art directors Anthony Deleo, Scott Carslake
design company Voice
country of origin Australia

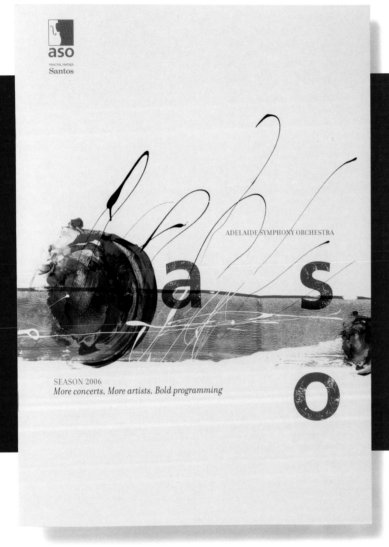

We asked the question: "what does the sound of a symphony look like?" and collaborated with second-year design students, who were asked to listen to music and express the sound on paper. We carefully dissected the results using individual elements from more than 50 pieces of work to develop the season identity.

VOICE DESIGN

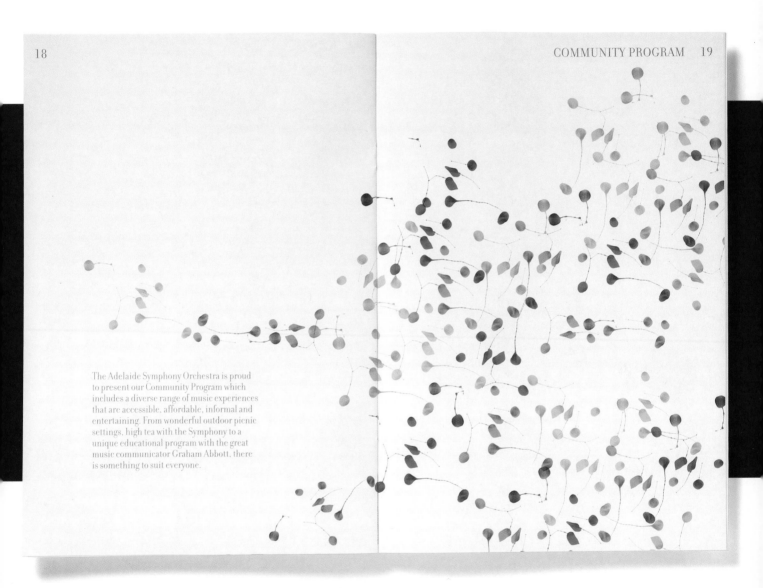

The Adelaide Symphony Orchestra is proud
to present our Community Program which
includes a diverse range of music experiences
that are accessible, affordable, informal and
entertaining. From wonderful outdoor picnic
settings, high tea with the Symphony to a
unique educational program with the great
music communicator Graham Abbott, there
is something to suit everyone.

PRINCIPAL PARTNER
Santos

CONTENTS

Introducing...
Compose Your Own Subscriptions
In 2006, the ASO introduces a flexible
new way of subscribing. We've stream-
lined the ticket pricing across all the
different series, so you can select
concerts from any ASO Series on offer.
Subscribers can choose multiples
of 3, 6, 9, 12 or 14, but in any concert
combination you like, allowing you
to tailor a subscription to suit your
tastes, schedule and budget.

DESIGN BY *Voice* PHOTOGRAPHY BY TOBY RICHARDSON

WE WILL DO EVERYTHING IN OUR POWER TO PRESENT THE PROGRAM
LISTED IN THIS BROCHURE, BUT SOMETIMES THINGS HAPPEN THAT ARE
BEYOND OUR CONTROL. IN THESE INSTANCES WE WILL HAVE TO VARY
THE PROGRAM WITHOUT NOTICE AND WE ASK FOR YOUR UNDERSTANDING.

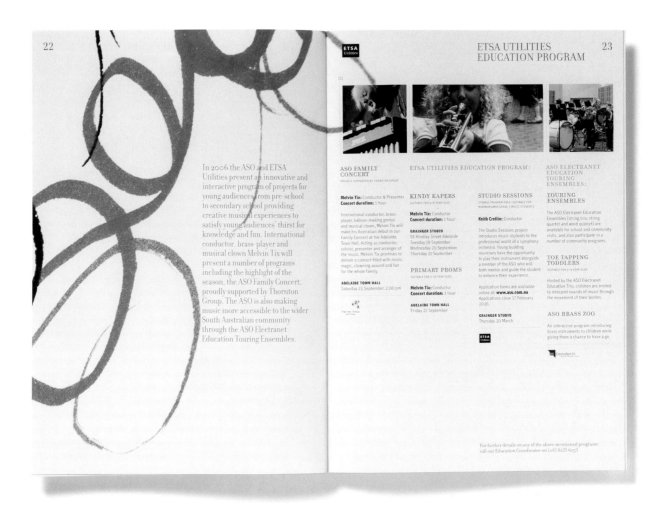

22

In 2006 the ASO and ETSA Utilities present an innovative and interactive program of projects for young audiences from pre-school to secondary school providing creative musical experiences to satisfy young audiences' thirst for knowledge and fun. International conductor, brass-player and musical clown Melvin Tix will present a number of programs including the highlight of the season, the ASO Family Concert, proudly supported by Thornton Group. The ASO is also making music more accessible to the wider South Australian community through the ASO Electranet Education Touring Ensembles.

ETSA UTILITIES EDUCATION PROGRAM

23

ASO FAMILY CONCERT
PROUDLY SUPPORTED BY THORNTON GROUP

Melvin Tix: Conductor & Presenter
Concert duration: 1 hour

International conductor, brass-player, balloon-making genius and musical clown, Melvin Tix will make his Australian debut in our Family Concert at the Adelaide Town Hall. Acting as conductor, soloist, presenter and arranger of the music, Melvin Tix promises to deliver a concert filled with music, magic, clowning around and fun for the whole family.

ADELAIDE TOWN HALL
Saturday 23 September, 2.00 pm

ETSA UTILITIES EDUCATION PROGRAM:

KINDY KAPERS
SUITABLE FOR 4-6 YEAR OLDS

Melvin Tix: Conductor
Concert duration: 1 hour

GRAINGER STUDIO
91 Hindley Street Adelaide
Tuesday 19 September
Wednesday 20 September
Thursday 21 September

PRIMARY PROMS
SUITABLE FOR 5-12 YEAR OLDS

Melvin Tix: Conductor
Concert duration: 1 hour

ADELAIDE TOWN HALL
Friday 22 September

STUDIO SESSIONS
STRINGS PROGRAM ONLY—SUITABLE FOR MINIMUM AMEB GRADE 3 MUSIC STUDENTS

Keith Crellin: Conductor

The Studio Sessions project introduces music students to the professional world of a symphony orchestra. Young budding musicians have the opportunity to play their instrument alongside a member of the ASO who will both mentor and guide the student to enhance their experience.

Application forms are available online at: **www.aso.com.au**
Applications close 17 February 2006.

GRAINGER STUDIO
Thursday 30 March

ASO ELECTRANET EDUCATION TOURING ENSEMBLES:

TOURING ENSEMBLES

The ASO Electranet Education Ensembles (string trio, string quartet and wind quintet) are available for school and community visits, and also participate in a number of community programs.

TOE TAPPING TODDLERS
SUITABLE FOR 2-4 YEAR OLDS

Hosted by the ASO Electranet Education Trio, children are invited to interpret sounds of music through the movement of their bodies.

ASO BRASS ZOO

An interactive program introducing brass instruments to children while giving them a chance to have a go.

For further details on any of the above mentioned programs call our Education Coordinator on (08) 8233 6253.

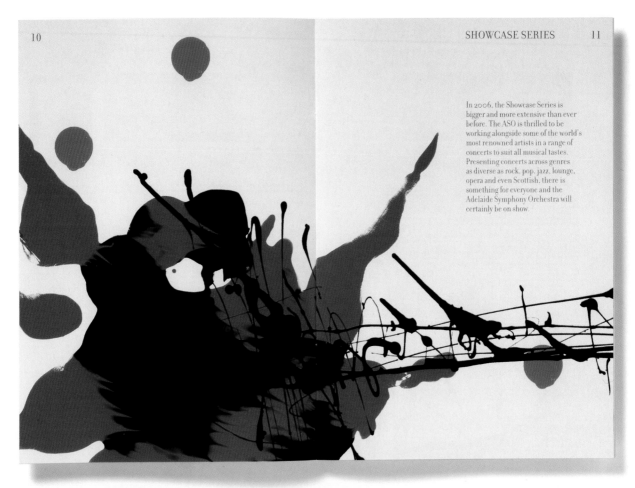

10

SHOWCASE SERIES 11

In 2006, the Showcase Series is bigger and more extensive than ever before. The ASO is thrilled to be working alongside some of the world's most renowned artists in a range of concerts to suit all musical tastes. Presenting concerts across genres as diverse as rock, pop, jazz, lounge, opera and even Scottish, there is something for everyone and the Adelaide Symphony Orchestra will certainly be on show.

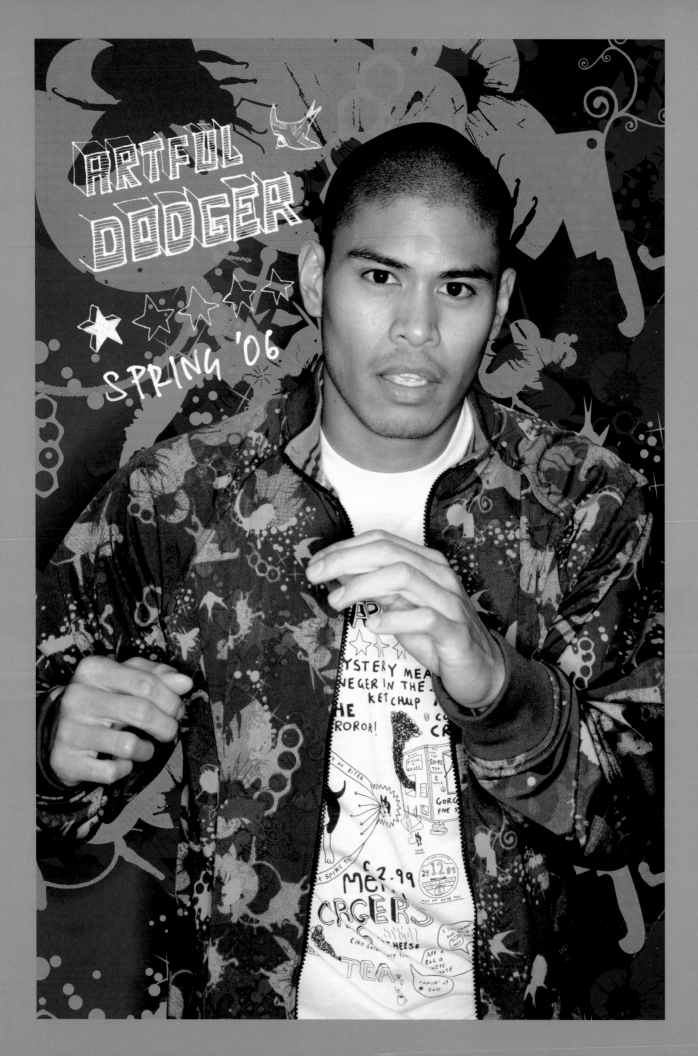

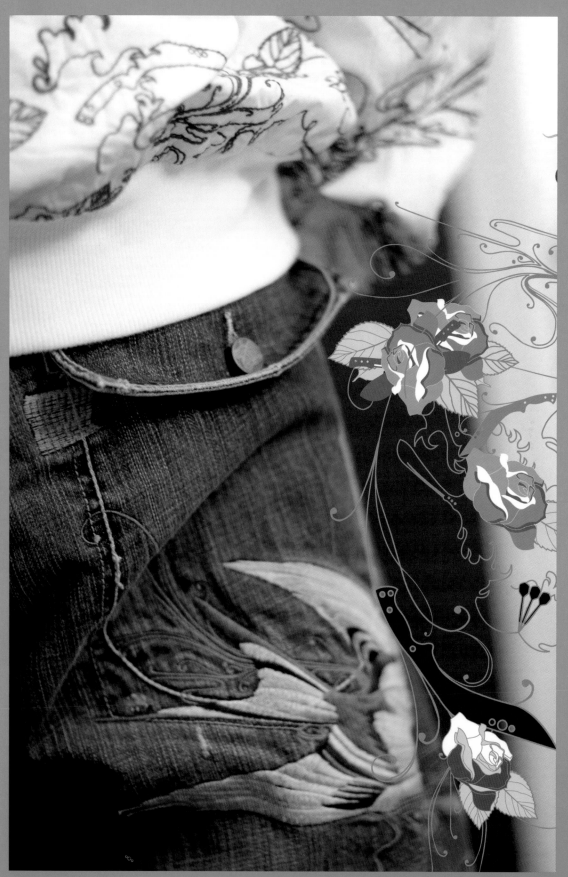

this page and overleaf
Artful Dodger
description Design of a casual
clothing range for men–using
embroidery and illustration.
designers John Glasgow,
Jonathan Kenyon
photographer Rinze van Brug
illustrators John Glasgow
and Jonathan Kenyon with
Daryl Waller
art directors Scott Langton,
Megan Murphy and Vault49
design company Vault 49
country of origin USA

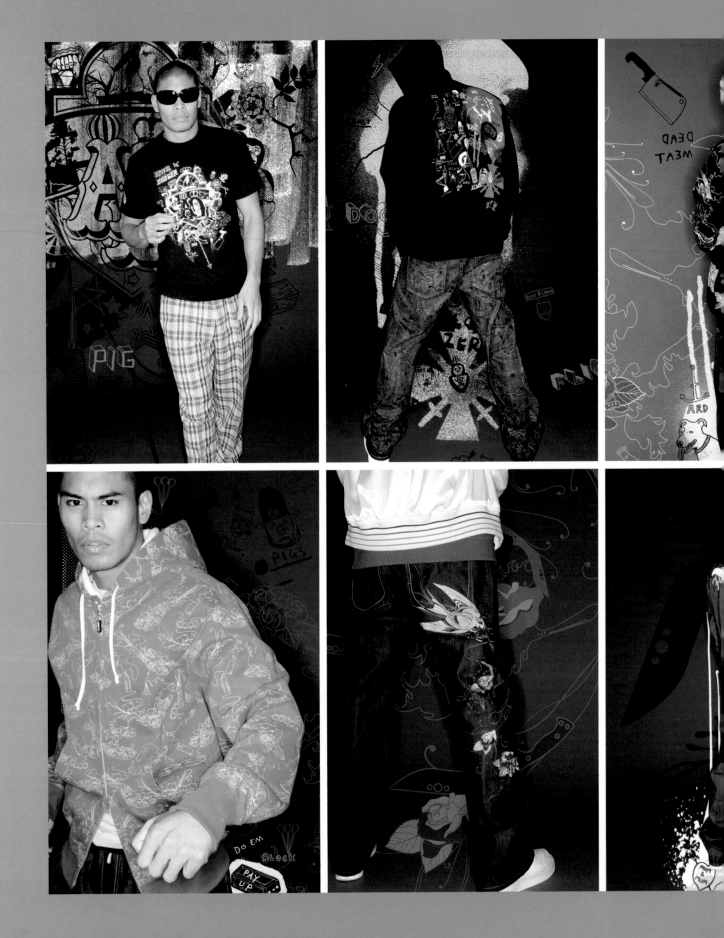

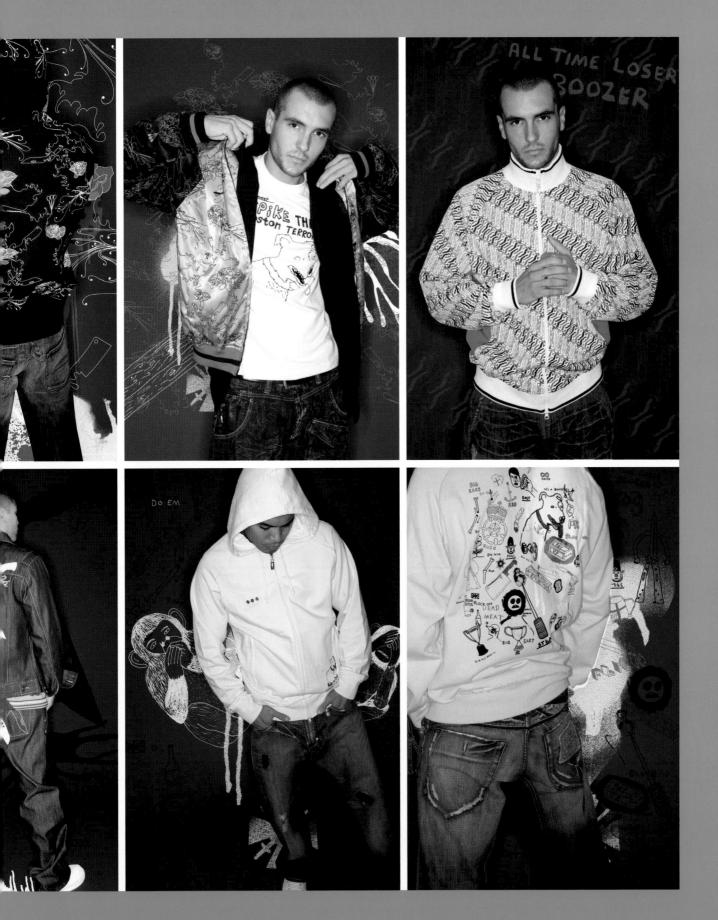

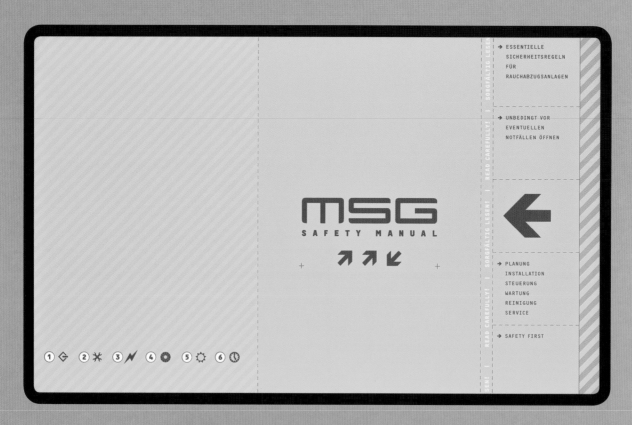

 m5G
SAFETY MANUAL

➔ ESSENTIELLE
SICHERHEITSREGELN
FÜR
RAUCHABZUGSANLAGEN

➔ UNBEDINGT VOR
EVENTUELLEN
NOTFÄLLEN ÖFFNEN

➔ PLANUNG
INSTALLATION
STEUERUNG
WARTUNG
REINIGUNG
SERVICE

➔ SAFETY FIRST

① ◇ ② ✳ ③ ⚡ ④ ✷ ⑤ ✿ ⑥ ◔

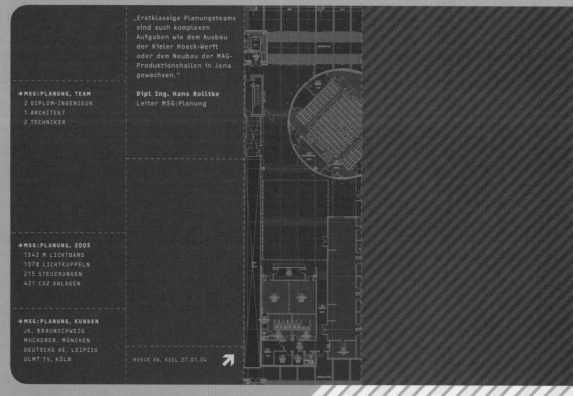

„Erstklassige Planungsteams
sind auch komplexen
Aufgaben wie dem Ausbau
der Kieler Hoeck-Werft
oder dem Neubau der MAG-
Produktionshallen in Jena
gewachsen."

Dipl Ing. Hans Rolltke
Leiter MSG:Planung

➔MSG:PLANUNG, TEAM
2 DIPLOM-INGENIEUR
1 ARCHITEKT
2 TECHNIKER

➔MSG:PLANUNG, 2005
1542 M LICHTBAND
1078 LICHTKUPPELN
215 STEUERUNGEN
421 CO2 ANLAGEN

➔MSG:PLANUNG, KUNDEN
JK, BRAUNSCHWEIG
MUCHERER, MÜNCHEN
DEUTSCHE AE, LEIPZIG
ULMT TV, KÖLN

HOECK AG, KIEL 27.01.04 ↗

this page and overleaf

MSG Safety Manual

dimensions 8 1/2 x 5 1/4 in 215 x 135 mm
description A 20-page corporate brochure
for a smoke and climate control system
company.
designers Ralf Sander, Petra Niedernolte
photographer Ralf Sander
art directors Ralf Sander, Petra Niedernolte
design company Sander & Cie
country of origin Germany

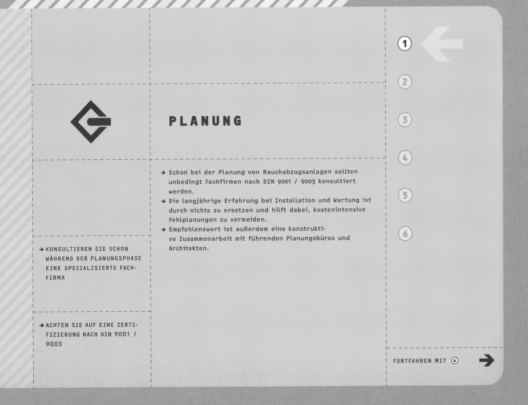

PLANUNG

1
2
3
4
5
6

→ Schon bei der Planung von Rauchabzugsanlagen sollten
 unbedingt Fachfirmen nach DIN 9001 / 9003 konsultiert
 werden.
→ Die langjährige Erfahrung bei Installation und Wartung ist
 durch nichts zu ersetzen und hilft dabei, kostenintensive
 Fehlplanungen zu vermeiden.
→ Empfehlenswert ist außerdem eine konstrukti-
 ve Zusammenarbeit mit führenden Planungsbüros und
 Architekten.

→ KONSULTIEREN SIE SCHON
 WÄHREND DER PLANUNGSPHASE
 EINE SPEZIALISIERTE FACH-
 FIRMA

→ ACHTEN SIE AUF EINE ZERTI-
 FIZIERUNG NACH DIN 9001 /
 9003

FORTFAHREN MIT ④ →

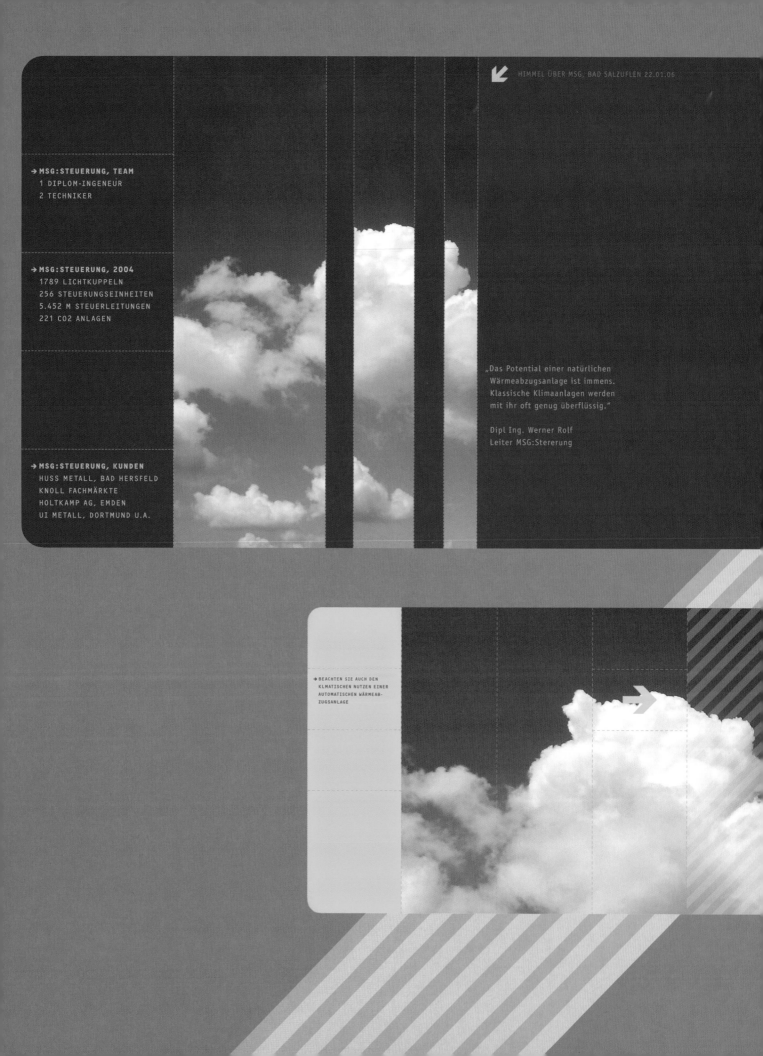

→MSG:STEUERUNG, TEAM
1 DIPLOM-INGENEUR
2 TECHNIKER

→MSG:STEUERUNG, 2004
1789 LICHTKUPPELN
256 STEUERUNGSEINHEITEN
5.452 M STEUERLEITUNGEN
221 CO2 ANLAGEN

„Das Potential einer natürlichen
Wärmeabzugsanlage ist immens.
Klassische Klimaanlagen werden
mit ihr oft genug überflüssig."

Dipl Ing. Werner Rolf
Leiter MSG:Stererung

→MSG:STEUERUNG, KUNDEN
HUSS METALL, BAD HERSFELD
KNOLL FACHMÄRKTE
HOLTKAMP AG, EMDEN
UI METALL, DORTMUND U.A.

→BEACHTEN SIE AUCH DEN
KLMATISCHEN NUTZEN EINER
AUTOMATISCHEN WÄRMEAB-
ZUGSANLAGE

1

2

3

4

5

6

STEUERUNG

→ Auf die Steuerung als Herz einer Rauch- und
Wärme-Abzugsanlage muß besonderes Augenmerk
gelegt werden.
Die Steuerung soll im Erstfall Leben retten und
Investitionen schützen.

→ Aber eine vollautomatisierte Rauch- und
Wäremeabzugsanlage dient nicht nur dem Schutz
von Menschen und Sachwerten. Sie wird außer-
dem zum gesteigerten Wohlbefinden der Bewohner
und zu einer erheblichen Kostenersparnis bei der
Gebäudeklimatisierung beitragen.

→ BEACHTEN SIE AUCH DEN
KLMATISCHEN NUTZEN EINER
AUTOMATISCHEN WÄRMEABZUGS-
ANLAGE

FAHREN SIE FORT MIT SCHRITT ④ →

Daycorp

dimensions 10 ⅝ x 9 ⅞ in
270 x 250 mm

description A "capabilities document" showcasing the work of a property developer and introducing its brand. An original typeface was created for the client's identity—this was used on all headings and then deconstructed on the following pages in order to create a "language" that touches every page.

designer Anthony Deleo

photographer Toby Richardson

art directors Anthony Deleo, Scott Carslake

design company Voice

country of origin Australia

this page and overleaf
Colour Cosmetica
dimensions 8 ¹/₄ x 11 ³/₄ in 210 x 297 mm
description The Colour Cosmetica Education
course manual detailing courses, training, and
qualifications.
designers Anthony Deleo, Scott Carslake
photographer David Solm
art directors Anthony Deleo, Scott Carslake
design company Voice
country of origin Australia

The artwork goes against the
expected nature of the cosmetics
industry by using uncoated
stock and few select images that
showcase the quality of their
graduates' work.

VOICE DESIGN

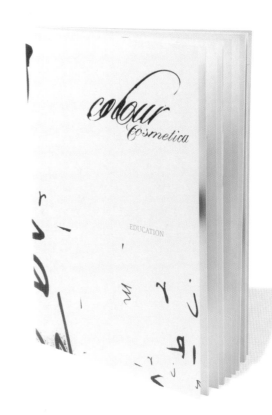

cosmetics + beauty

SECTION C

hair

HAIR

hair

HAIR

hair

HAIR

HAIR

hair

SECTION B

print media / session styling

print media / session styling

pr m ia l

print media / session styling

prin t m edia
sess ion styl i ng

SECTION A

THE FIVE
CERTIFICATE III
IN HAIRDRESSING

SECTION · B I PAGES · 20+21

Colour Cosmetica presents the full qualification in Hairdressing. Successful applicants will qualify with a nationally recognised Certificate in Hairdressing. Whether you decide to study hairdressing via the apprenticeship system or work through full time studies, Colour Cosmetica is there to guide you on your path. With a strategy of combining experience and studies, Colour Cosmetica can provide the best pathway to becoming a fully qualified and recognised hairdresser. The course is divided into five stages.

Stage one
This stage covers:
- perfecting shampooing, head massage, blow drying and finishing with product
- styling techniques that include roller setting, plaiting, tonging, fingerwaves and pincurls, chignon work and how to combine these skills to personalise and produce the desired effect
- understanding head shape and bone structure
- learning how to conduct a full client consultation
- exploring the intricacies of client care
- artistry
- hair science and theory led by a specialist technician

Introductory basic precision cutting skills are then introduced and include:
- one length haircut design
- classic bob
- basic layering.

Participants are guided and monitored throughout all of their work sessions. Theory and practical assignments are given to guide and assess progress. At the end of each stage students are given a one-to-one appraisal to ensure they are heading in the right direction.

Stage two
In this stage participants are introduced to principles and fundamentals of colour and given time to perfect the basics of cutting hair before moving on to more advanced techniques.
This stage covers:
- continuation of one-length cuts
- understanding colour formulas
- understanding colour charts
- classic tint application basic gradation shapes
- exploration of a variety of lengths
- sound gradation
- variations of layering.

Work sessions are monitored to assess progress.

Stage three
In this stage students will learn:
- further classic cutting and colouring techniques and will be introduced to the basics of perming and highlighting
- short hair looks
- contemporary shapes
- round and square layering
- basic perm techniques
- highlighting and foil work
- freehand tinting.

A mock cutting and colouring exam will take place at the end of this stage.

Stage four
In this stage:
- greater emphasis is given to perfect work as a whole producing strong clean finishes. Basic men's haircutting techniques are introduced. Participants will learn the differences between ladies and men's cutting and further use of colour and perming techniques
- classic men's cutting techniques
- scissors over comb techniques and using clippers as a finishing technique
- contemporary colouring technique

A colouring and perming exam will be given at the end of this stage.

Stage five
The last stage is designed to give students the coaching and time to perfect the skills they have learned in a real life salon situation. A cutting and overall exam is given in the last week and participants are marked on the models they complete. The course culminates in a Graduated Final show and Certificate Ceremony where students are required to work together to produce stage presentations with a class finale. Our experts will guide students through theme identification, model calls, clothes styling, make-up, music and lighting to help them show the skills they have learned. Senior Colour Cosmetica staff, student's family, friends, magazine journalists and potential employers attend graduate's final shows.

This stage covers:
- advanced layering and gradation
- disconnection and freehand techniques
- advanced finishing techniques
- further exploration of men's hairdressing.

SUCCESSFUL STUDENTS WILL BE AWARDED NATIONAL VOCATIONAL QUALIFICATIONS IN CERTIFICATE III IN HAIRDRESSING.

Course Specifications
Duration of 12 months
- Delivered full time
- Part time apprentice training (354 hours)
- Dates on request

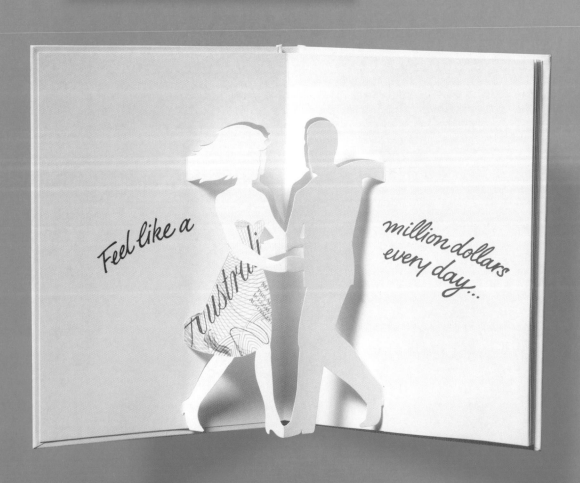

When I retire I'm going to...

dimensions 6 ½ x 8 ⅝ in 165 x 220 mm

description The designers used the pop-up book medium, coupled with simple rhyming verse to both stimulate imagination and encourage memorability through interactivity. This booklet was designed for Map Financial Strategies–a client who develops financial solutions specifically dictated by their customers' lifestyle choices.

designers Scott Carslake, Stuart Gluth

illustrator Stuart Gluth

art directors Scott Carslake, Stuart Gluth

design company Voice

country of origin Australia

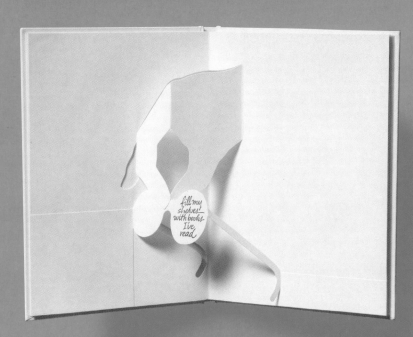

*fill my
shelves
with books
I've
read*

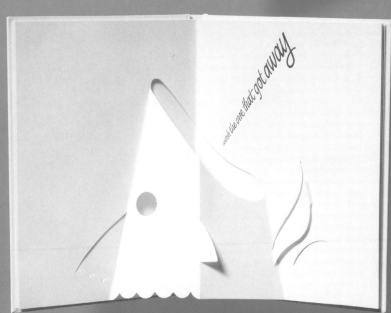

wish like one that got away

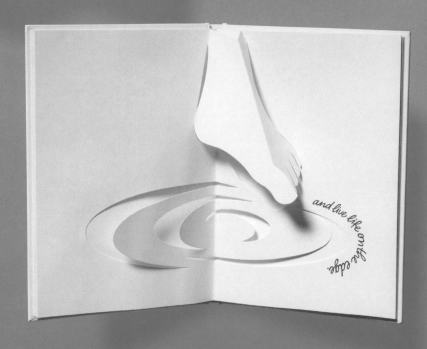

and live like one on the edge.

A Weekend with Petra,

or the New Triumph Speed Triple

dimensions 9 x 5 ⁷/₈ in 230 x 150 mm

description 16-page promotional brochure for
a motorcycle, taking the form of a personal
photographic diary. (Unpublished.)

designers Ralf Sander, Petra Niedernolte

photographer Ralf Sander

art directors Ralf Sander, Petra Niedernolte

design company Sander & Cie

country of origin Germany

A WEEKEND WITH PETRA
TRAVELOUGE, JUNE 2006

A WEEKEND WITH PETRA
TRAVELOUGE, JUNE 2006

CHRISTMAS?
SATURDAY, 17 JUNE 2006

10:12 PM
We are sitting at the shore of this small
lake, and the sun is going down slow-
ly. Petra seems to become a little bit
romantic. But suddenly, it occurs to
me, that I have not seen the cockpit illu-
mination in the darkness yet and I go at
it immediately.
"Wow look, these guys made it perfect,
too. Looks pretty good, like everything."
"Oh man, have you anything else on
your mind than your bike? What about
this nice place and the sundown. What
about me?"
Hm, I can't remember exactly, but that's,
how I must have felt on Christmas eve-
ning, when my mum
advised me to stop playing with my new
toys and to go to bed. But I think, she
allowed me to take the toys with me to
bed – sometimes.

↗ Weight (Dry)
189 kg

☐ Note 3 | 11:32 AM
Look. This amazing
beauty. Even in
darkness she cuts a
figur. The metallic
lacquer is glimmering
like hell and forms
a fantastic contrast
to the
chrome and polished
aluminum parts

↗ TRAVEL FACTS

8:30 PM / 9:30 PM
FRIEDRICHSHAFEN
MEERSBURG

⊢⊣ 35 KM
HARBOUR
BODENSEE

☼ SUNNY TWILIGHT

⟳ 29/26°

↗ GÖGGINGEN

HASELWEILER

→ **Maximum Powe-**
98PS / 9.100 rp
→ **Maximum Torqu-**
105Nm / 5.100 r

☐ **Note 18 | 12:42 <**
The sound of th-
three-cylinder
engine drives m-
crazy. It's not th-
technical, smoot-
sound of four.
It's much more a-
low rotations, an-
very mechanic. I
more and more
on higher revs.

→ **TRAVEL FACTS**

⏱ 9:00 AM-11:00 PM
GÖGGINGEN

★ STOCKACH

⟷ 580 KM

⚓ HARBOUR
⌂ BODENSEE

☼ ALMOST SUNNY
🌡 16,25°

GÖGGINGEN +

SALEM +

ÜHLFINGEN +

STOCKACH +

11:22 AM
Petra has forgotten her kidney-belt in our
hotel which is over 30 miles away from our
current position. Looks, like this is gonna be a
perfect weekend, though. "Honey, I think, it's
not a good idea, to drive without the kidney
belt too long. So have a break here in this
nice town. I drive back and get the belt."
She agrees and I have fantastic 100 kilome-
ters.

(I think, it wasn't the direct way)

HELLO WORLD:
HUNGARY

ni3 hao3 shi4 jie4 | hola mundo

HIP HOP SOCIET

hiphopsamfundet | heep hop eshtemah

GORILLAZ

According to Gorillaz
guitarist Noodle, the

NEXT ON THE IMF

hip hop society
one world
hello world: iceland

ONE WORLD

einn heimur | un' mondo

PASSAGE TO INI

färd till indien | raahroe beh hendoostan

TONIGHT ON THE IMF

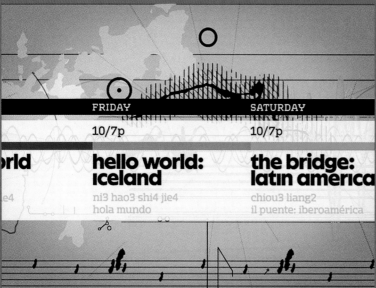

FRIDAY SATURDAY

10/7p 10/7p

orld **hello world: iceland** **the bridge: latin america**

je4 ni3 hao3 shi4 jie4 chiou3 liang2
 hola mundo il puente: iberoamérica

NEXT ON THE IMF

LCD Soundsystem

International Music Feed (IMF)

description Identity project for a new music network showing videos from all over the world. The task included logo design, type design, illustration, live action, stop motion, and computer graphics. The design takes visual clues from maps, musical scores, tattoos, and the 1972 Olympics.
designers Jens Gehlhaar, Clarissa Tossin, Jonathan Notaro, Rob Feng, Max Erdenberger, Andy Bernet, Tom Koh
illustrator Clarissa Tossin
photographers Ian Brook, Pat Notaro
art directors Jens Gehlhaar, Jonathan Notaro
design company Brand New School
country of origin USA

In the show openers, hand-colored, gritty, and grainy photography serves as a counterweight to the clean vectors and fluid animations of the illustrations. Compared with the majestic, sweeping scale of the illustrations, the photographic imagery uses mostly tabletop-size or miniature scale objects.

BRAND NEW SCHOOL

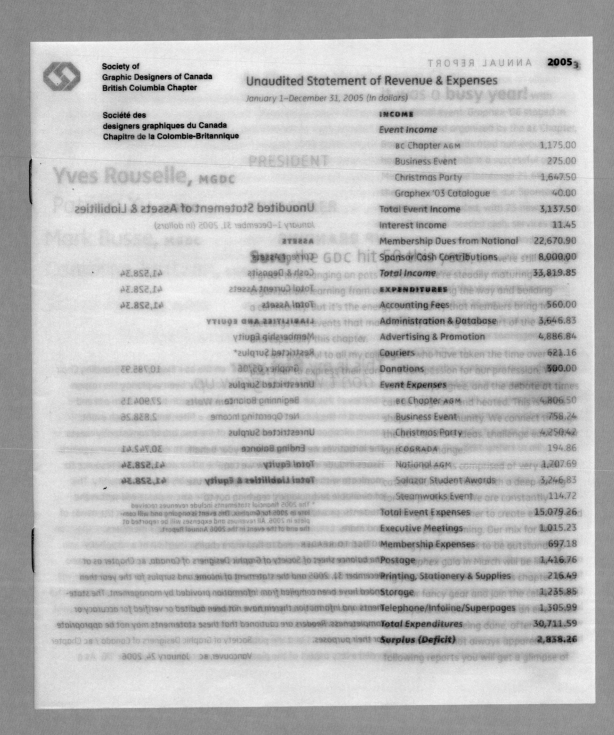

above
The Society of Graphic Designers of Canada Annual Report, 2005
dimensions 6 x 7 in 152 x 178 mm
description A transparent annual report for the British Columbia Chapter of the Society of Graphic Designers of Canada. Each page is perfectly readable on its own, but the paper results in text layering.
designer Marian Bantjes
country of origin Canada

facing page
The Society of Graphic Designers of Canada Annual Report, 2004
dimensions 23 x 36 in 584 x 914 mm
description An all-blackletter annual report of the British Columbia chapter of the Society of Graphic Designers of Canada. Printed as a poster in black and silver.
designer Marian Bantjes
illustrator Marian Bantjes
country of origin Canada

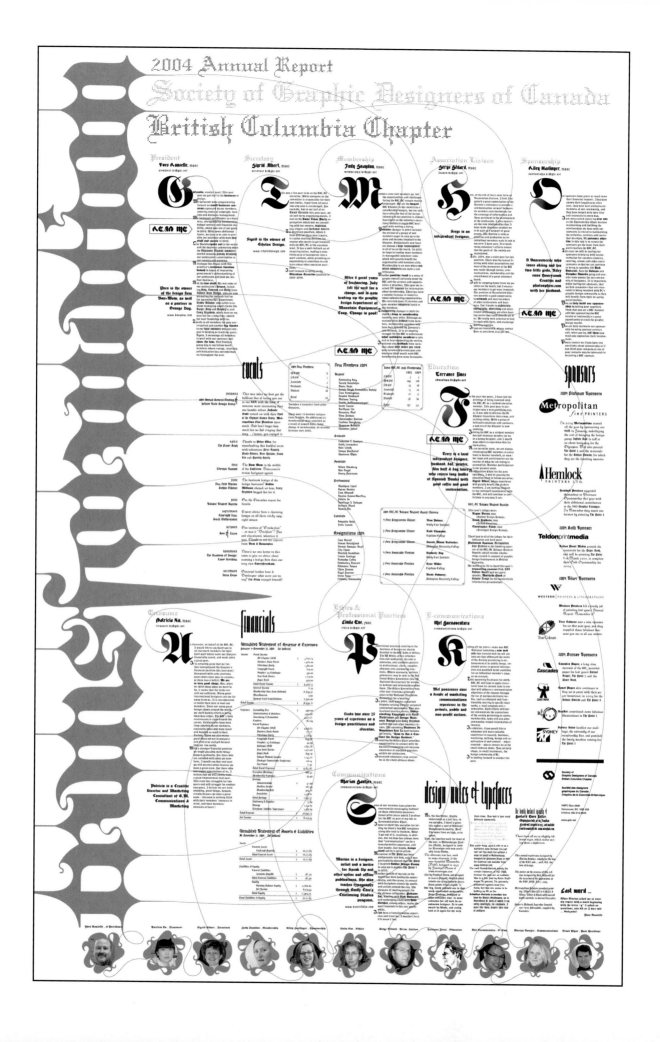

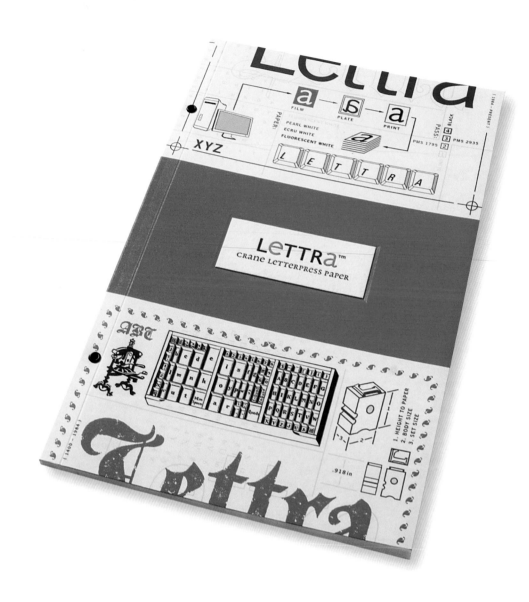

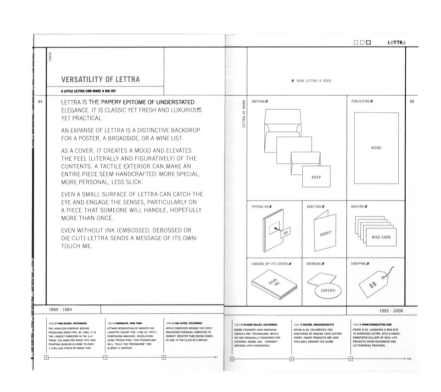

Lettra Swatchbook

dimensions 6 x 9 ¹/₂ in 152 x 241 mm

description A swatchbook created for Crane & Co. to showcase their paper's beautiful printability and to serve as an educational tool on letterpress printing.

designers Michael Osborne, Cody Dingle

letterpress One Heart Press

lithography Moquin Press

art director Michael Osborne

design company Michael Osborne Design

country of origin USA

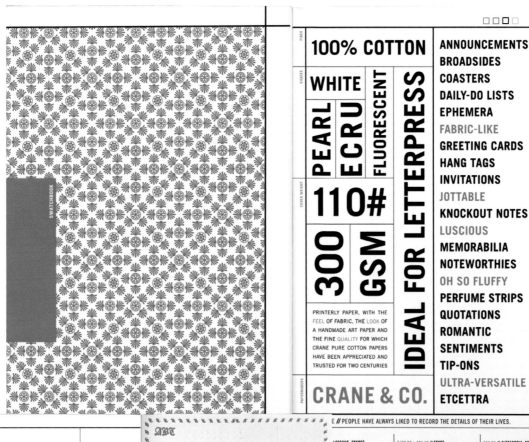

□ □ □ □ LeTTRa

100% COTTON

WHITE

PEARL ECRU FLUORESCENT

110#

300 GSM

PRINTERLY PAPER, WITH THE FEEL OF FABRIC, THE LOOK OF A HANDMADE ART PAPER AND THE FINE QUALITY FOR WHICH CRANE PURE COTTON PAPERS HAVE BEEN APPRECIATED AND TRUSTED FOR TWO CENTURIES

CRANE & CO.

IDEAL FOR LETTERPRESS

ANNOUNCEMENTS
BROADSIDES
COASTERS
DAILY-DO LISTS
EPHEMERA
FABRIC-LIKE
GREETING CARDS
HANG TAGS
INVITATIONS
JOTTABLE
KNOCKOUT NOTES
LUSCIOUS
MEMORABILIA
NOTEWORTHIES
OH SO FLUFFY
PERFUME STRIPS
QUOTATIONS
ROMANTIC
SENTIMENTS
TIP-ONS
ULTRA-VERSATILE
ETCETTRA

01

SWATCHBOOK

DESIGN MINDSHIFT

WHEN WHAT YOU PUT WHERE, MATTERS A LOT

SPECIALTY PRINTING PROCESSES ARE PERFORMED ONE COLOR AT A TIME (EXCEPT THERMOGRAPHY, WHICH IS REALLY AN EXTENSION OF LITHOGRAPHY). MULTIPLE PASSES CAN "STRESS" THE SUBSTRATE AS WELL AS THE TIMETABLE AND PROJECT BUDGET.

EACH PRESS PASS REQUIRES ITS OWN DIE. IN SOME INSTANCES, ARTWORK FOR A SINGLE COLOR MAY NEED TO BE SEPARATED YET AGAIN, INTO TWO DIES. AN ENGRAVED CERTIFICATE, FOR EXAMPLE, MAY BE TOO LARGE TO PRINT IN A SINGLE PASS. FOR LETTERPRESS, THE OPTIMAL INKING FOR LARGE SOLIDS AND FINE TYPE IS SO DIFFERENT, THAT TRYING TO COMBINE BOTH IN A SINGLE PRESS PASS WILL COMPROMISE QUALITY.

LETTRA IS SOFT TO THE TOUCH, BUT EXTREMELY STABLE ON PRESS. IT WITHSTANDS MULTIPLE PRESS OPERATIONS AND HOLDS SUPERB REGISTRATION THROUGH SUCCESSIVE HIGH-PRESSURE PASSES.

SECOND PRESS PASS // LETTERPRESS (RED)

Registration to the first pass is essential – if it is "off" anywhere, it will be off everywhere. We could comment that it takes two t's to tango.

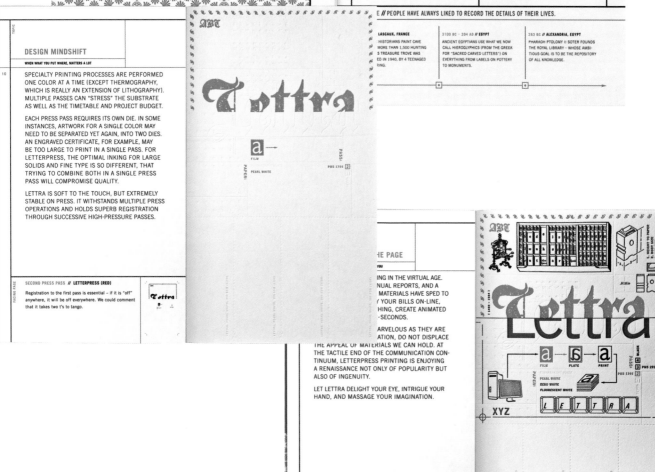

// PEOPLE HAVE ALWAYS LIKED TO RECORD THE DETAILS OF THEIR LIVES.

LASCAUX, FRANCE
HISTORIANS PAINT CAVE MORE THAN 1,500 HUNTING TREASURE TROVE WAS ED IN 1940, BY 4 TEENAGED RING.

3100 BC – 394 AD // EGYPT
ANCIENT EGYPTIANS USE WHAT WE NOW CALL HIEROGLYPHICS (FROM THE GREEK FOR "SACRED CARVED LETTERS") ON EVERYTHING FROM LABELS ON POTTERY TO MONUMENTS.

283 BC // ALEXANDRIA, EGYPT
PHARAOH PTOLEMY II SOTER FOUNDS THE ROYAL LIBRARY – WHOSE AMBITIOUS GOAL IS TO BE THE REPOSITORY OF ALL KNOWLEDGE.

a → FILM PASS:
PAPER: PEARL WHITE PMS 1795 [2]

HE PAGE

ING IN THE VIRTUAL AGE.
NUAL REPORTS, AND A
MATERIALS HAVE SPED TO
Y YOUR BILLS ON-LINE,
HING, CREATE ANIMATED
-SECONDS.

ARVELOUS AS THEY ARE
ATION, DO NOT DISPLACE
THE APPEAL OF MATERIALS WE CAN HOLD. AT THE TACTILE END OF THE COMMUNICATION CONTINUUM, LETTERPRESS PRINTING IS ENJOYING A RENAISSANCE NOT ONLY OF POPULARITY BUT ALSO OF INGENUITY.

LET LETTRA DELIGHT YOUR EYE, INTRIGUE YOUR HAND, AND MASSAGE YOUR IMAGINATION.

FINAL PRESS PASS // LETTERPRESS (BLACK)

The black pass registers to the red and the blue. The image, and this demonstration on Lettra, are now complete. This fluffy, absorbent sheet, so soft to the touch, has shown itself to be a strong, silent type on press.

Lettra

a → FILM a → PLATE a → PRINT BLACK
PASS: [4] PMS 2935
PAPER: PEARL WHITE PMS 1795 [2]
ECRU WHITE
FLUORESCENT WHITE

.018in

XYZ L E T T R A

1. RIGHT TO PAPER
2. RIGHT SIZE
3. GET SIZE

THE
TOP 10 TEN
Quotations
of
THE DISTINGUISHED GENTLEMAN FROM MISSISSIPPI
DR. DOUGLAS LEWIS

FOR DR. DOUGLAS LEWIS, TO COMMEMORATE 27 YEARS
OF STELLAR SERVICE TO THE CITIZENS' STAMP ADVISORY COMMITTEE
OCTOBER 19, 2005

Top Ten Quotations
dimensions 4 1/4 x 5 1/2 in 108 x 140 mm
description A booklet designed to commemorate
Dr. Douglas Lewis for 27 years of service to the
Citizens' Stamp Advisory Committee. It contains
ten quotes documented during committee
meetings from over a quarter of a century.
designers Michael Osborne, Alice Koswara
letterpress One Heart Press
art director Michael Osborne
design company Michael Osborne Design
country of origin USA

NUMBER TWO

"A
PHANTASMAGORICAL
IDEA"

2

AND THE
№ ONE
FAMOUS
QUOTATION of
DR. DOUGLAS
LEWIS...

THE
TOP 10 TEN
QUOTATIONS
of
THE DISTINGUISHED GENTLEMAN FROM MISSISSIPPI
DR. DOUGLAS LEWIS

NUMBER TEN

" INCANDESCENTLY
LUMINOUS
DIPLOMATS "

10

NUMBER NINE

"A *Q*uantum *of* RATIOCINATION"

9

NUMBER EIGHT

"Conjoined Congeniality"

8

NUMBER SEVEN

"Showstoppingly Beautiful!"

7

21

Preset-X™ Design by Julian Morey. ®?® © 2003 Club Twenty-One

21

A is for Aardvark (Alpine)
B is for Butterfly (Skye)
C is for Cat (Frieze Bold)
D is for Dog (Electro)
E is for Elephant (Portfolio)
F is for Fox (Kathode)
G is for Giraffe (Pacific Bold)
H is for Horse (Checkout)
I is for Iguana (Typogram)
J is for Jaguar (Checkout Extended Ultra-Light)
K is for Koala (Spacer)
L is for Lion (Jakarta)
M is for Moose (VMR)
N is for Newt (Preset-F)
O is for Octopus (Octago)
P is for Peacock (Brassplate)
Q is for Quetzal (Liquid-B)
R is for Rat (Roadworks)
S is for Squirrels (Skye Outline)
T is for Turtle (Simpson Typewriter)
U is for Unicorn (Thompson Typewriter)
V is for Vole (Paintworks)
W is for Whale (Greenwich)
X is for X-Ray Fish (Signplate)
Y is for Yak (Ionia)
Z is for Zebra (Zexon)

this page
Club-21 Ascii Art Alphabet Animals Poster
dimensions 16 ⅛ x 21 ½ in
410 x 546 mm
description Poster designed to promote the Club-21 typeface foundry. Printed on Dutchman Smooth White 120gsm paper in blue, red, yellow, and black.
designer Julian Morey
design company Julian Morey Studio
country of origin UK

previous page, left
Club-21 Preset-O Poster
dimensions 11 ¾ x 16 ½ in
297 x 420 mm
description Poster designed to promote the Club-21 typeface foundry. Printed on Splendorgel Extra White 100gsm paper in blue and cyan.
designer Julian Morey
design company Julian Morey Studio
country of origin UK

previous page, right
Club-21 Preset-X Poster
dimensions 11 ¾ x 16 ½ in
297 x 420 mm
description Poster designed to promote the Club-21 typeface foundry. Printed on Splendorgel Extra White 100gsm paper in fluorescent green and gold.
designer Julian Morey
design company Julian Morey Studio
country of origin UK

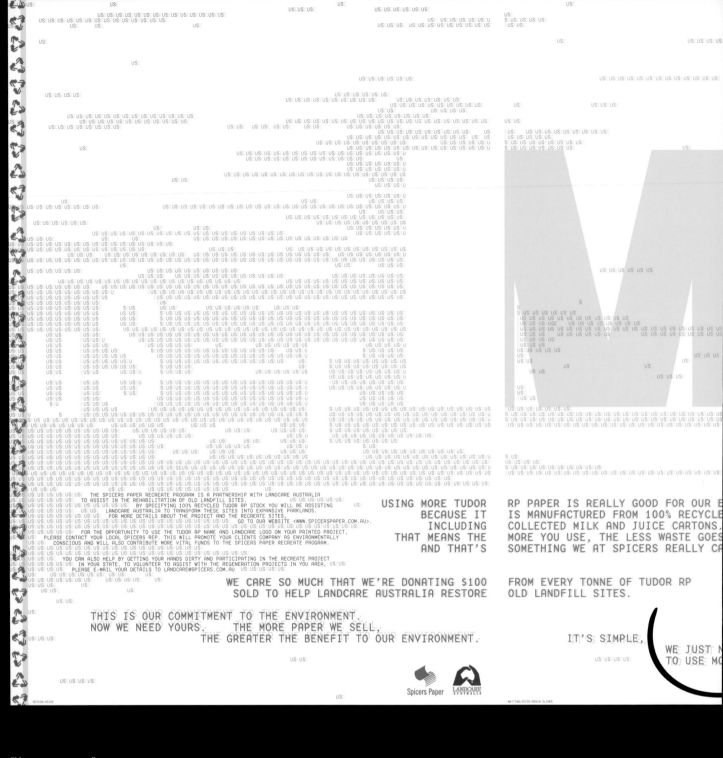

"Use more paper"

dimensions 16 ¹/₂ x 23 ³/₈ in 420 x 594 mm
(single poster)
description Series of three individual posters which
form the message "Use more paper" when placed
next to one another. Created for the Spicers Paper
Recreate program in Australia, promoting 100%
recycled Tudor RP stock.
designers Scott Carslake, Anthony Deleo
art directors Scott Carslake, Anthony Deleo
design company Voice

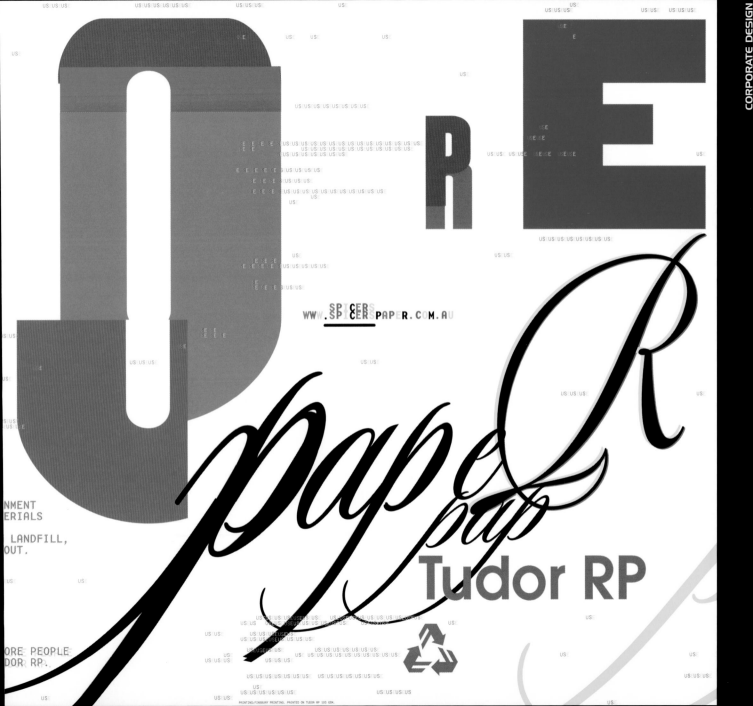

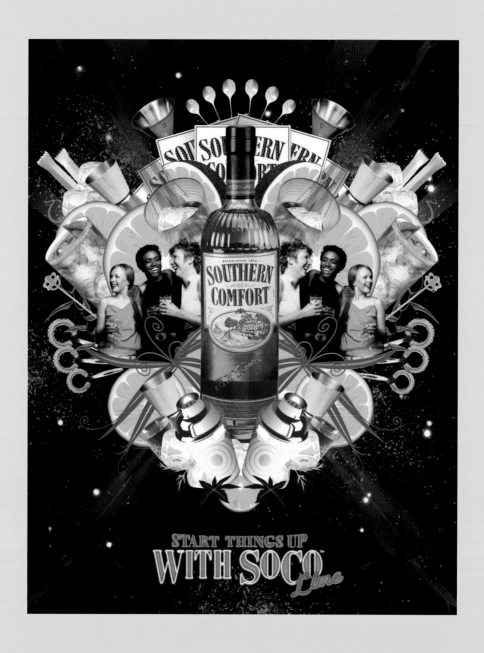

above

Southern Comfort

dimensions 8 ¹/₂ x 11 in 216 x 280 mm

description Press advertisement for
Southern Comfort whiskey.

designers John Glasgow, Jonathan Kenyon

art director Andrea Ricker (Arnold)

design company Vault 49

country of origin USA

right

VH I

dimensions 24 x 30 in 610 x 762 mm

description Print and press advertisements
for VH1 television channels.

designers John Glasgow, Jonathan Kenyon

photographers VH1

art director Nancy Mazzei (VH1)

design company Vault 49

country of origin USA

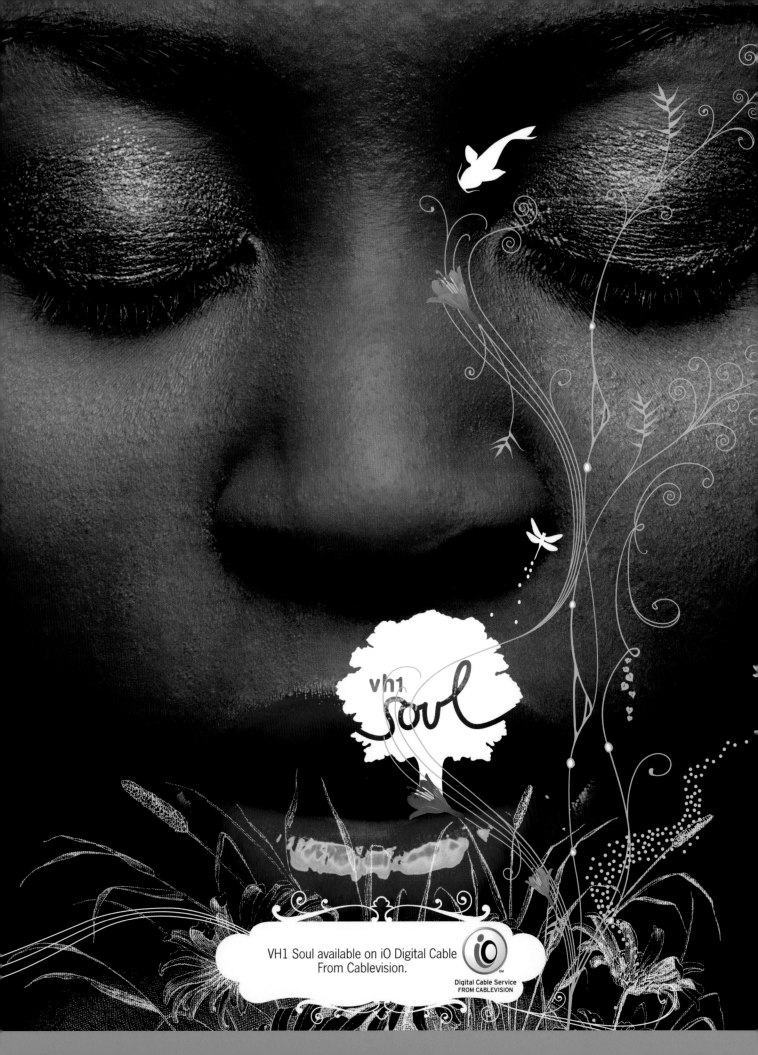

VH1 Soul available on iO Digital Cable
From Cablevision.

Digital Cable Service
FROM CABLEVISION

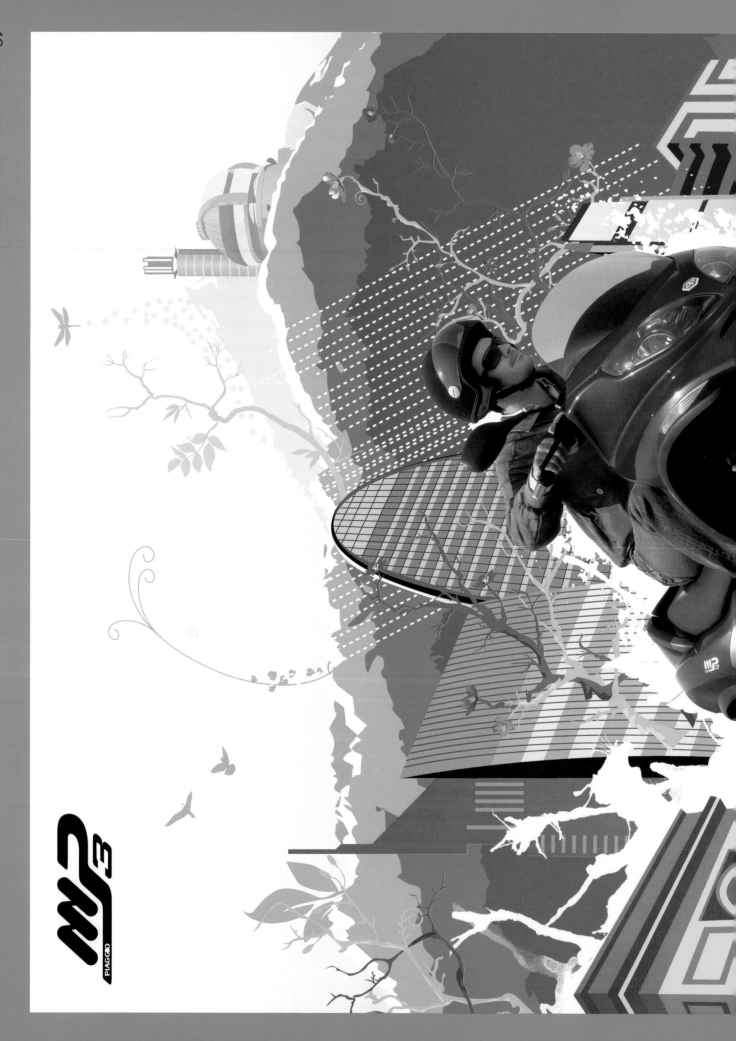

NASCE PIAGGIO MP3. WELCOME. TOMORROW.

Liberi Tutti

PIAGGIO®

Piaggio MP3

dimensions 8 1/4 x 11 5/8 in
210 x 297 mm

description
European print and
press advertisements
for Piaggio MP3.

designers John Glasgow,
Jonathan Kenyon

art director Marianne
Asciak (Industrial Strange)

design company Vault 49

country of origin USA

overleaf

T-Mobile Sidekick 3

dimensions 18 x 10 7/8 in
457 x 276 mm

description
All media advertisements
for T-Mobile cellular
phone network.

designers John Glasgow,
Jonathan Kenyon

art directors Marisa
Powell (Publicis West)

design company Vault 49

country of origin USA

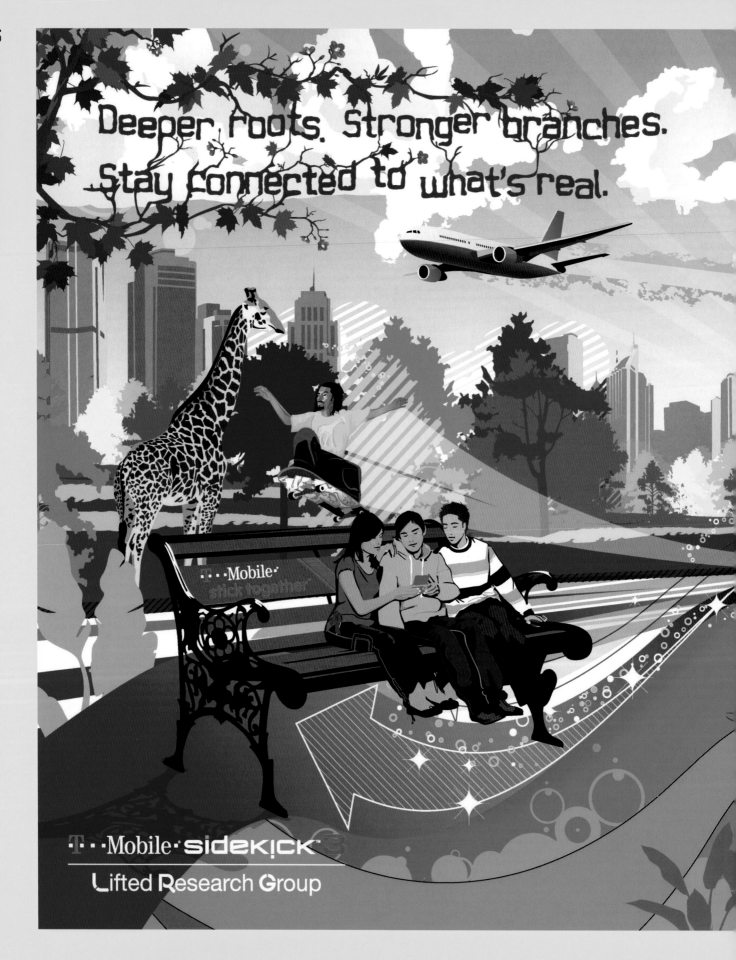

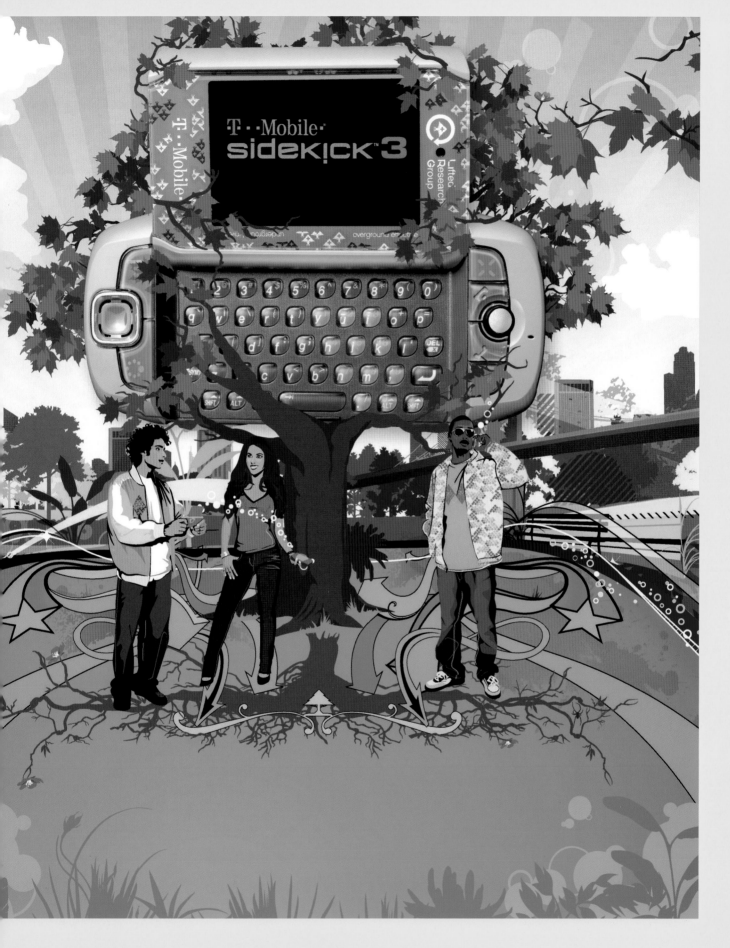

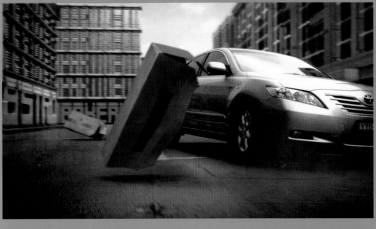

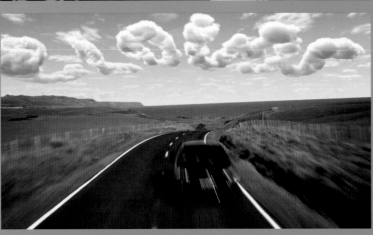

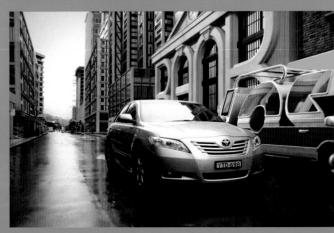

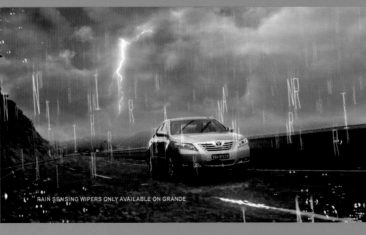

RAIN SENSING WIPERS ONLY AVAILABLE ON GRANDE

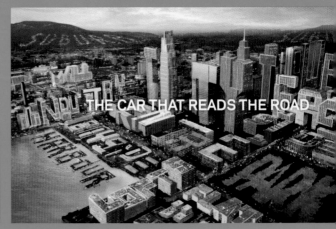

THE CAR THAT READS THE ROAD

This TV campaign for the Toyota Camry shows how the highly evolved automobile "reads the road." It encounters buildings, cityscapes, other cars on the road, clouds, and plants that resemble letters and words—letting it know what lies ahead. Shot over seven days in New Zealand, the three spots took four months in post-production.

BRAND NEW SCHOOL

Toyota Camry, "The Car that Reads the Road"
dimensions 1024 x 576 pixels
description Television advertisement campaign for Toyota Camry.
illustrators Keetra Dixon, Danny Ruiz, Eric Adolfsen, Ludovic Schorno
photographer Chris White
live action directors Jonathan Notaro, Jens Gehlhaar
animation directors Jonathan Notaro, Dickson Chow
art director Jonathan Notaro
design company Brand New School
country of origin USA

Nike Jordan
description T-shirt design for Nike Jordan.
designer Kerry Roper
illustrator Kerry Roper
art director Kerry Roper
design company Beautiful
country of origin UK

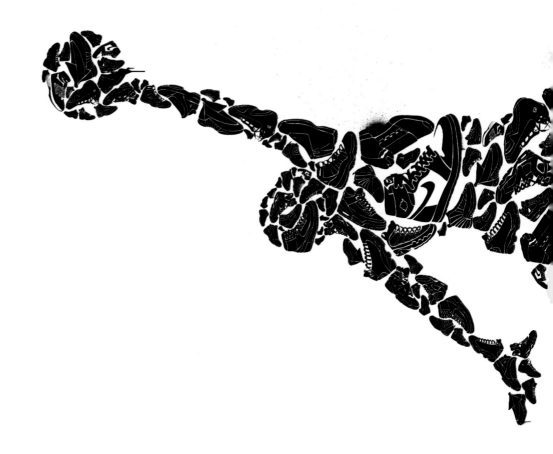

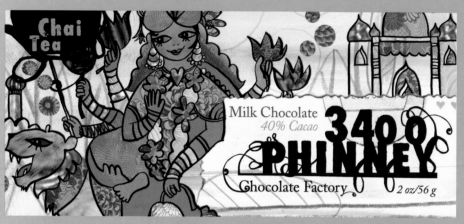

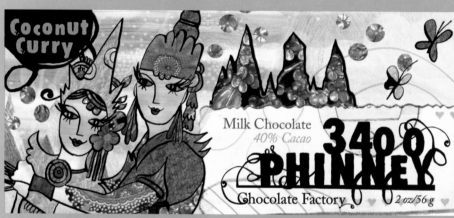

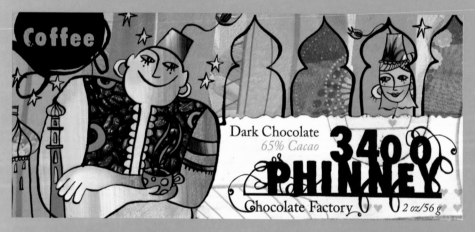

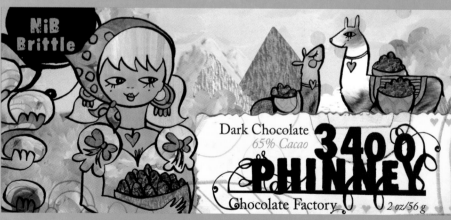

3400 Phinney Chocolate
dimensions 5 x 2 in 127 x 51 mm
description Chocolate bars packaging design
for a line of organic, flavored chocolate bars.
designer Zaara (Marta Windeisen)
illustrator Zaara (Marta Windeisen)
art director Zaara (Marta Windeisen)
design company Kitten Chops Studio
country of origin USA

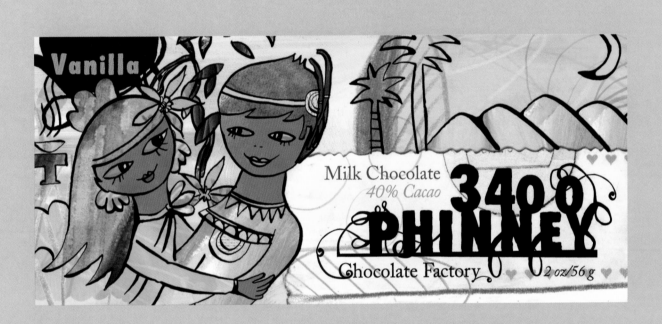

Theo Chocolate
dimensions 3 x 7 in 76 x 178 mm
description Logo and packaging design
for a gourmet line of organic chocolates,
made in Seattle, Washington (USA).
designer Zaara (Marta Windeisen)
illustrator Zaara (Marta Windeisen)
art director Zaara (Marta Windeisen)
design company Kitten Chops Studio
country of origin USA

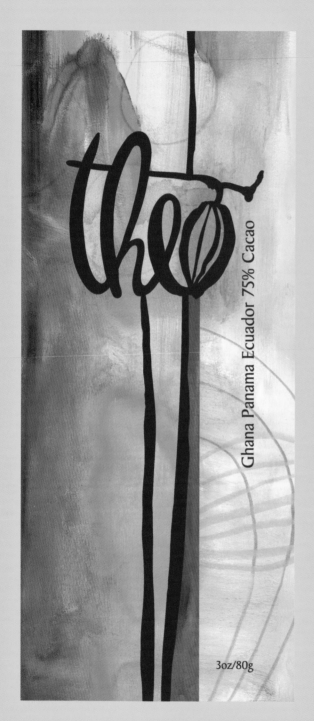

Ghana Panama Ecuador 75% Cacao

3oz/80g

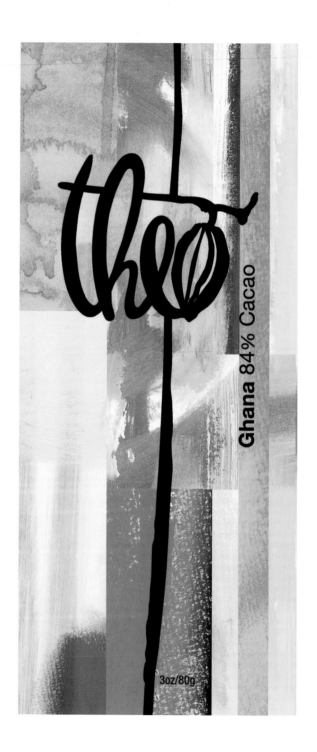

Ghana 84% Cacao

3oz/80g

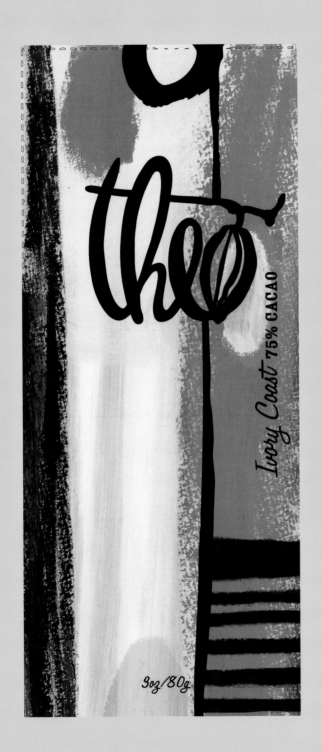

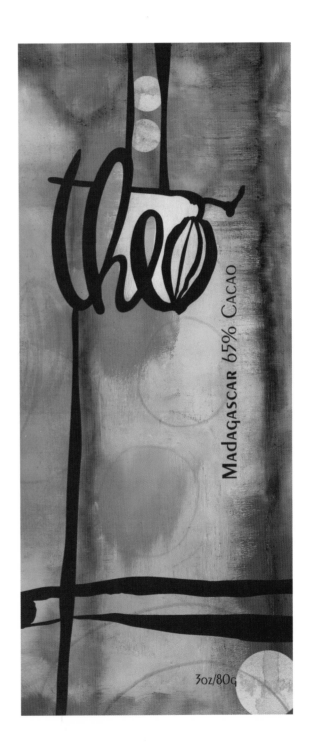

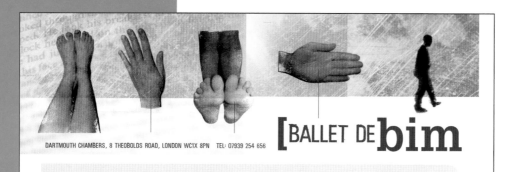

DARTMOUTH CHAMBERS, 8 THEOBOLDS ROAD, LONDON WC1X 8PN TEL: 07939 254 656

stationery for Ballet de Bim
letterhead
8 1/4 x 11 3/4 in 210 x 297 mm (A4)
business card
3 3/8 x 2 1/8 in 85 x 55 mm
comp slip
8 1/4 x 3 7/8 in 210 x 100 mm
description Stationery and identity
work for a choreographer using
collage illustration.
designer Craig Yamey
art director Craig Yamey
design company Yam
country of origin UK

DARTMOUTH CHAMBERS, 8 THEOBOLDS ROAD, LONDON WC1X 8PN TEL: 07939 254 656

stationery for Philip Haralambos
letterhead
8 1/4 x 11 3/4 in 210 x 297 mm (A4)
description Identity and stationery
for still life/interiors stylist using
photographic and illustrative elements.
designer Craig Yamey
art director Craig Yamey
design company Yam
country of origin UK

philip haralambos still life stylist

45 Killyon Road, London SW8 2XS | t: 020 7450 6950 | m: 07753 640837 | e: philipharalambos@hotmail.com

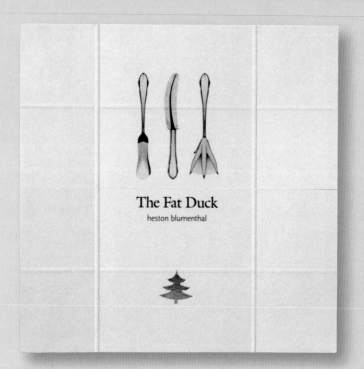

The Fat Duck Christmas Card 2006

dimensions 4 ¹/₈ x 4 ¹/₈ in 104 x 104 mm

description Christmas card for Heston Blumenthal's
3-Michelin-star restaurant called "The Fat Duck."
Printed, foil-blocked, and hand-finished by the Malvern
Press Ltd. UK

designer Milos Covic

art college The Design Laboratory at Central
St. Martin's College of Art and Design

country of origin UK

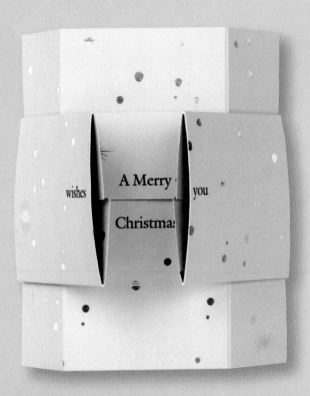

design for the

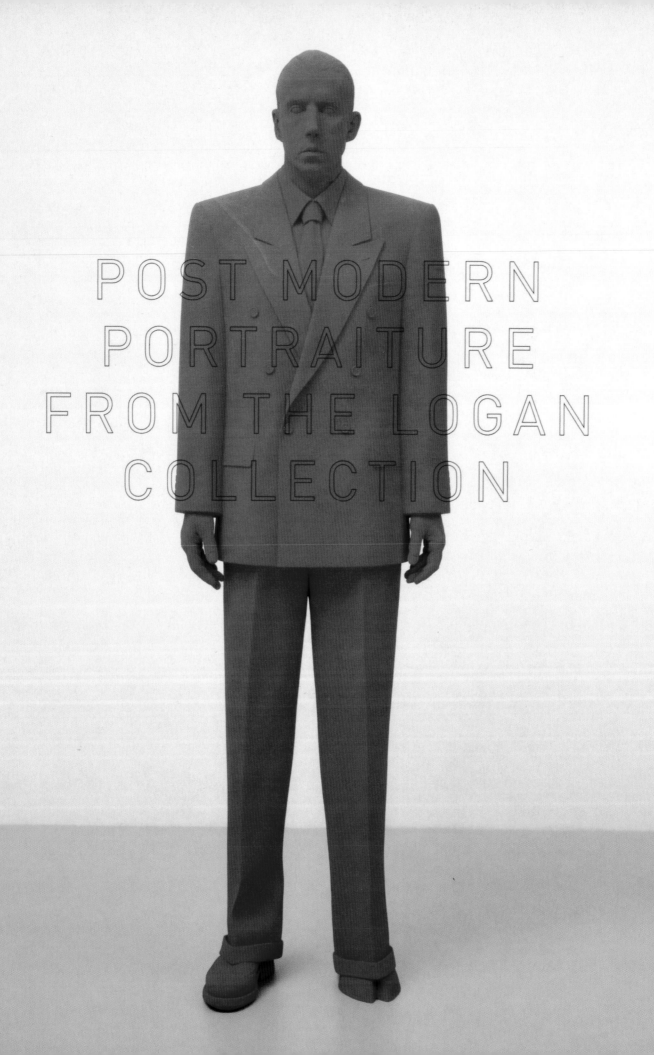

CONTENTS

Post Modern Portraiture from the Logan Collection

dimensions 8 1/4 x 11 1/4 in 210 x 286 mm

description This exhibition catalog for the Logan Collection collects all the works that can be classified as portraits. True to the iconoclastic spirit of the collection, many of the works are non-figurative.

designer Bob Aufuldish

art director Bob Aufuldish

design company Aufuldish & Warinner

country of origin USA

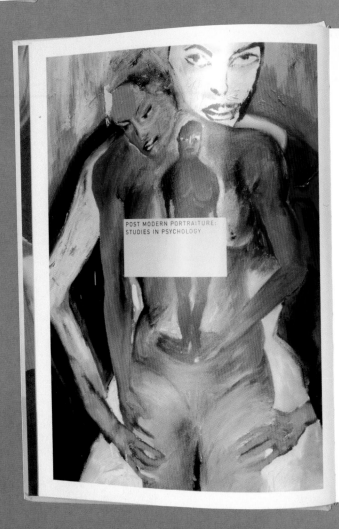

POST MODERN PORTRAITURE:
STUDIES IN PSYCHOLOGY

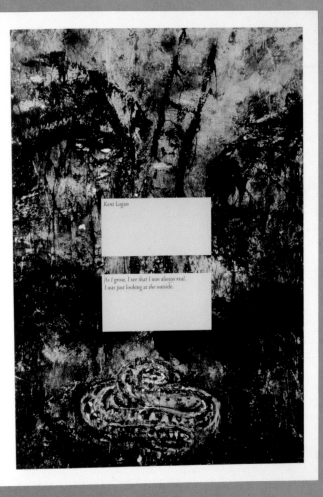

Kent Logan

As I grow, I see that I was always real.
I was just looking at the outside.

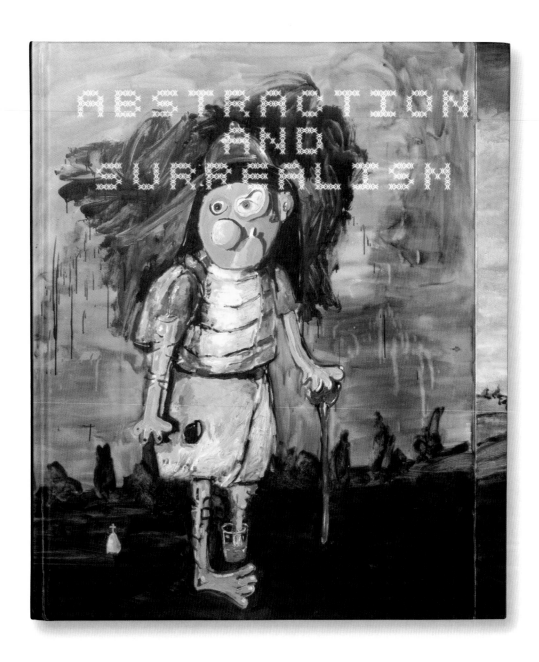

**A New Modernism for a New Millennium
(Abstraction and Surrealism)**

dimensions 8 x 9 ¼ in 203 x 235 mm

description Catalog published by The Logan Collection
Vail for an exhibition examining a recent resurgence of
abstraction and surrealism in contemporary art. The design
employs contrasting organic and geometric typefaces
to suggest these dual trends. The essays are printed on
a different paper stock with die cut edges sandwiched
between sections of plates and installation views.

designer Bob Aufuldish
art director Bob Aufuldish
design company Aufuldish & Warinner
country of origin USA

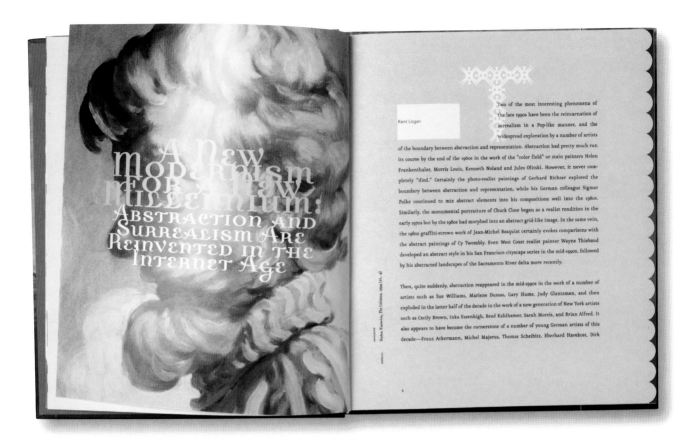

**RADAR: Selections from the Collection
of Vicki and Kent Logan**
dimensions 8 x 11 in 203 x 280 mm
description Catalog for the opening exhibition in the
Anschutz Gallery of the Denver Art Museum's new Frederic
C. Hamilton Building. The installation began far in advance
of the opening, which allowed the book to feature actual
photographs of the exhibition. The designers made color
corrections against the art–rather than transparencies–so
the works are reproduced with greater accuracy than is usual.
designer Bob Aufuldish
art director Bob Aufuldish
design company Aufuldish & Warinner
country of origin USA

The curators chose RADAR as the title
to describe the Logans' collecting vision:
"radar" being "a spotlight that could cut
through fog." Working directly with the
DAM curatorial team led to many of the
ideas used in the design of the project—
from the macro choice of cover image
(is that the Mona Lisa or not?) to the
micro choice of typefaces.

AUFULDISH & WARINNER

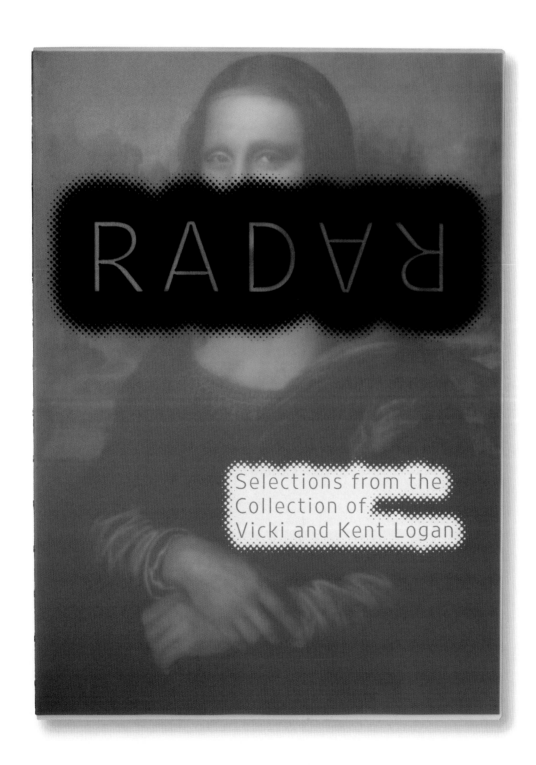

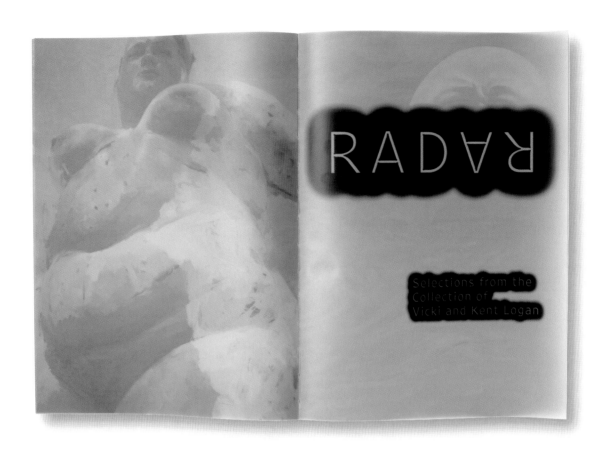

RADAR

Selections from the
Collection of
Vicki and Kent Logan

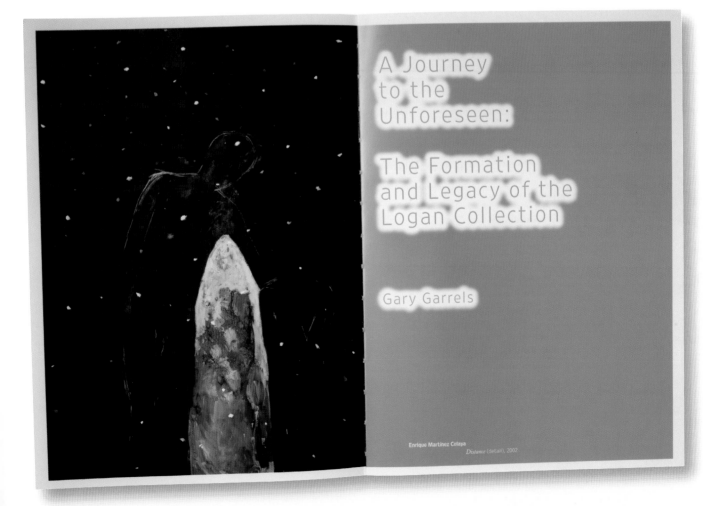

A Journey
to the
Unforeseen:

The Formation
and Legacy of the
Logan Collection

Gary Garrels

Enrique Martinez Celaya
Distance (detail), 2002

Insights/Dialogues

dimensions 8 x 11 in 203 x 280 mm

description Brochure for an arts organization.
The Colorado Contemporary Arts Collaboration
includes The Denver Art Museum, The Aspen Art
Museum, and The Logan Collection Vail. Their
goal, announced with this brochure, is to broaden
the range of contemporary and modern art
experiences in Colorado. The brochure highlights
the range of exhibitions that the organization
intends to mount.

designer Bob Aufuldish

art director Bob Aufuldish

design company Aufuldish & Warinner

country of origin USA

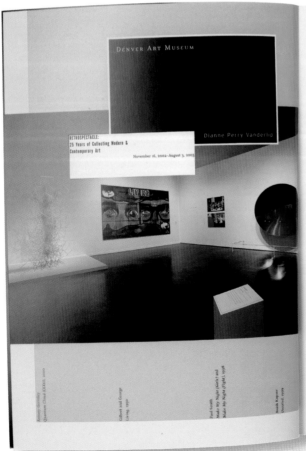

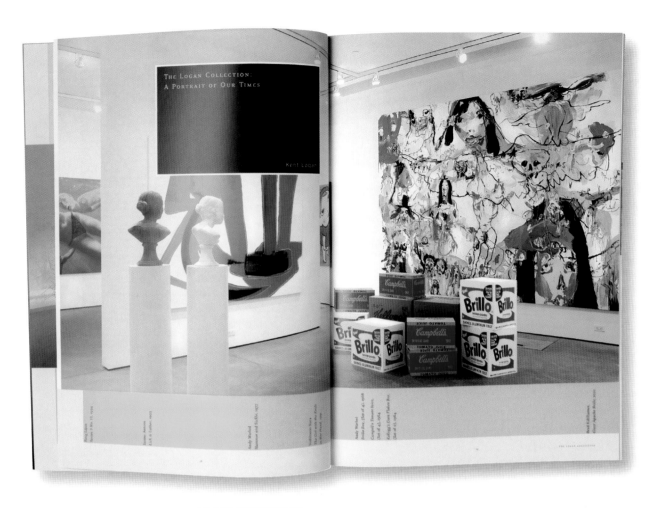

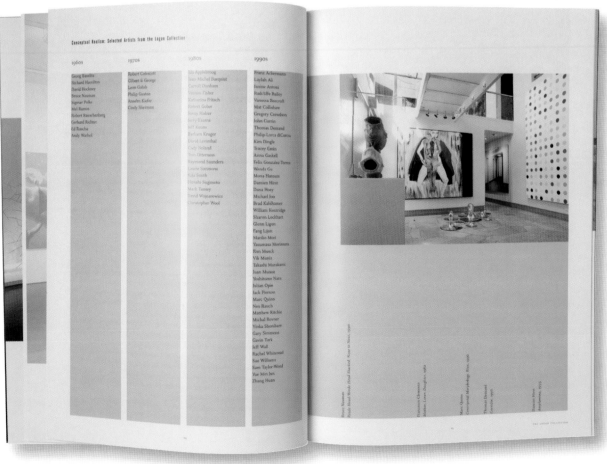

Conceptual Realism: Selected Artists from the Logan Collection

1960s	1970s	1980s	1990s
Georg Baselitz	Robert Colescott	Ida Applebroog	Franz Ackermann
Richard Hamilton	Gilbert & George	Jean-Michel Basquiat	Laylah Ali
David Hockney	Leon Golub	Carroll Dunham	Janine Antoni
Bruce Nauman	Philip Guston	Eric Fischl	Radcliffe Bailey
Sigmar Polke	Anselm Kiefer	Katharina Fritsch	Vanessa Beecroft
Mel Ramos	Cindy Sherman	Robert Gober	Mat Collishaw
Robert Rauschenberg		Jenny Holzer	Gregory Crewdson
Gerhard Richter		Jeff Koons	John Currin
Ed Ruscha		Barbara Kruger	Thomas Demand
Andy Warhol		David Levinthal	Philip-Lorca diCorcia
		Cady Noland	Kim Dingle
		Tom Otterness	Tracey Emin
		Raymond Saunders	Anna Gaskell
		Laurie Simmons	Felix Gonzalez-Torres
		Kiki Smith	Wenda Gu
		Hiroshi Sugimoto	Mona Hatoum
		Mark Tansey	Damien Hirst
		David Wojnarowicz	Dana Hoey
		Christopher Wool	Michael Joo
			Brad Kahlhamer
			William Kentridge
			Sharon Lockhart
			Glenn Ligon
			Fang Lijun
			Mariko Mori
			Yasumasa Morimura
			Ron Mueck
			Vik Muniz
			Takashi Murakami
			Juan Muñoz
			Yoshitomo Nara
			Julian Opie
			Jack Pierson
			Marc Quinn
			Neo Rauch
			Matthew Ritchie
			Michal Rovner
			Yinka Shonibare
			Gary Simmons
			Gavin Turk
			Jeff Wall
			Rachel Whiteread
			Sue Williams
			Sam Taylor-Wood
			Yue Min Jun
			Zhang Huan

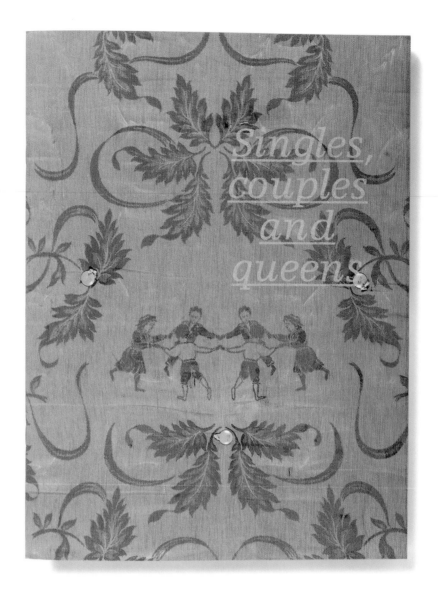

pages 72–77
Singles, couples and queens
dimensions 9 $^5/_8$ x 12 $^3/_4$ in 245 x 323 mm
description Publication designed to accompany Toby Richardson's photographic exhibition of old mattresses discarded to the hard-waste scrap heap.
designer Scott Carslake
photographer Toby Richardson
art director Scott Carslake
design company Voice
country of origin Australia

M

mother often asks 'Why don't you take photographs of normal things?'

And it has taken me some time to realise that's exactly what I do – as a photographer, I document everyday life. I attempt to find extraordinary beauty and interest in everyday objects, my camera allows me to uncover the stories/messages these objects possess.

Recently this desire has seen me documenting councils' Hard Waste collections. I have become increasingly interested in documenting individual remnants of everyday life, particularly people's discarded mattresses. These objects bear the traces of intensive use, they show the imprints and marks of the life in which they had a function. They are individually stained with their owners' sweat and urine, each mattress has its own unique signature that distinguishes it from any other mattress.

Along with these objects are the intensely personal words from their previous owners. This is what intrigues me, these records of everyday living.

This is about more than the aestheticisation of waste; it questions our awareness of environmental issues and challenges our obsessive consumerism. It's about infinitely more than just waste.

I hope this work persuades you to question our obsessive nature as humans, and tempts you to engage in voyeuristic behaviour.

Toby Richardson
Lecturer of Photography
South Australian School of Art

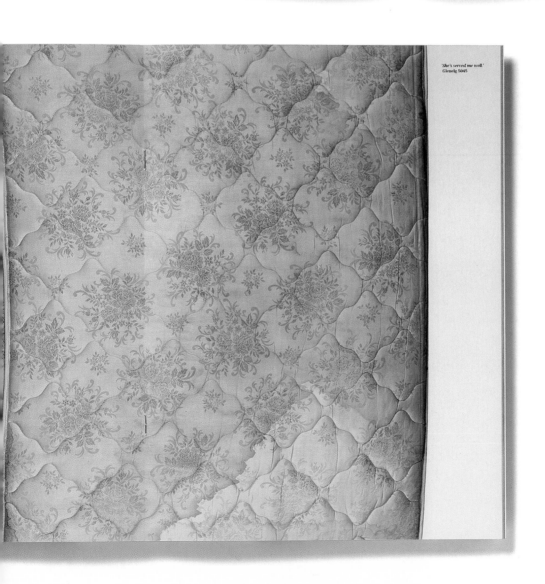

'She's served me well.'
Glenelg 5045

The mattresses are displayed in a continuous
sequence where the white space between each one
is different resulting in some of the images running
from one spread to the next.

VOICE DESIGN

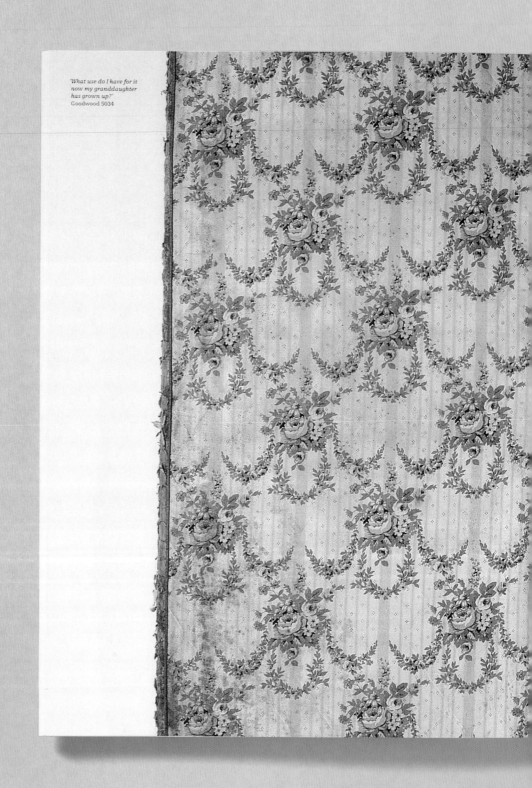

*'What use do I have for it
now my granddaughter
has grown up?'*
Goodwood 5034

'We both had our
preferred side.'
Firle 5070

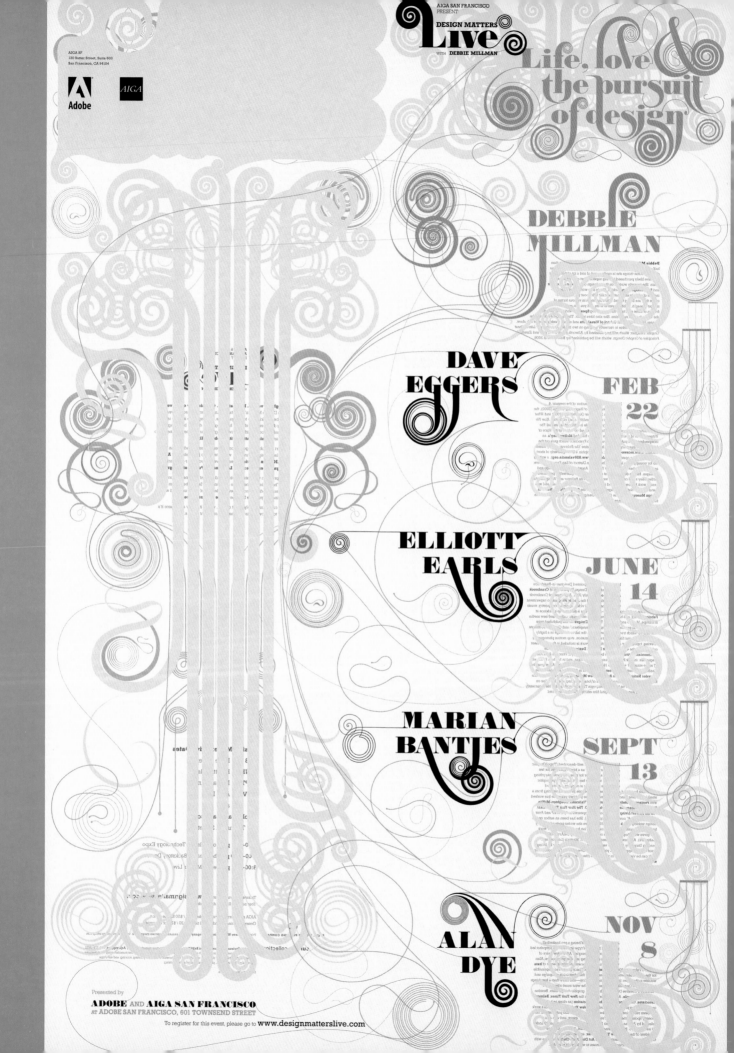

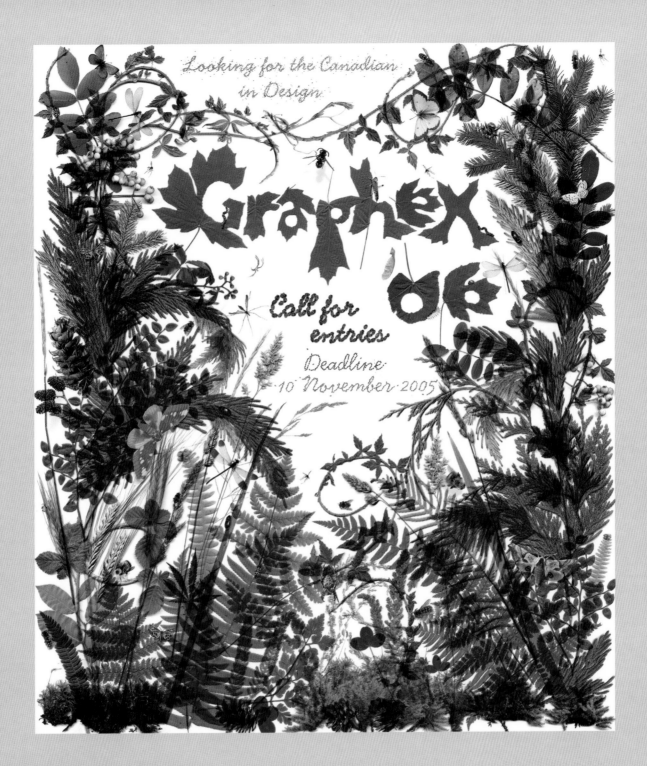

facing page
Design Matters Live
dimensions 21 x 32 in 533 x 813 mm
description A poster and visual identity for a series
of interviews by Debbie Millman, titled "Design
Matters Live." Printed on black, white, gold, and
silver on translucent paper, the piece is designed
to work with an interplay of elements from both the
front and back of the poster.
designer Marian Bantjes
illustrator Marian Bantjes
country of origin Canada

above
Graphex '06 Call for Entries
dimensions 19 x 22 in 483 x 559 mm
description Poster for Call for Entries for the
Society of Graphic Designers of Canada's biennial
design awards, Graphex.
designer Marian Bantjes
illustrator Marian Bantjes
country of origin Canada

Jetlag/Exhibition
dimensions 38 7/8 x 11 5/8 in 988 x 297 mm
description Poster showing different sets of
pictures photographed during trips around
the world from Paris to Bangkok. Collected
especially for the Jetlag exhibition.
designer Marco Simonetti
dsign company Soulengineer
country of origin Switzerland

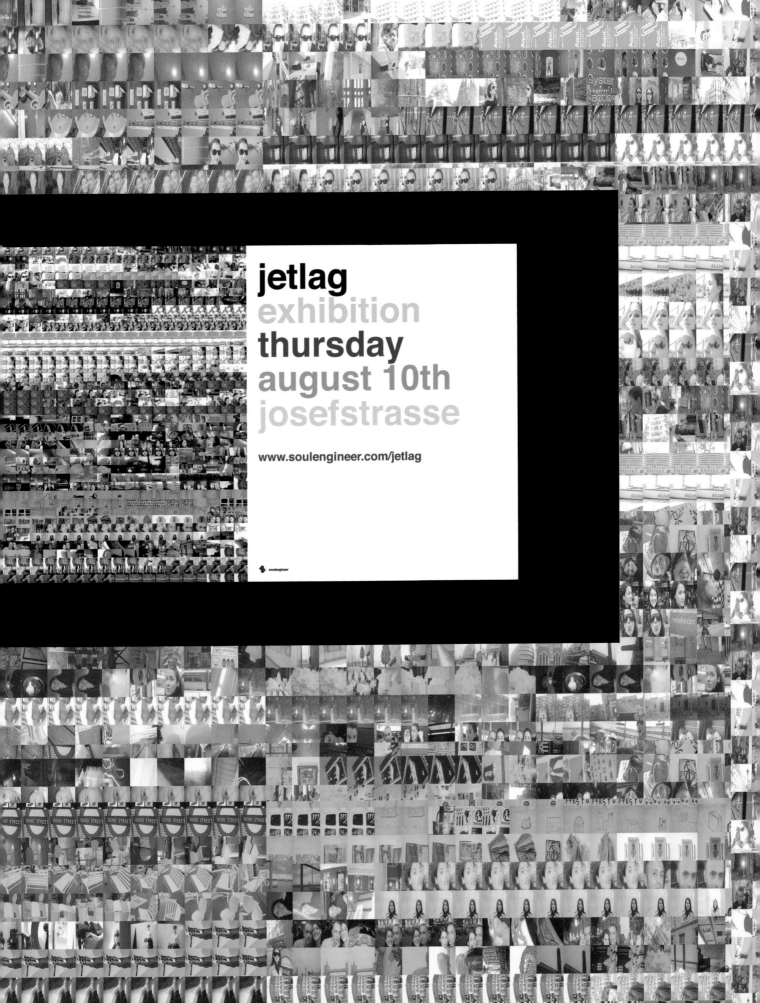

jetlag
exhibition
thursday
august 10th
josefstrasse

www.soulengineer.com/jetlag

soulengineer

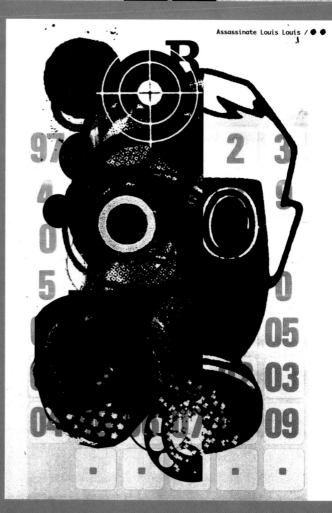

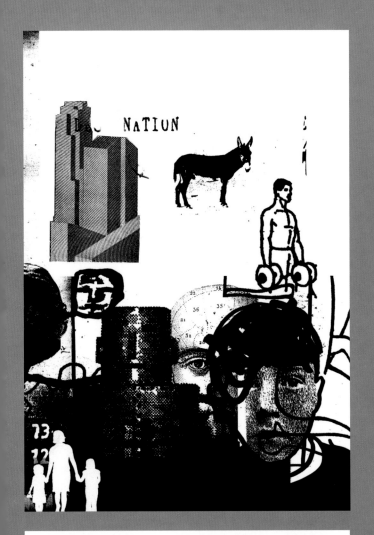

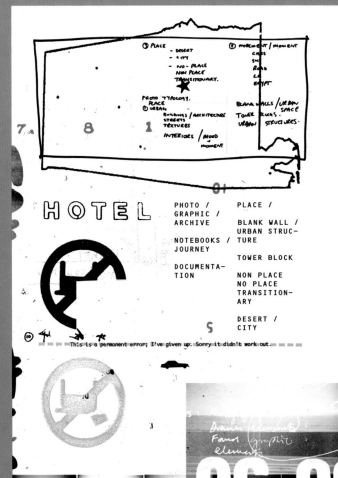

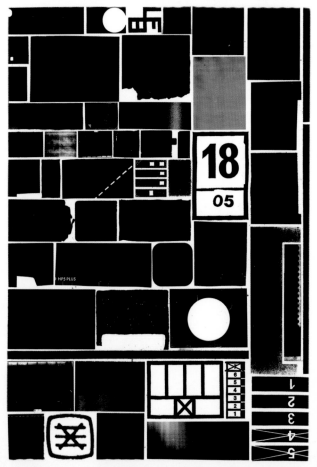

previous page

Catalog

dimensions 23 ³/₈ x 33 ¹/₈ in 594 x 841 mm (A1)

description Eight of nine posters produced for an exhibition as part of "Catalog"–a university-funded research project exploring the idea of a "graphic collection." First shown in the Coningsby Gallery, London.

designer Alex Williamson

illustrator Alex Williamson

country of origin UK

facing page

Mumbo Jumbo

poster 33 ¹/₂ x 46 ³/₄ in 849 x 1189 mm (A0)

flyer 4 ¹/₈ x 5 ⁷/₈ in 104 x 148 mm

description Film poster and promotional flyer for a Bevan Walsh short film, "Mumbo Jumbo."

designer Rina Donnersmarck

illustrator Rina Donnersmarck

country of origin UK

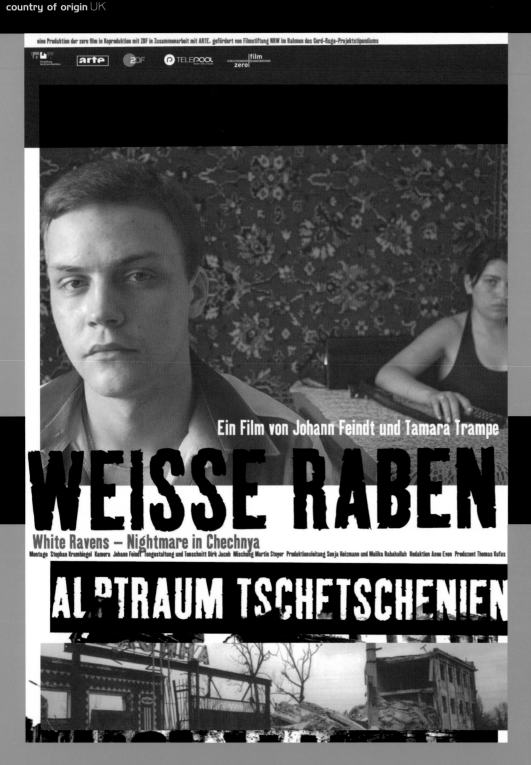

left

Weisse Raben—Alptraum Tschetschenien

dimensions 23 ³/₈ x 33 in 594 x 840 mm

description Film poster for Weisse Raben (White Ravens–A nightmare in Chechnya), a German documentary, released in 2005.

design company Doppelpunkt Kommunikationsdesign

country of origin Germany

VILLAGETWIN

/ Independent Cinema

/ COMING SOON

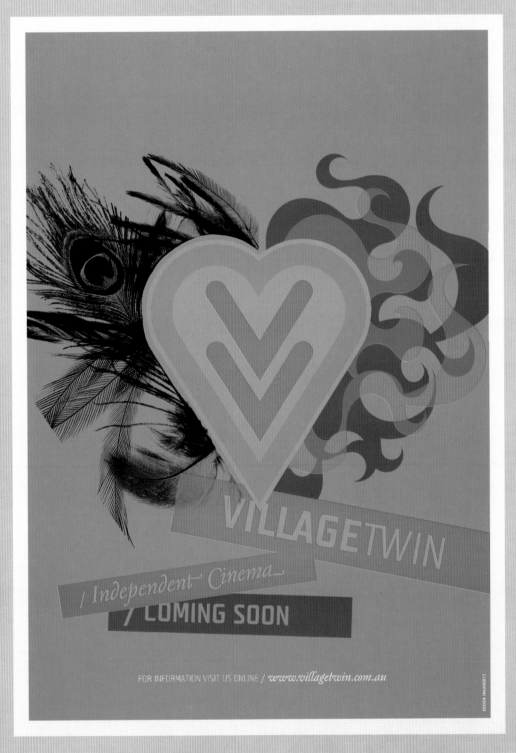

facing page and above

Village Twin

dimensions 16 ¹/₂ x 23 ³/₈ in 420 x 594 mm

description Posters from a series promoting
Village Twin Cinema.

design company Inkahoots

country of origin Australia

overleaf

Meme poster

dimensions 12 ¹/₂ x 17 ³/₈ in 316 x 440 mm

description Poster for an exhibiton in Japan.
The type was made from wood, then printed,
scanned, and reworked in Adobe Photoshop.

designer Lee Basford

design company Fluid

country of origin UK

pages 90-93

British Design

dimensions 12 x 9 ³/₄ in 305 x 250 mm

description Design and layout for "British
Design 2006-2007." Different approaches to
designing the book.

design company Fluid

country of origin UK

BRITISH DESIGN 06/07

BRANDING·GRAPHIC·PACKAGING·NEW MEDIA·PRODUCT·INTERIOR·RETAIL·EVENT

BRITISH DESIGN

2006 - 2007

Branding and Graphic Design

Packaging Design

New Media Design

Interior, Retail and Event

Design

BRANDING & GRAPHIC DESIGN
PACKAGING DESIGN
NEW MEDIA DESIGN
INTERIOR, RETAIL & EVENT DESIGN
PRODUCT DESIGN

WE ARE HERE

**BRITISH
DESIGN
06/07**

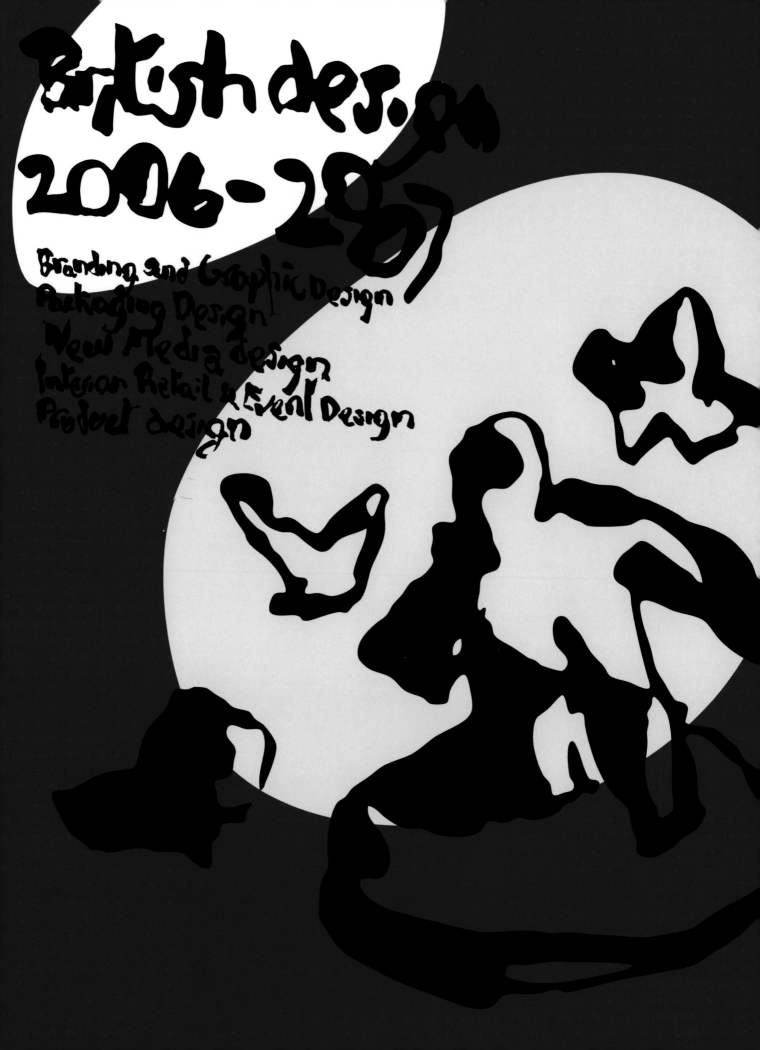

EVERYTHI NG

SO£D

E VE RYTH I NG

HOLY

facing page
Dirty Three
above
Karl Marx
dimensions 16 1/2 x 23 3/8 in 420 x 594 mm

description Posters from "Influence" series, from
an exhibition exploring the relationship between
personal and cultural identity.
design company Inkahoots/Red Connect
country of origin Australia

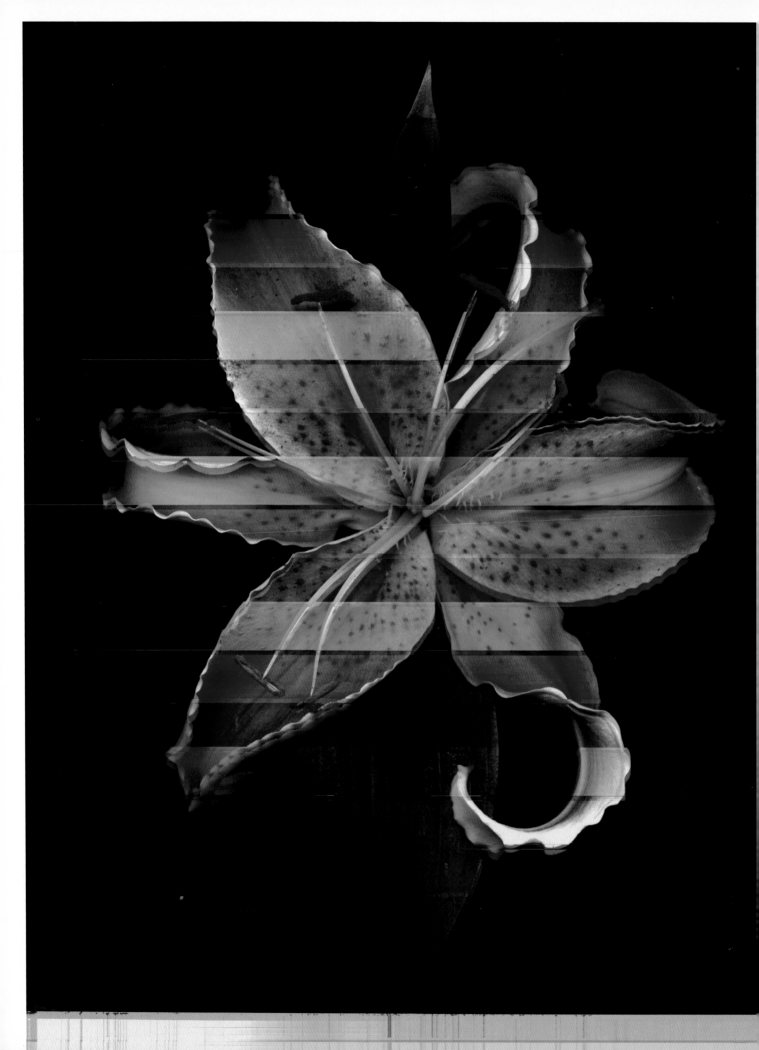

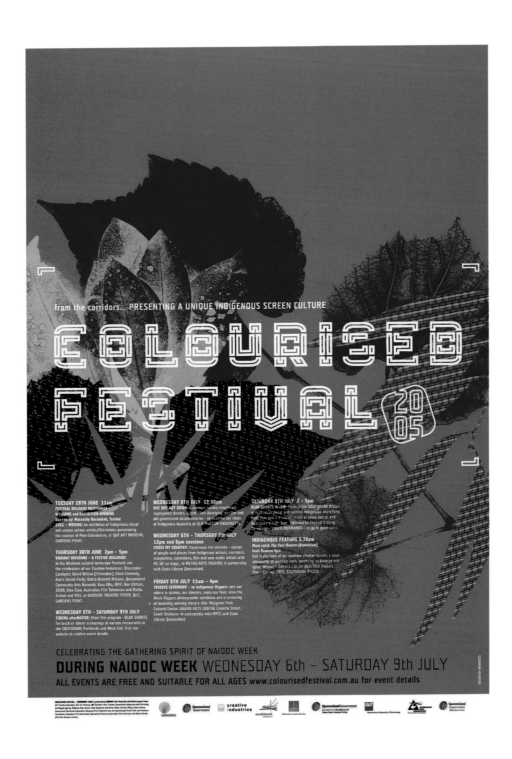

facing page
John Berger
dimensions 16 1/2 x 23 3/8 in 420 x 594 mm
description Poster from "Influence" series,
from an exhibition exploring the relationship
between personal and cultural identity.
design company Inkahoots/Red Connect
country of origin Australia

above
Colourised Film Festival
dimensions 16 1/2 x 23 3/8 in 420 x 594 mm
description Posters promoting an Australian
indigenous film festival.
design company Inkahoots
country of origin Australia

Berliner Festspiele

tt
04

41. theatertreffen

Berlin 2. bis 18. Mai 2003
Information: 254 89 100 www.berlinerfestspiele.de

Berliner Festspiele

Berliner Festspiele

tt
04

41. theatertreffen

Berlin 2. bis 18. Mai 2003
Information: 254 89 100 www.berlinerfestspiele.de

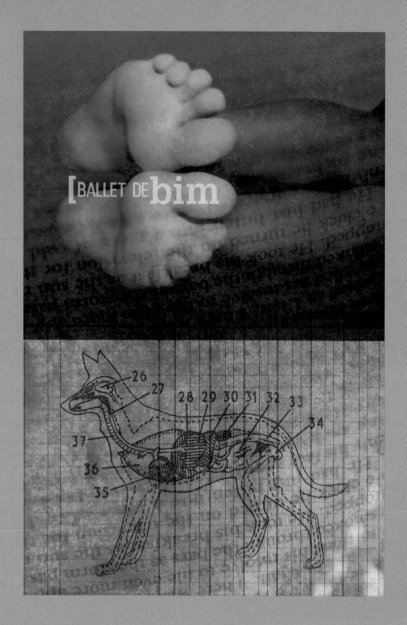

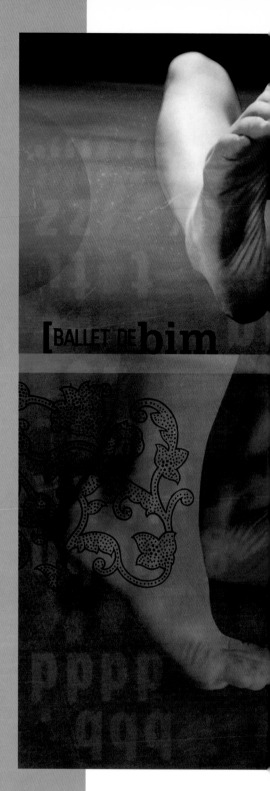

pages 98–99

Theatertreffen

dimensions 33 x 46 ³/₄ in 840 x 1188 mm
description Posters for "Theatertreffen," the most
significant German-speaking theater festival. The festival
shows ten most notable productions selected from
over 300 every season. Sample posters, designed for
marketing purposes, unpublished.
design company Doppelpunkt Kommunikationsdesign
country of origin Germany

these pages

promotional postcards for Ballet de Bim

dimensions 4 x 5 ⁷/₈ in 100 x 150 mm
description Promotional postcards for Ballet de Bim
dance company (with contact details on reverse).
designer Craig Yamey
art director Craig Yamey
design company Yam
country of origin UK

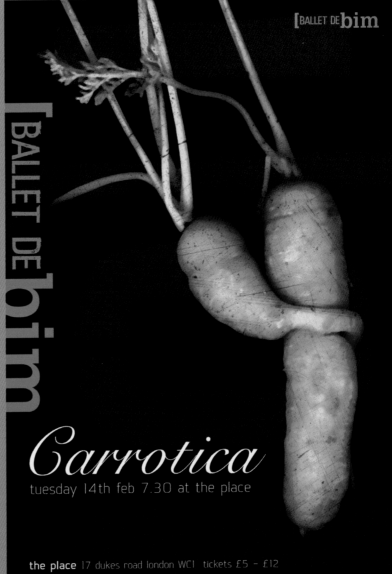

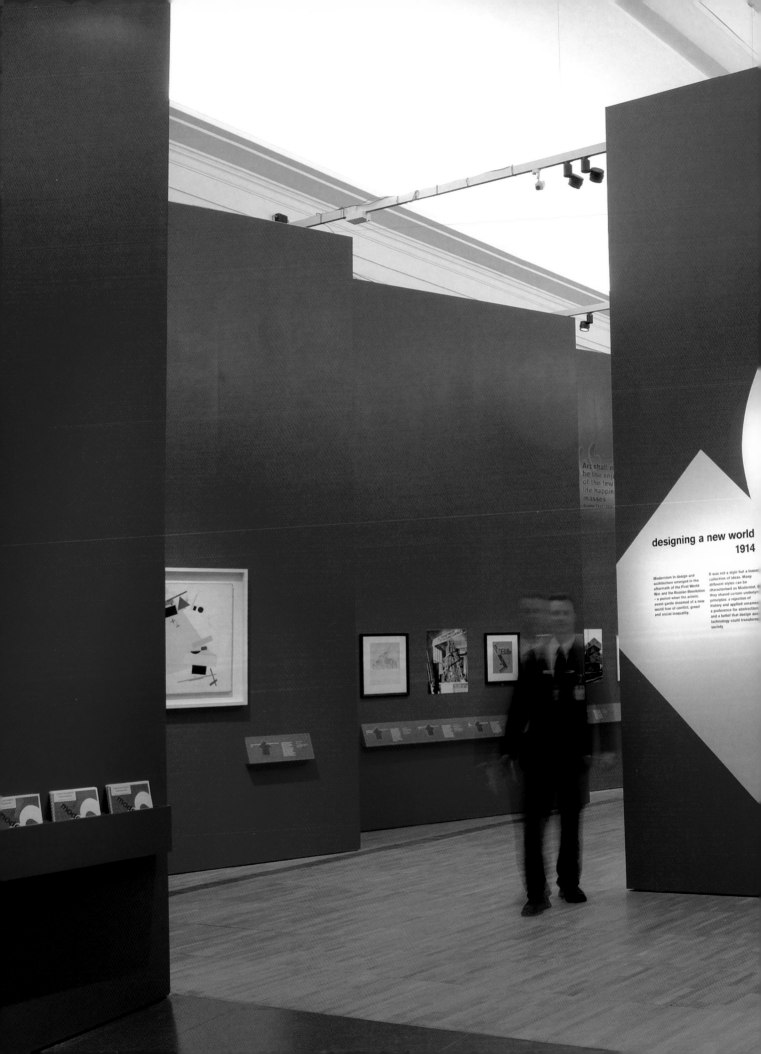

designing a new world
1914

Modernism in design and
architecture emerged in the
aftermath of the First World
War and the Russian Revolution
– a period when the artistic
avant-garde dreamed of a new
world free of conflict, greed
and social inequality.

It was not a style but a loose
collection of ideas. Many
different styles can be
characterised as Modernist, but
they shared certain underlying
principles: a rejection of
history and applied ornament,
a preference for abstraction,
and a belief that design and
technology could transform
society.

Art shall n
be the enj
of the few
life happin
masses

dernism

was largely
om about
onditions
from the
eal world.
ers were
their work,
nass market
on to the
m. But
d, and it
l force in
d of today.

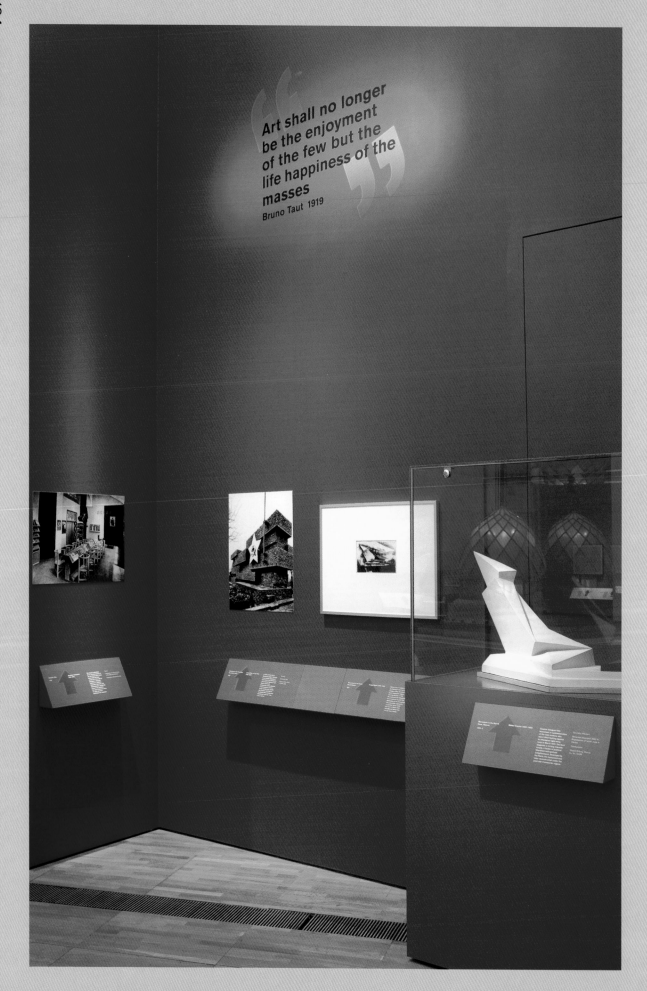

"Art shall no longer be the enjoyment of the few but the life happiness of the masses"

Bruno Taut 1919

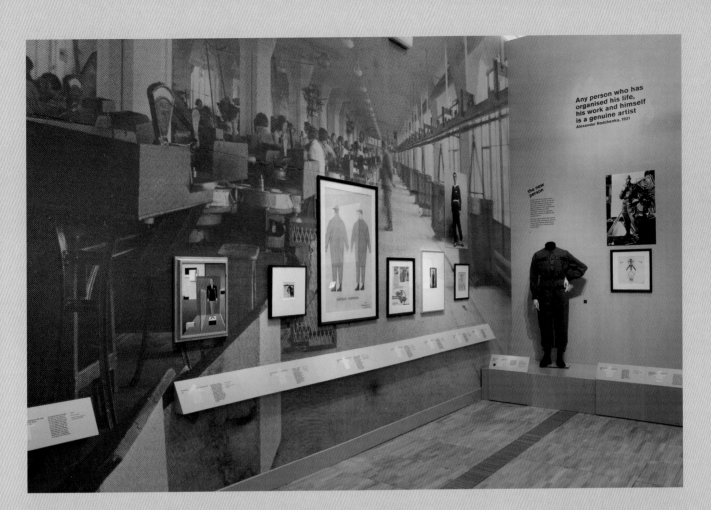

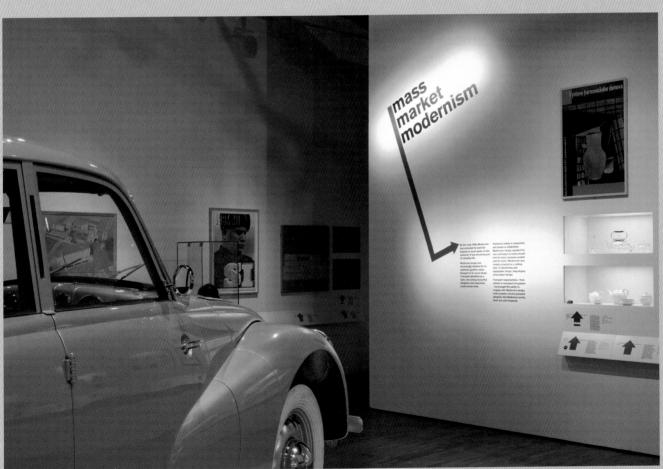

pages 102–107
Modernism Exhibition
description Design of the Modernism exhibition at
the Victoria & Albert Museum in London, 2006.
exhibition graphics David Hillman, Amelia Gainford
exhibition architecture Eva Jirinca Associates
photographer Nick Turner
design company Pentagram
country of origin UK

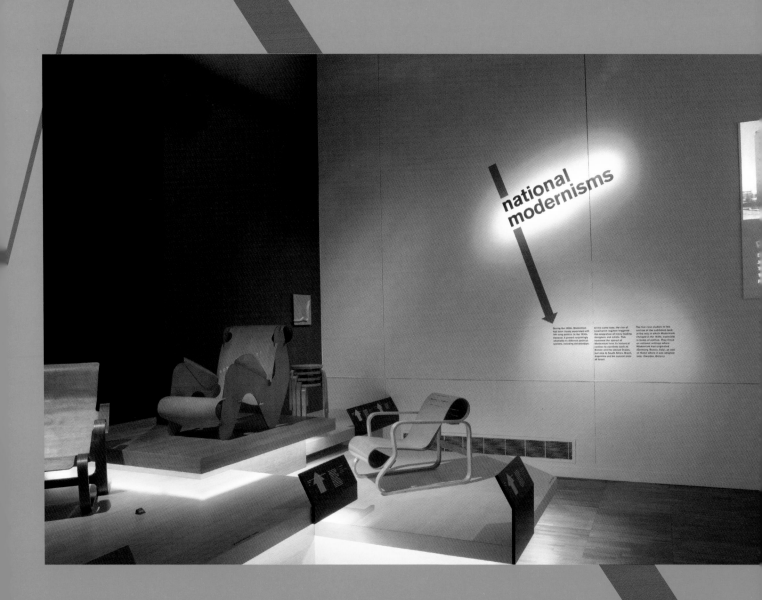

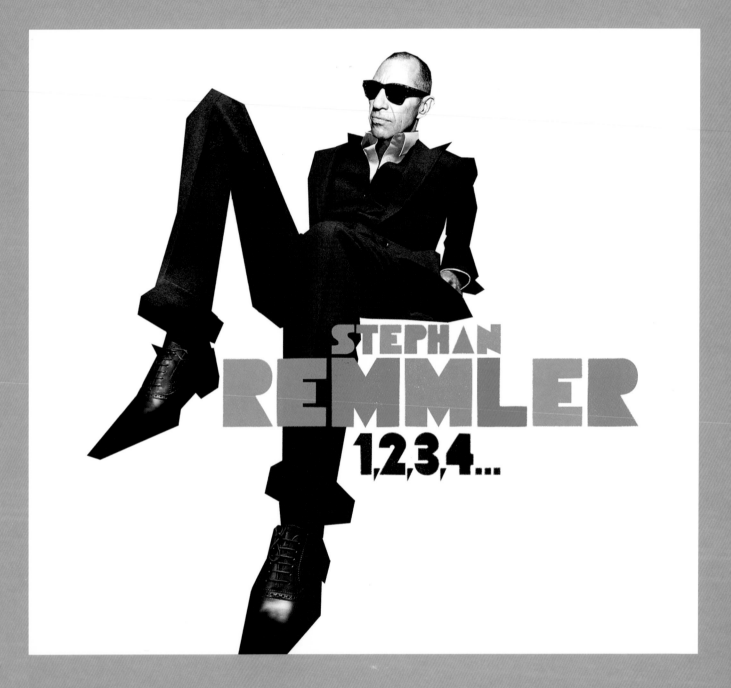

Stephan Remmler: 1,2,3,4...

dimensions 5 1/2 x 4 7/8 in 142 x 124 mm

description CD cover design for Stephan
Remmler's album "1,2,3,4...".

designer Moritz

illustrator Moritz

design company Büro Destruct

country of origin Switzerland

FUNKOLUTION

... in town

Funkolution
dimensions 5 ½ x 4 ⅞ in 142 x 124 mm
description Album cover for "Funkolution:
In Town" (2006).
designer MBrunner
design company Büro Destruct
country of origin Switzerland

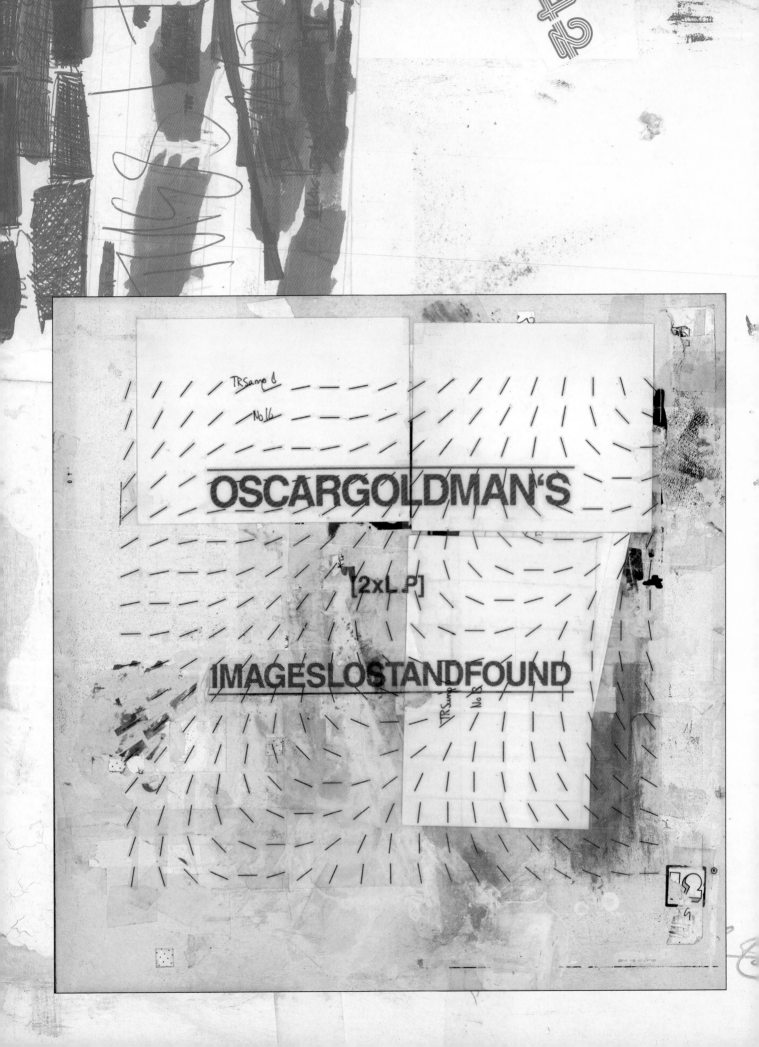

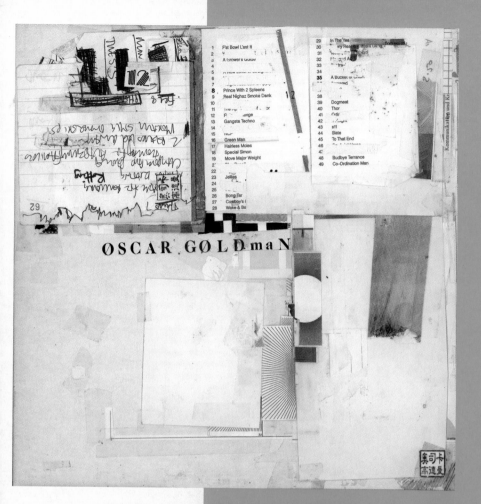

Oscar Goldman: Images Lost and Found
dimensions 12 ³/₈ x 12 ³/₈ in 315 x 315 mm
description Design for a debut 2-LP release from Oscar Goldman, produced by analog means using mixed media between 2001–2006 and influenced by travel in Taiwan. This recording is dedicated to the living memory of Ian "Moonman" Fletcher.
designer Oscar Goldman
illustrator Oscar Goldman
design company Substance ®
country of origin UK

Devil's Gun: Raising the Beast

dimensions 12 x 12 in 305 x 305 mm

description LP sleeve design for the debut
single by Devil's Gun.

designer Kerry Roper

illustrator Kerry Roper

art director Kerry Roper

design company Beautiful

country of origin UK

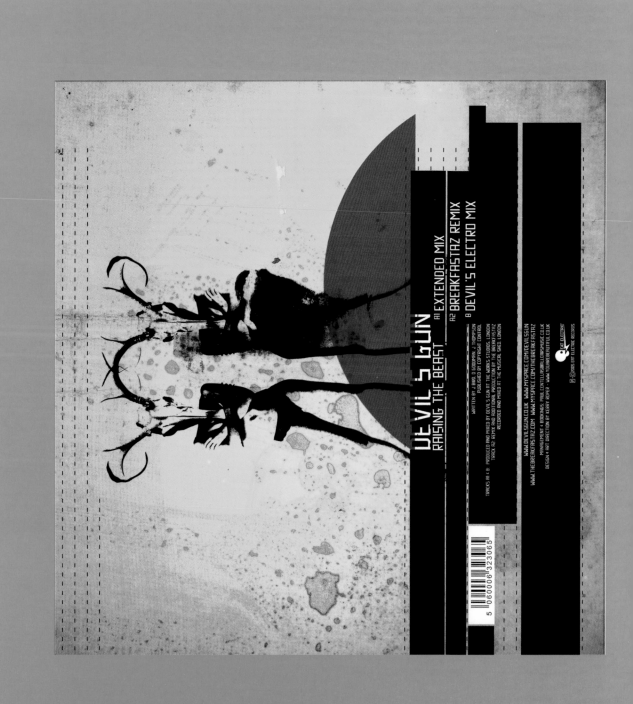

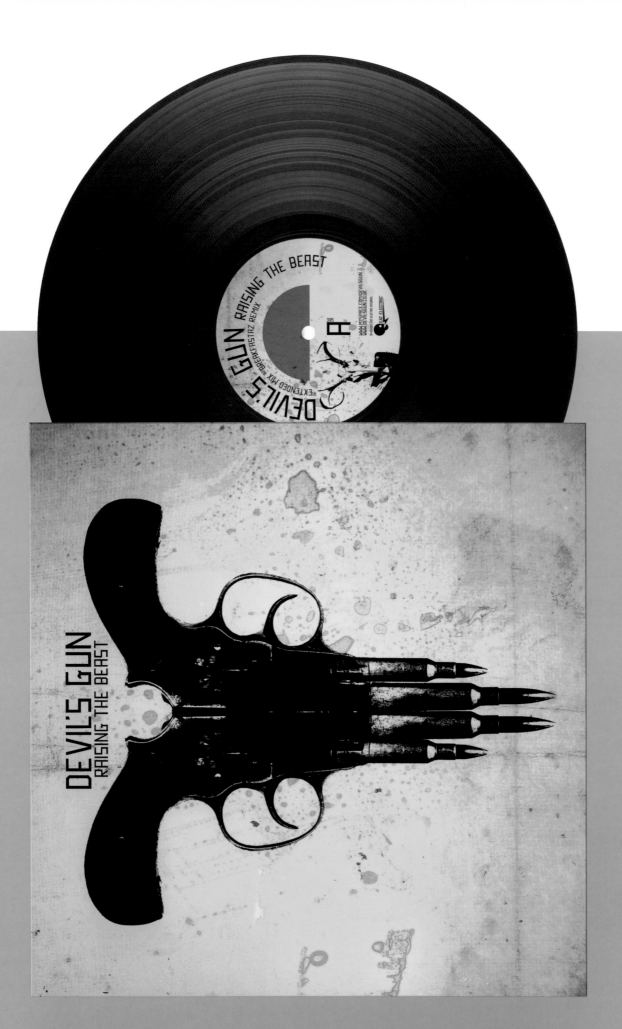

Moth: Immune to Gravity

dimensions 5 1/2 x 4 7/8 in 142 x 124 mm

description CD album design for the band Moth.

designer Kerry Roper

illustrator Kerry Roper

photographer Kerry Roper

art director Kerry Roper

design company Beautiful

country of origin UK

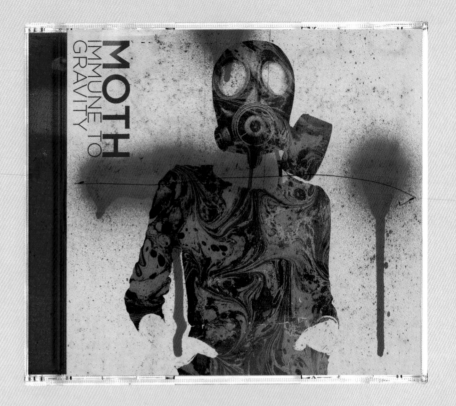

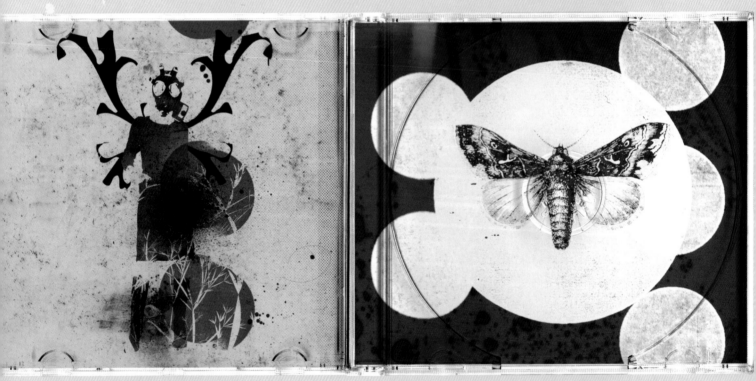

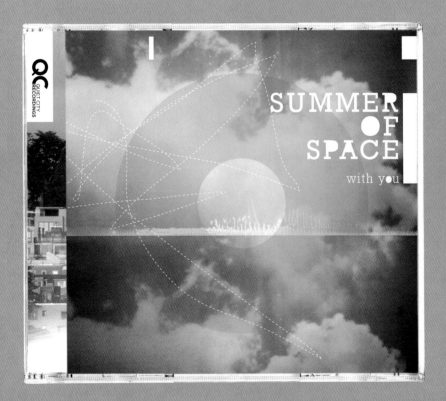

Summer of Space: With You

dimensions 5 ½ x 4 ⅞ in 142 x 124 mm
description CD album design for Summer of Space, an electronica/house/down-tempo band.
designer Kerry Roper
illustrator Kerry Roper
art director Kerry Roper
design company Beautiful
country of origin UK

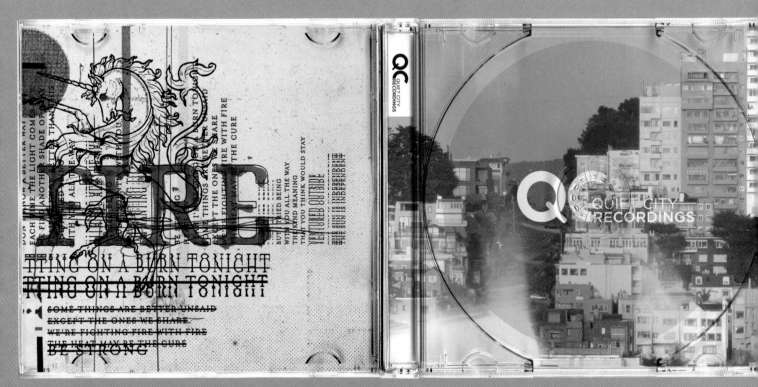

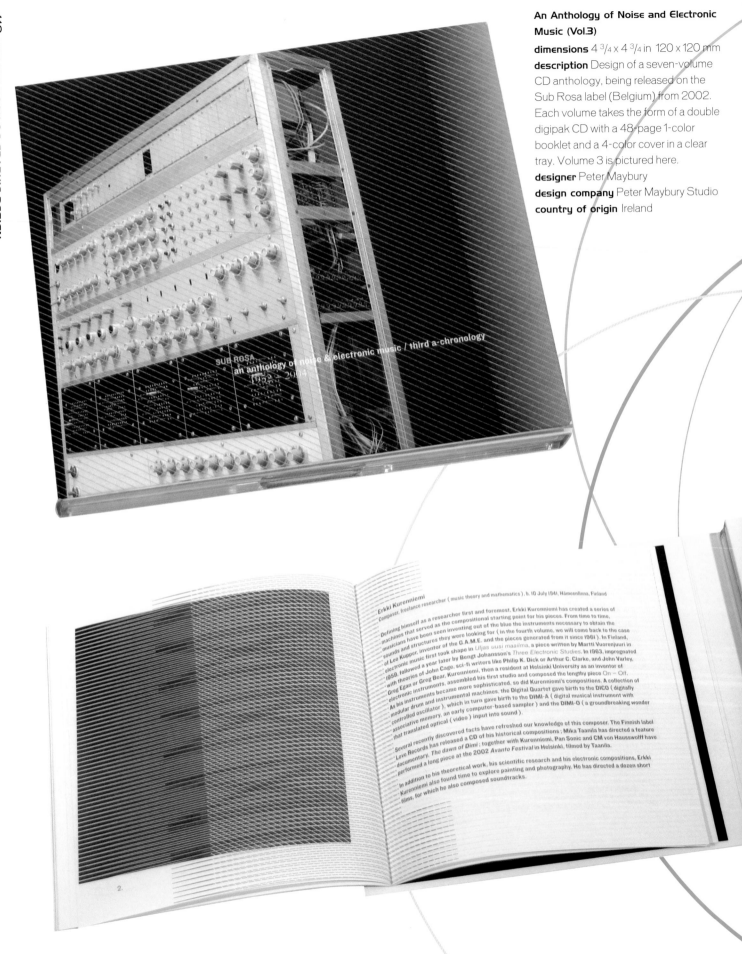

An Anthology of Noise and Electronic Music (Vol.3)

dimensions 4 3/4 x 4 3/4 in 120 x 120 mm
description Design of a seven-volume CD anthology, being released on the Sub Rosa label (Belgium) from 2002. Each volume takes the form of a double digipak CD with a 48-page 1-color booklet and a 4-color cover in a clear tray. Volume 3 is pictured here.
designer Peter Maybury
design company Peter Maybury Studio
country of origin Ireland

SUB ROSA
an anthology of noise & electronic music / third a-chronology
[1952 — 2004]

Erkki Kurenniemi
Composer, freelance researcher (music theory and mathematics), b. 10 July 1941, Hämeenlinna, Finland

Defining himself as a researcher first and foremost, Erkki Kurenniemi has created a series of machines that served as the compositional starting point for his pieces. From time to time, musicians have been seen inventing out of the blue the instruments necessary to obtain the sounds and structures they were looking for (in the fourth volume, we will come back to the case of Leo Kupper, inventor of the G.A.M.E. and the pieces generated from it since 1961). In Finland, electronic music first took shape in *Uljas uusi maailma*, a piece written by Martti Vuorenjuuri in 1959, followed a year later by Bengt Johansson's *Three Electronic Studies*. In 1963, impregnated with theories of John Cage, sci-fi writers like Philip K. Dick or Arthur C. Clarke, and John Varley, Greg Egan or Greg Bear, Kurenniemi, then a resident at Helsinki University as an inventor of electronic instruments, assembled his first studio and composed the lengthy piece On – Off. As his instruments became more sophisticated, the Digital Quartet gave birth to the DICO (digitally controlled oscillator), which in turn gave birth to the DIMI-A (digital musical instrument with associative memory, an early computer-based sampler) and the DIMI-O (a groundbreaking wonder that translated optical (video) input into sound).

Several recently discovered facts have refreshed our knowledge of this composer. The Finnish label Love Records has released a CD of his historical compositions ; Mika Taanila has directed a feature documentary, *The dawn of Dimi* ; together with Kurenniemi, Pan Sonic and CM von Hausswolff have performed a long piece at the 2002 *Avanto Festival* in Helsinki, filmed by Taanila.

In addition to his theoretical work, his scientific research and his electronic compositions, Erkki Kurenniemi also found time to explore painting and photography. He has directed a dozen short films, for which he also composed soundtracks.

2.

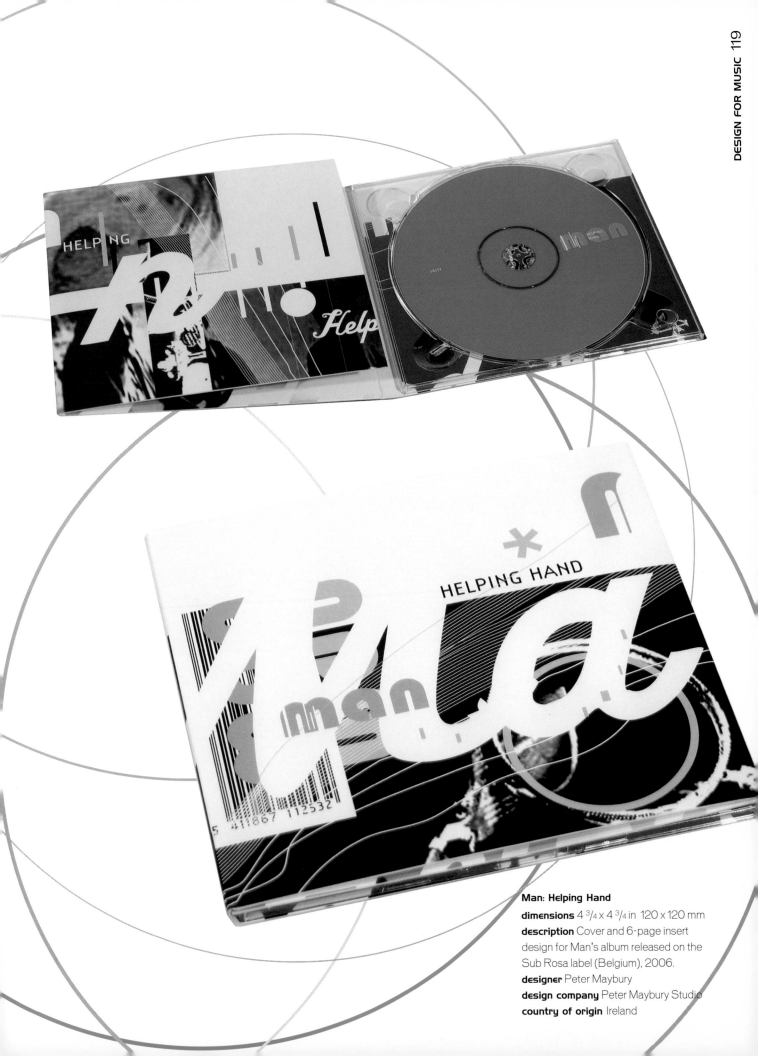

Man: Helping Hand

dimensions 4 ³/₄ x 4 ³/₄ in 120 x 120 mm
description Cover and 6-page insert design for Man's album released on the Sub Rosa label (Belgium), 2006.
designer Peter Maybury
design company Peter Maybury Studio
country of origin Ireland

Mo: Take (right)
Mo: Open Space (below)
dimensions 4 ³/₄ x 4 ³/₄ in 120 x 120 mm
description Cover design for two
CD singles by blues singer Mo.
designer Craig Yamey
photographer Craig Yamey
art director Craig Yamey
design company Yam
country of origin UK

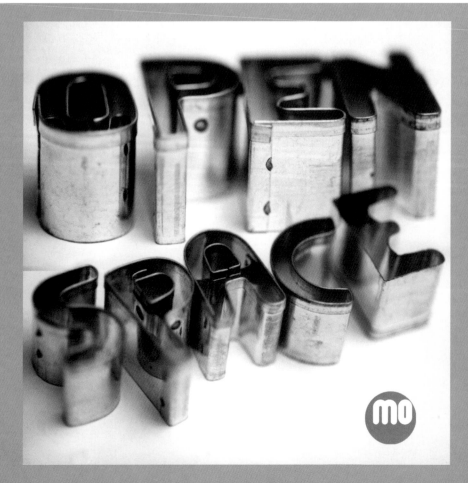

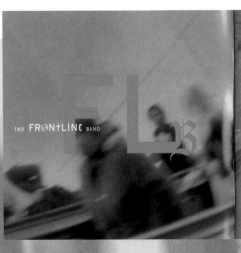

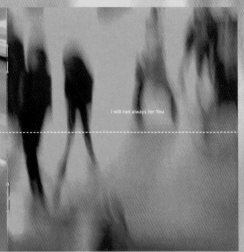

Make my heart

Still

so I can hear You

I will run always for You

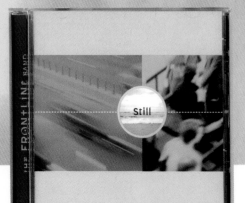

RESTING PLACE
Daphne Rademaker

Heaven is My throne and earth is My footstool
Where is the house you will build for Me
Whom of you will hear the cry of My heart
Where will My resting place be

chorus
Here oh Lord, have I prepared for You a home
Long have I desired for You to dwell
Here oh Lord, have I prepared a resting place
Here oh Lord, I wait for You alone

Vocals: Chris Joyner, Laurel Snapper
Acoustic guitar: Chris Joyner
Electric guitar: Steve Fowler
Bass: Paul Barber
Wurlitzer & bell line: Becky Cotter
Drums: Doug Bassett

©1991 Mercy Vineyard Publishing

RAINDANCE
peterkeys

James 5:17-18, I Corinthians 14:15.

Keyboards: peterkeys
Indian flute: Kevin Day
Spoken word: Laurel Snapper
Written, arranged, programmed and produced by: peterkeys
Additional drum programming by Kevin 131

WATER OF SAND
Kevin Day

Make my heart still so I can hear You
Clean my soul in Your glory
Holy God — Splendor clothes Your presence
There is no other to measure
Up to the height of Your love
Living Lord — I adore You, Savior

chorus
Make water out of sand
Get glory from these hands of clay
I bow down under Your grace
Make diamonds out of stones
Cut me to the bone deep in my heart
I bow down under Your grace

Vocals: Kevin Day, Suzanne Bailey
Keyboards: Kevin Day
Acoustic & electric guitars: Dan Rebeiz
Bass: Steve Thomas
Drum programming: Kevin 131

©1999 Pete Balmond / All rights reserved
d2aykeon@aol.com

Recorded at Assembly Line Studio by Kevin 131
Indian flute and voice recorded at Jammin Java by Tony Alany
Mixed by Tony Alany at Jammin Java Studio, Vienna va

This recording would not be possible
without the support of Lon Solomon,
Ken Baugh and the leadership of McLean
Bible Church. We are blessed and thankful
to have a team that is willing to step out of
the boat and walk on water for the glory
of our Lord, Jesus Christ. May He lift your
spirits and touch your souls through the
power of His inspired music.

THE FRONTLINE BAND

Tony Alany	Psalm 33:1
Laura Avery	2 Peter 1:5-8
Suzanne Bailey	Psalm 16
Paul Barber	1 John 4:7-8
Doug Bassett	Ephesians 5:21
peterkeys	1 Peter 4:10-11
Becky Cotter	2 Corinthians 3:16 & 18
Kevin Day	Isaiah 26:8
Harry Evans	Proverbs 3:5-6
Steve Fowler	Psalm 40:1
John Grant	Proverbs 107:1-2
Chris Joyner	1 Corinthians 15:58
Greg Lopez	John 15:5
Brad Matlack	1 Peter 2:9-10
Will Pavone	James 1:17
Stephanie Pummill	Psalm 104:1-4
Dan Rebeiz	1 John 2:15-17
Laurel Snapper	Psalm 97:10-11
Steve Thomas	Psalm 32:7
Posido Vega	Matthew 6:34
Brandon Vient	Jonah 2:7-9
Andy Zipf	1 Timothy 4:12
Kevin 131	Exodus 33:10

The Frontline Band: Still

dimensions 5 1/2 x 5 in 140 x 127 mm
description CD design for Frontline
Ministries, a "Generation X" church-
based band from McLean, Virginia,
USA.
designer David Kasparek
art director David Kasparek
design company Visualmentalstimuli
country of origin USA

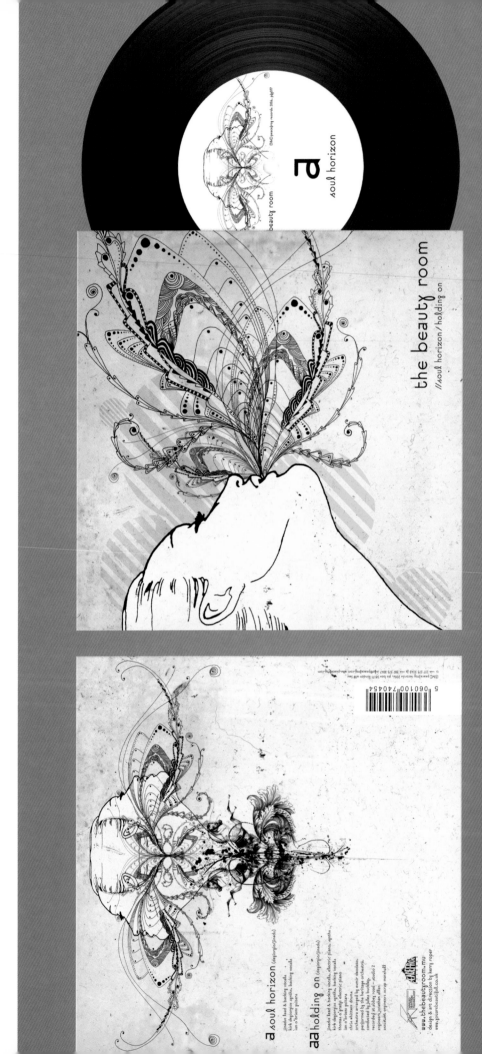

The Beauty Room
dimensions 7 x 7 in 178 x 178 mm
description 7 inch sleeve design for Beauty Room's "About Horizon/ Holding On" single from the "Beyond an Infinite" album.
designer Kerry Roper
illustrator Kerry Roper
art director Kerry Roper
design company Beautiful
country of origin UK

Mo: Love makes you fat

dimensions 14 1/8 x 4 3/4 in
360 x 120 mm (gatefolded)
description CD sleeve and
gatefold artwork for an album
by blues singer Mo.
designer Craig Yamey
illustrator Craig Yamey
photographer Craig Yamey
art director Craig Yamey
design company Yam
country of origin UK

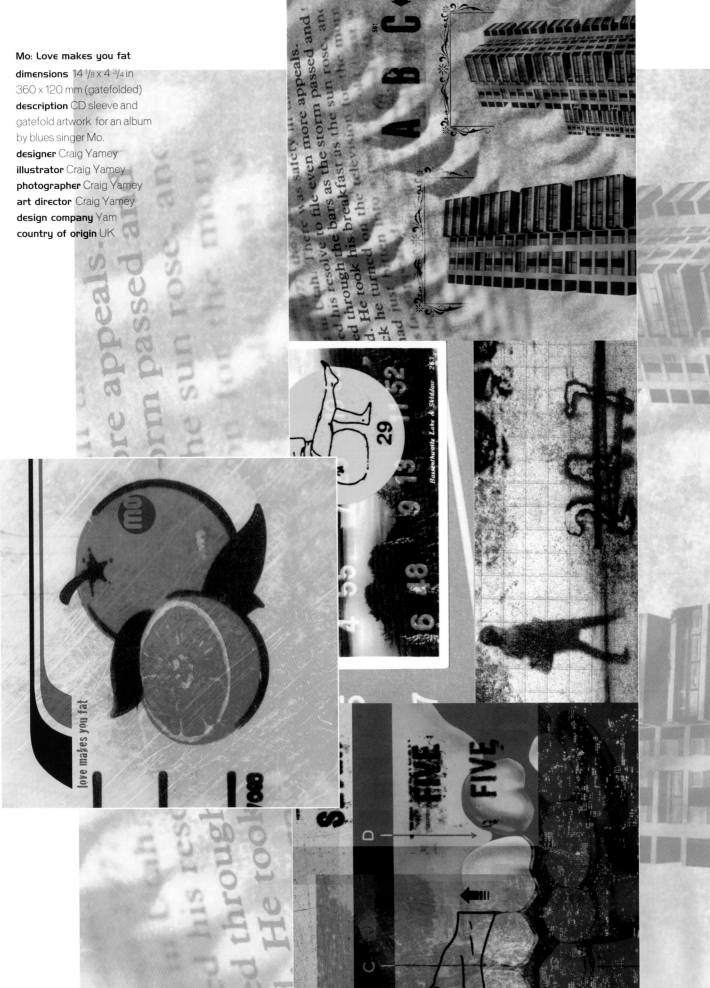

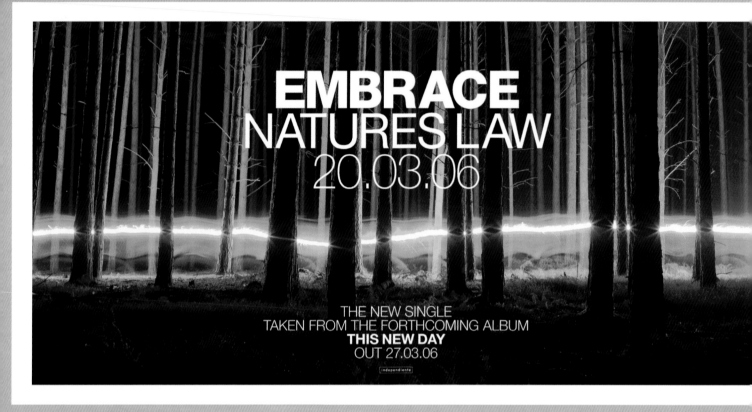

EMBRACE
NATURES LAW
20.03.06

THE NEW SINGLE
TAKEN FROM THE FORTHCOMING ALBUM
THIS NEW DAY
OUT 27.03.06

independiente

above
Embrace: Nature's Law
dimensions
120 x 240 in 3048 x 6096 mm
description Music poster, part of
a CD single promotion campaign
for the band Embrace.
designer Richard Bull
photographer Rick Guest
art director Richard Bull
design company Yacht Associates
country of origin UK

facing page
Embrace: Target
dimensions
120 x 80 in 3048 x 2032 mm
description Music poster, part of
a CD single promotion campaign
for the band Embrace.
designer Richard Bull
photographer Rick Guest
art director Richard Bull
design company Yacht Associates
country of origin UK

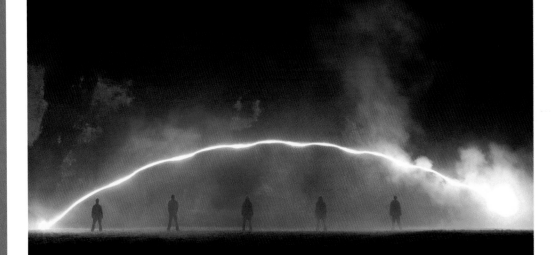

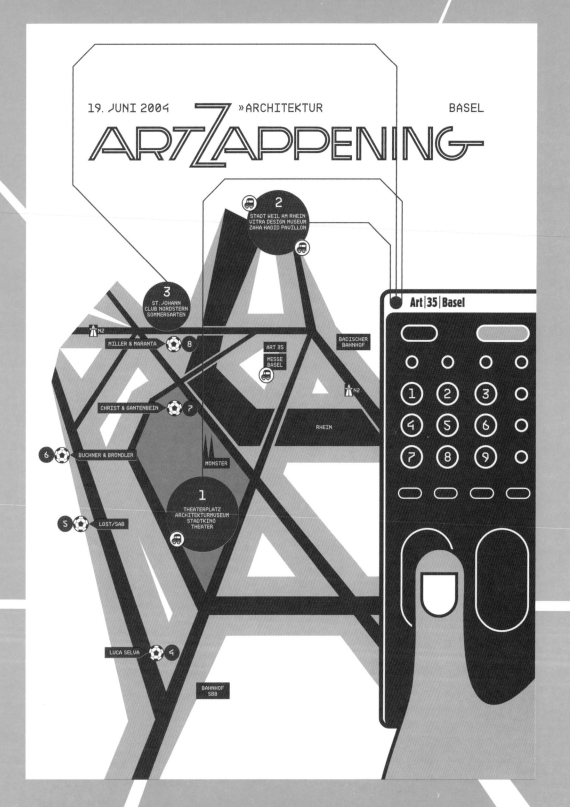

above
Artzappening

dimensions 27 1/2 x 39 3/8 in 700 x 1000 mm
description Poster for event weekend during the international art show "Art Basel" (2004).
designer Lopetz
design company Büro Destruct
country of origin Switzerland

facing page
Jazzers

dimensions 35 1/4 x 50 3/8 in 895 x 1280 mm
description Monthly program poster for Kulturhallen Dampfzentrale Bern.
designer MBrunner
illustrator MBrunner
design company Büro Destruct
country of origin Switzerland

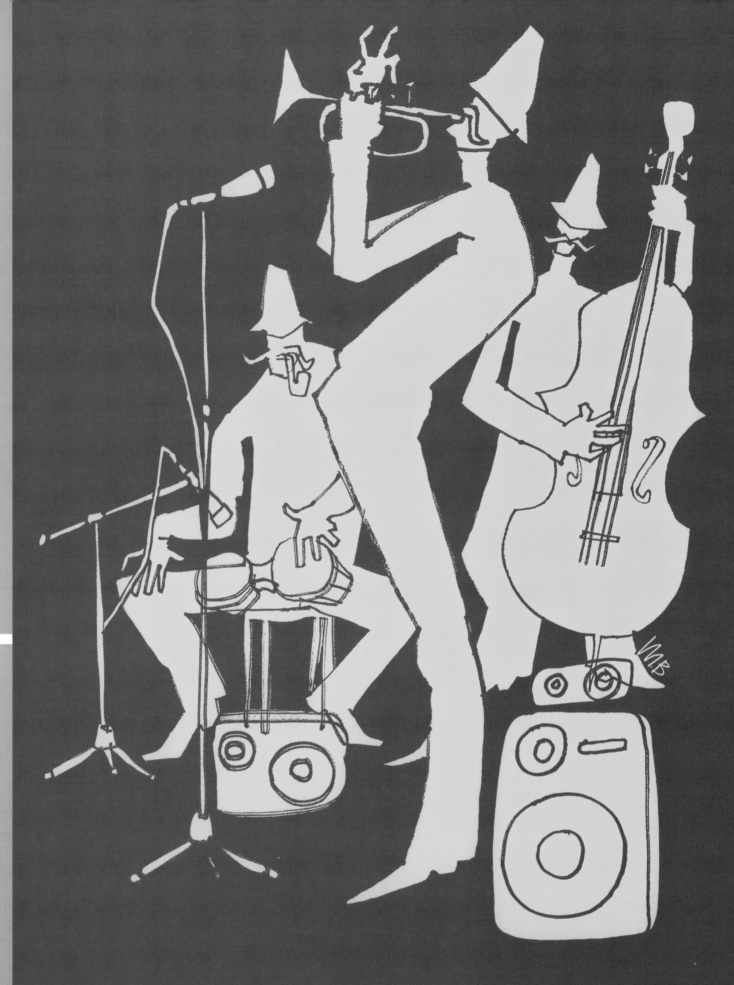

 KULTURHALLEN
DAMPFZENTRALE
WWW.DAMPFZENTRALE.CH

below
Ska Night
dimensions 16 ¹/₂ x 16 ¹/₂ in 420 x 420 mm
description Ska night poster
for Reitschule Dachstock Bern (2006).
designer Lopetz
design company Büro Destruct
country of origin Switzerland

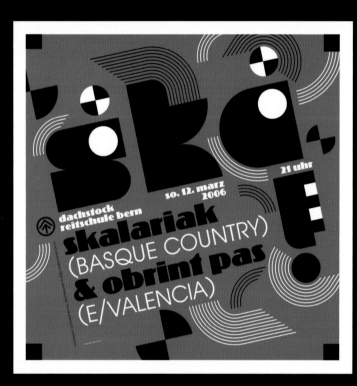

right
Pauke
dimensions 35 ¹/₄ x 50 ³/₈ in 895 x 1280 mm
description Monthly program poster for
Kulturhallen Dampfzentrale Bern (2005).
designer MBrunner
photographer Yoshi Kusano
design company Büro Destruct
country of origin Switzerland

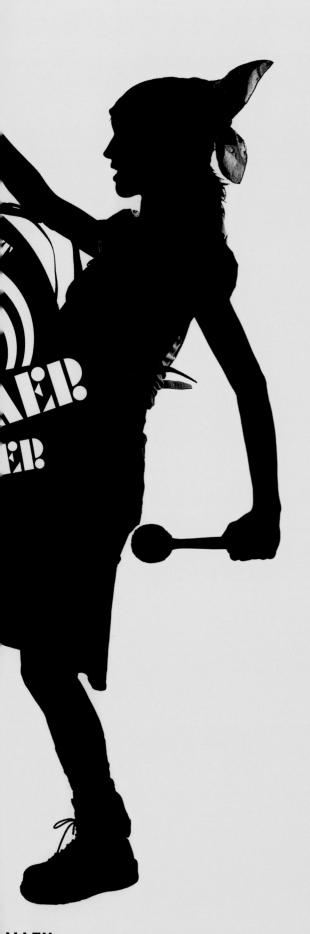

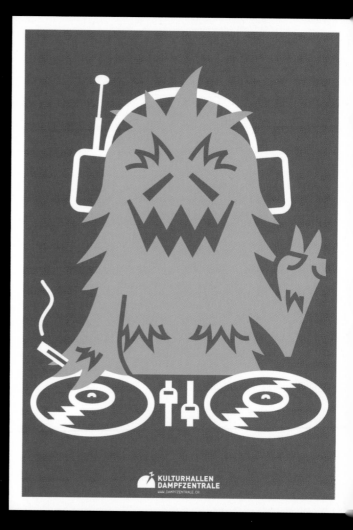

above
DJ Hairy
dimensions 35 ¹/₄ x 50 ³/₈ in 895 x 1280 mm
description Monthly program poster for
Kulturhallen Dampfzentrale Bern (2003).
designer MBrunner
design company Büro Destruct
country of origin Switzerland

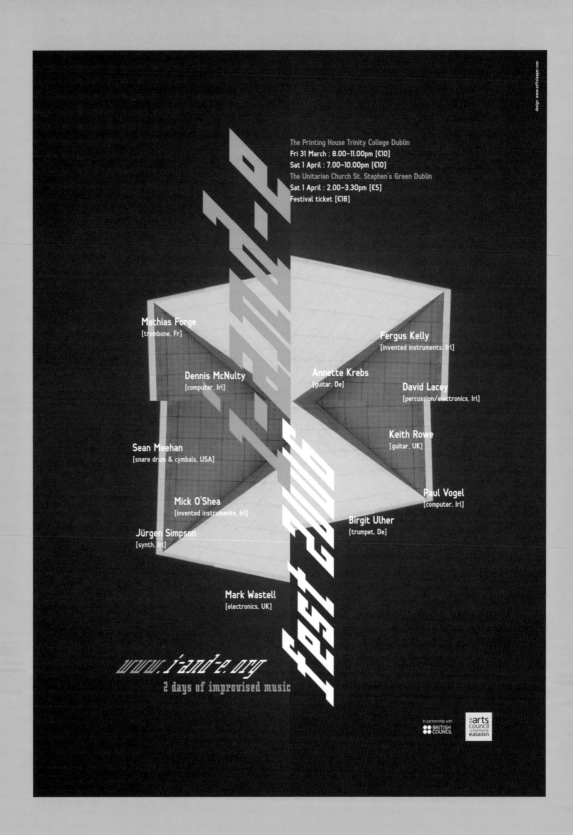

above

i-and-ε

dimensions 11 ³/₄ x 16 ¹/₂ in 297 x 420 mm

description A poster (graphic montage) for the
i-and-e festival (2006), litho-printed with 2 spot
colors on uncoated stock. i-and-e organizes
irregular concerts of contemporary improvised
music in Ireland.

designer Peter Maybury

design company Peter Maybury Studio

country of origin Ireland

facing page

The Frontline Band: Still

description Poster for Frontline Ministries,
a "Generation X" church-based band
from McLean, Virginia, USA.

designer David Kasparek

art director David Kasparek

design company Visualmentalstimuli

country of origin USA

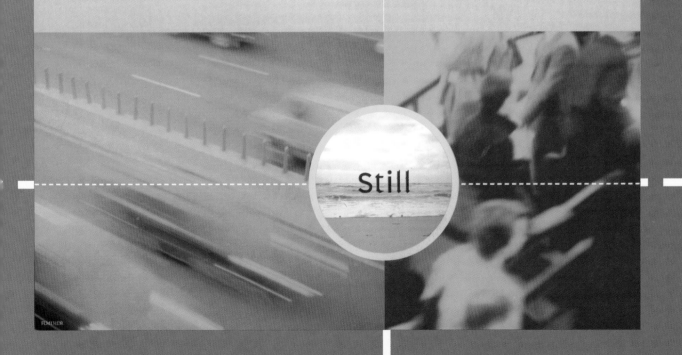

tHE **FRONTLINE** BAND

FLB

THE NEW ALBUM

Still

Available on **CD** or Cassette

Still

Vision

dimensions 11 ³/₄ x 38 ¹/₂ in 297 x 977 mm
description Poster and flyer for the open-air
electronic music festival "Vision" (2006).
designer H1reber
illustrator H1reber
design company Büro Destruct
country of origin Switzerland

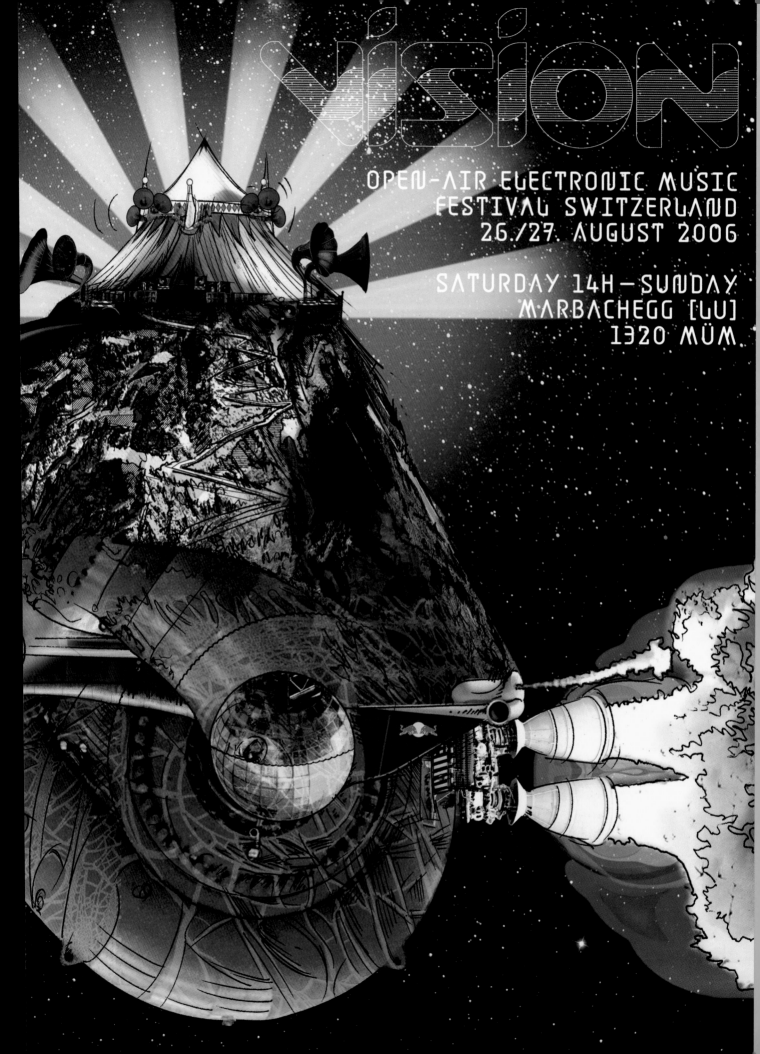

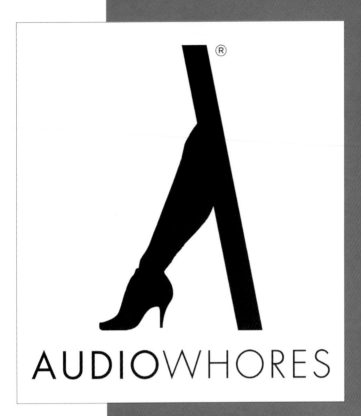

facing page
Blaze of Glory
description Poster and flyer design promoting Blaze of Glory at The Social bar in London.
designer Kerry Roper
illustrator Kerry Roper
art director Kerry Roper
design company Beautiful
country of origin UK

above
Audio Whores visual identity
description Logo design for the DJ duo Audio Whores.
designer Kerry Roper
illustrator Kerry Roper
art director Kerry Roper
design company Beautiful
country of origin UK

right
Scrambler visual identity
description Logotype identity for the adventure company Scrambler.
designer Kerry Roper
art director Kerry Roper
design company Beautiful
country of origin UK

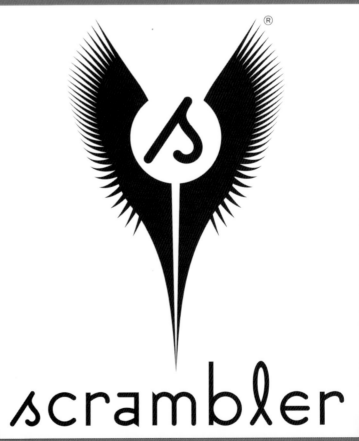

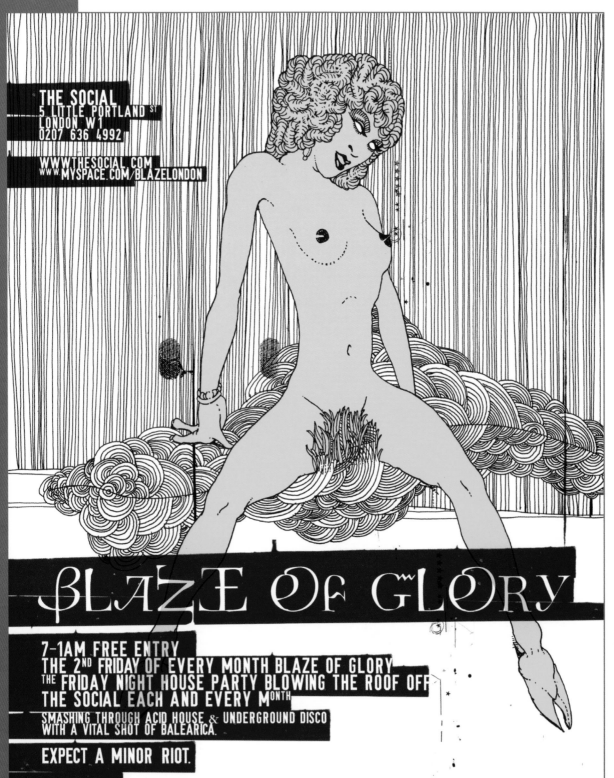

THE SOCIAL
5 LITTLE PORTLAND ST
LONDON W1
0207 636 4992

WWW.THESOCIAL.COM
WWW.MYSPACE.COM/BLAZELONDON

βLAZE OF GLORY

7-1AM FREE ENTRY
THE 2ND FRIDAY OF EVERY MONTH BLAZE OF GLORY
THE FRIDAY NIGHT HOUSE PARTY BLOWING THE ROOF OFF
THE SOCIAL EACH AND EVERY MONTH
SMASHING THROUGH ACID HOUSE & UNDERGROUND DISCO
WITH A VITAL SHOT OF BALEARICA.

EXPECT A MINOR RIOT.

RESIDENTS:
MATTY J (TIRK/CHIBUKU)
BEN TERRY (THEY SHOOT HORSES DON'T THEY?)
art direction: www.youarebeautiful.co.uk

THESOCIAL

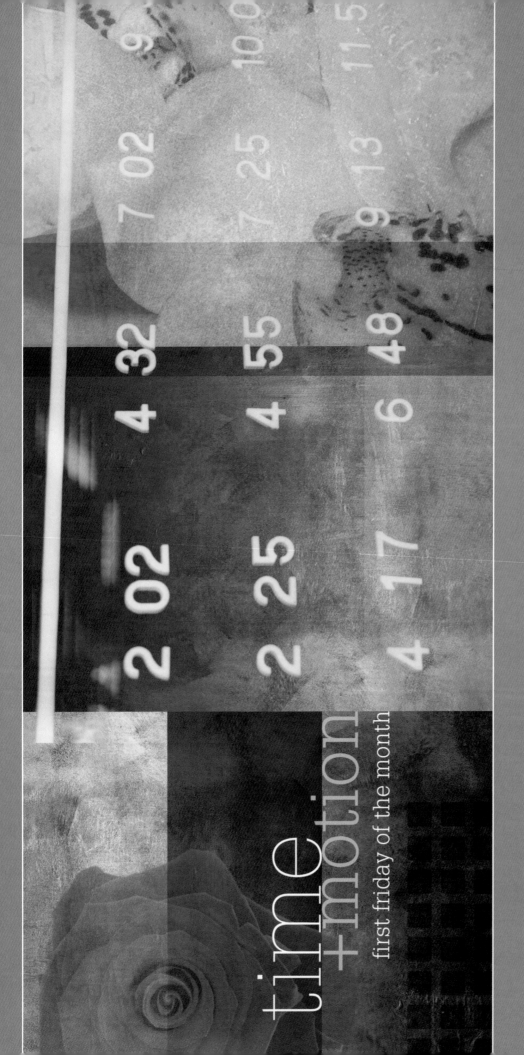

time +motion

first friday of the month

CLUB *Kali*

second and forth friday of the month at the dome, tufnell park.

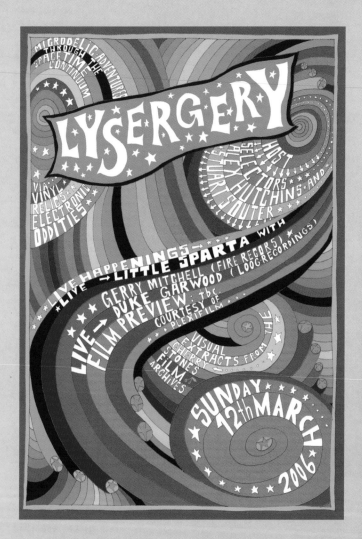

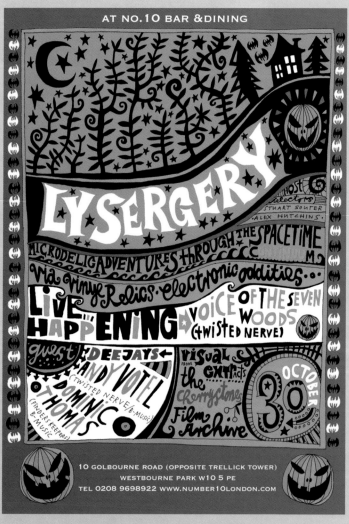

Lysergery

posters 8 1/4 x 11 3/4 in 210 x 297 mm

flyers 4 1/8 x 5 7/8 in 104 x 148 mm

description Posters and flyers designed
for a monthly club night in London.

designer Rina Donnersmarck

illustrator Rina Donnersmarck

country of origin UK

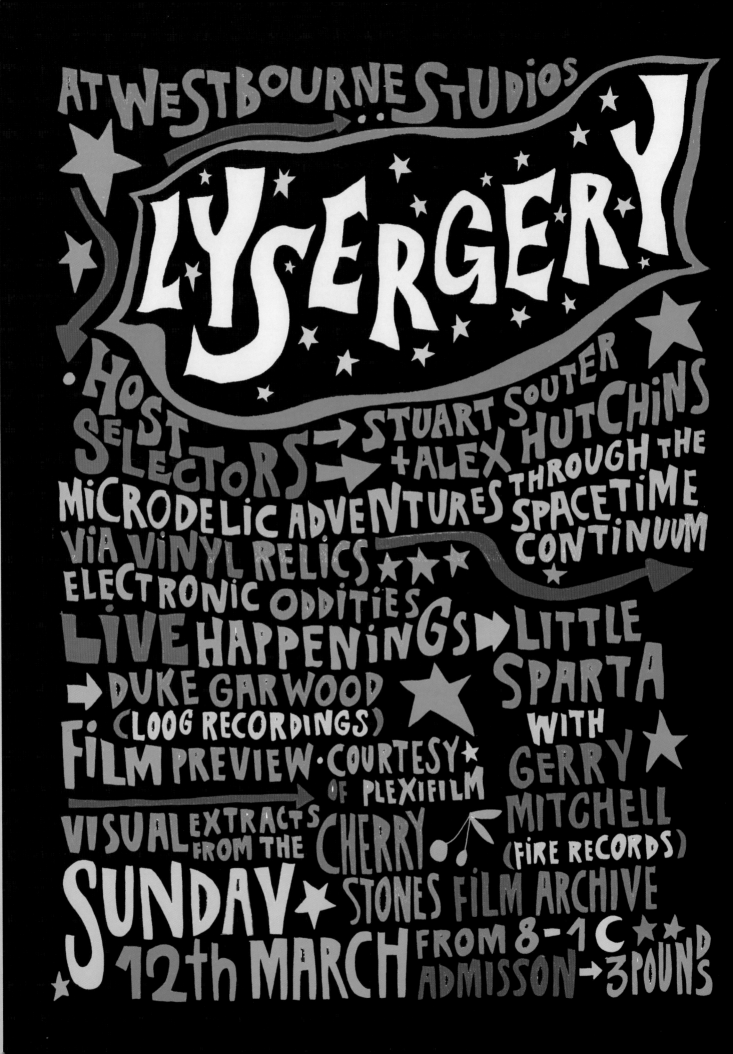

this page, right and facing page, bottom right
Lysergery
dimensions 4 1/8 x 5 7/8 in 104 x 148 mm
description Flyers designed for a monthly
club night in London.
designer Rina Donnersmarck
illustrator Rina Donnersmarck
country of origin UK

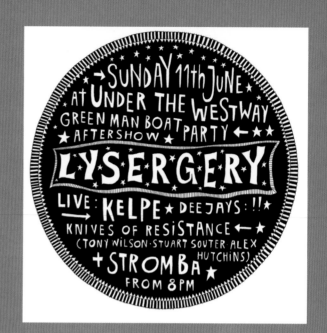

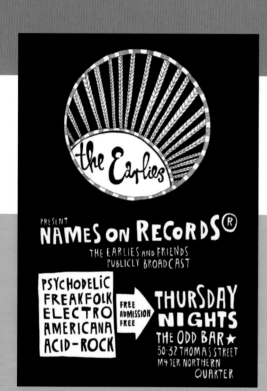

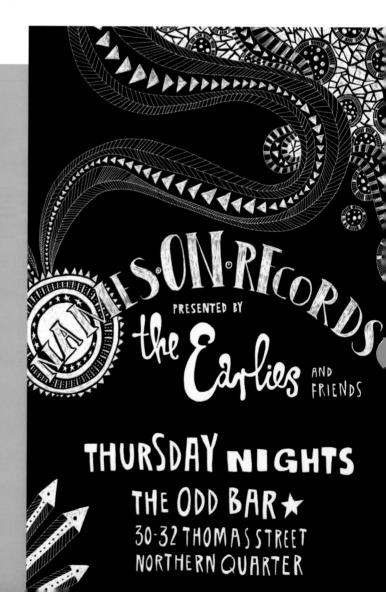

above and right
The Earlies: Names on Records
dimensions 11 3/4 x 16 1/2 in 297 x 420 mm
description Posters for a club night in
Manchester, UK, promoting The Earlies
band.
designer Rina Donnersmarck
illustrator Rina Donnersmarck
country of origin UK

below left
Cyclones
dimensions 4 1/8 x 5 7/8 in 104 x 148 mm
description Musical flyer designed to promote an English band called Cyclones.
designer Rina Donnersmarck
illustrator Rina Donnersmarck
country of origin UK

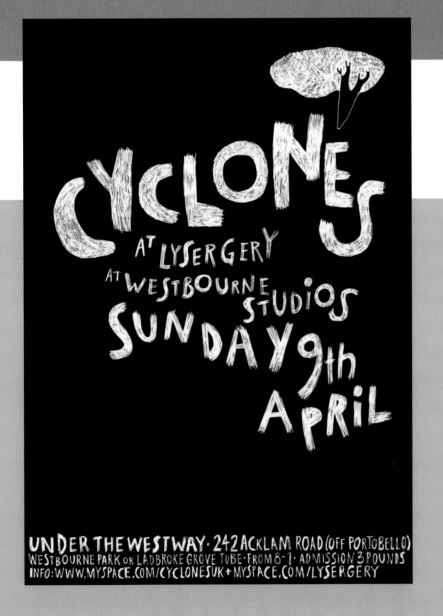

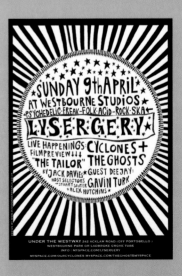

design for
educ

youth & education 2006

queensland theatre company

Queensland Government

QueenslandTheatreCompany

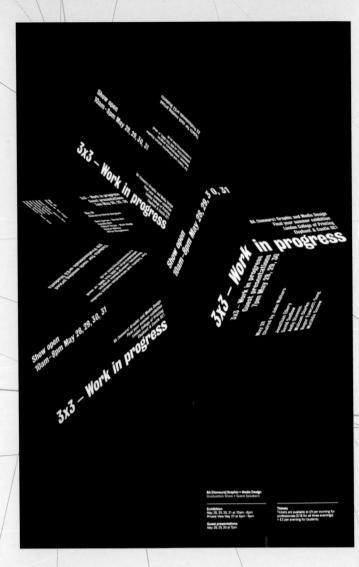

previous page, left
Amphetamine Use Information Cards
dimensions 3 ¹/₈ x 4 ³/₄ in 80 x 120 mm
description Queensland Health information
cards targeted at drug users and health
workers, explaining amphetamine-related
issues in a direct and relevant way.
design company Inkahoots
country of origin Australia

previous page, right
Youth & Education 2006
dimensions 16 ¹/₂ x 23 ³/₈ in 420 x 594 mm
description Theater program poster for the
Queensland Theatre Company.
design company Inkahoots
country of origin Australia

3x3 Poster Campaign
dimensions 23 ³/₈ x 33 ¹/₈ in 594 x 841 mm
description Promotional posters for the final year exhibition
of an undergraduate (BA) course at London College of
Communication (formerly London College of Printing). The
poster uses manipulated typography which is photographed
to create dimension-negative space.
designers Malcolm Clarke, David Sudlow, and Dixonbaxi
art directors Malcolm Clarke, David Sudlow, and Dixonbaxi
photographer Jason Tozer
art college London College of Communication
country of origin UK

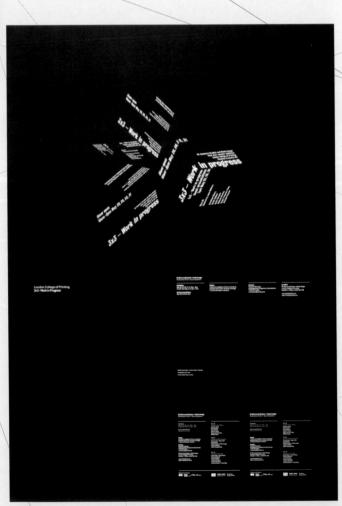

I treated the typography in a way
that suggested a three-dimensional
space through graphic contrast
and hand-rendered typography
covering the cubes, which refer to
the BA course.
MALCOLM CLARKE

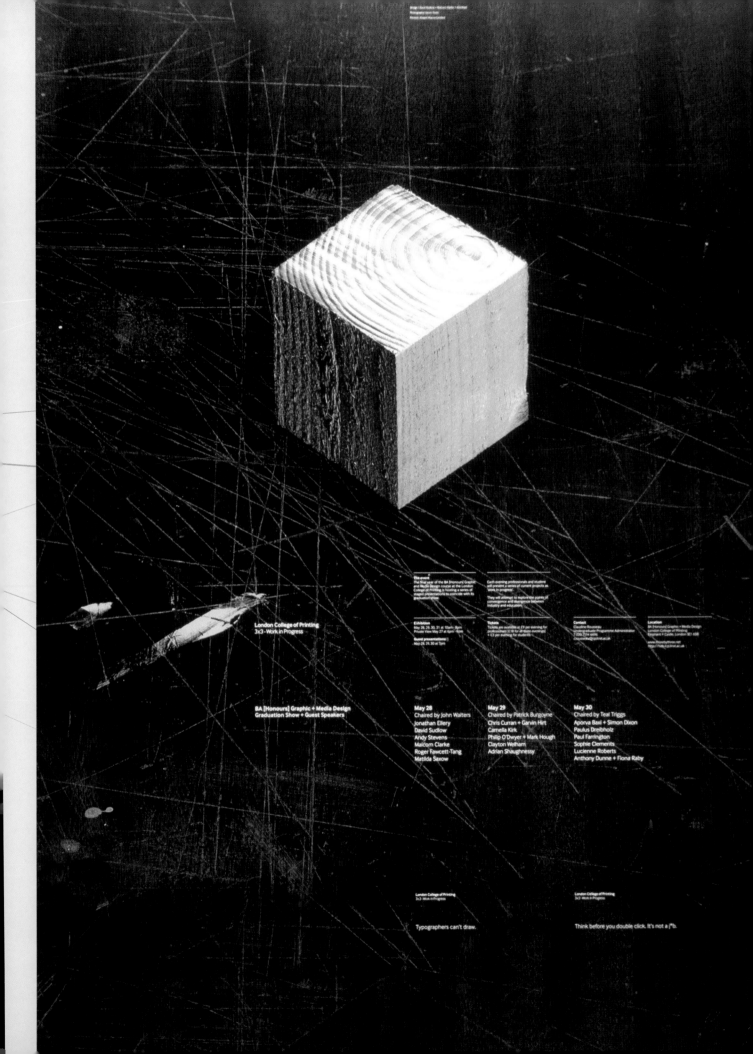

Image / Illustration: Chris Ryan / Interpolate / dinner
Photography: Glenn Tutssel
Printed: Expert Macro London

The event
The final year of the BA [Honours] Graphic
and Media Design course at the London
College of Printing is hosting a series of
staged presentations to coincide with its
graduation show.

Each evening professionals and student
will present a series of current projects as
work in progress.

They will attempt to explore the points
of convergence and divergence between
industry and education.

Exhibition
May 28, 29, 30, 31 at 10am – 8pm
Private View May 27 at 6pm – 9pm

Guest presentations
May 28, 29, 30 at 7pm

Tickets
Tickets are available at £9 per evening for
professionals (£18 for all three evenings)
+ £3 per evening for students.

Contact
Claudine Rousseau
Undergraduate Programme Administrator
T 020 7514 6886
c.rousseau@lcp.linst.ac.uk

Location
BA [Honours] Graphic + Media Design
London College of Printing
Elephant + Castle, London SE1 6SB

London College of Printing
3x3 – Work in Progress

BA [Honours] Graphic + Media Design
Graduation Show + Guest Speakers

May 28
Chaired by John Walters

Jonathan Ellery
David Sudlow
Andy Stevens
Malcom Clarke
Roger Fawcett-Tang
Matilda Saxow

May 29
Chaired by Patrick Burgoyne

Chris Curran + Garvin Hirt
Camella Kirk
Philip O'Dwyer + Mark Hough
Clayton Welham
Adrian Shaughnessy

May 30
Chaired by Teal Triggs

Aporva Baxi + Simon Dixon
Paulus Dreibholz
Paul Farrington
Sophie Clements
Lucienne Roberts
Anthony Dunne + Fiona Raby

London College of Printing
3x3 – Work in Progress

London College of Printing
3x3 – Work in Progress

Typographers can't draw.

Think before you double click. It's not a j*b.

this page

CCA Master of Architecture Program

dimensions 16 x 24 in 406 x 610 mm

description Poster promoting a California College
of the Arts postgraduate architecture course.

designer Bob Aufuldish

art director Bob Aufuldish

photographer Bob Aufuldish

design company Aufuldish & Warinner

country of origin USA

facing page

**California College of the Arts is Visiting
Architecture Spring 2005 Lecture Series**

dimensions 11 x 17 in 280 x 432 mm

description Promotional flyer for California College
of the Arts.

designer Bob Aufuldish

art director Bob Aufuldish

photographer Kathy Warinner

design company Aufuldish & Warinner

country of origin USA

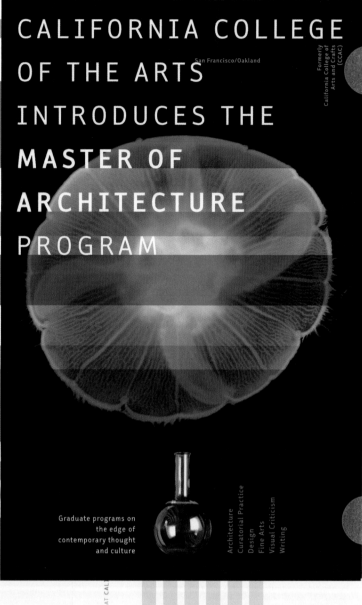

CALIFORNIA COLLEGE OF THE ARTS
INTRODUCES THE
MASTER OF
ARCHITECTURE
PROGRAM

San Francisco/Oakland

Formerly
California College of
Arts and Crafts
(CCAC)

Graduate programs on
the edge of
contemporary thought
and culture

Architecture
Curatorial Practice
Design
Fine Arts
Visual Criticism
Writing

The graduate architecture program at
California College of the Arts
integrates material, artistic, and
critical approaches to the study and
practice of architecture.

Focusing on design and fabrication,
the studio-based program provides
a rigorous architectural education
with a strong emphasis on
experimentation, exploration, and
creativity.

Groundbreakin[g]
developments i[n]
technology are
students to cap[ture]
opportunities i[n]
profession.

The college's metropolitan setting enhances the educational experience. The
city of San Francisco serves as an urban laboratory, inspiring new ways to
configure architecture and space. Students are encouraged to take advantage
of the program's setting within an art college and collaborate within and
across disciplines. Small class size ensures access to the college's diverse
faculty of practicing professionals. The popular Architecture Lecture Series
brings top international scholars and practitioners to the campus, introducing
students to the latest developments in architectural theory and practice.

Graduates of the MArch Program will possess a thorough understanding of
materials and fabrication processes, as well as comprehensive knowledge of
digital tools and techniques. The college's interdisciplinary approach gives
students a fluency in art and design concepts and an exposure to alternative
models of architectural design and practice.

This program is a three-year first professional master's degree in architecture.
It is designed for students who have earned a bachelor's degree in another
field and wish to study architecture. The program also accommodates
students who have begun their architecture study at the undergraduate level.
Advanced standing may be granted to students who have some previous
education in architecture. Placement is based on review of portfolio and tran-
scripts. Upon graduation, students will be qualified, after a three-year intern-
ship, to take the National Council of Architectural Registration Boards
(NCARB) licensing exam.

The MArch Program is a candidate for accreditation by the National
Architectural Accrediting Board (NAAB). Accreditation will be effective for
students graduating from the program in 2006. The BArch program at
California College of the Arts is fully accredited by NAAB.

California College of the Arts hosts graduate information nights in
September and November. Visit www.cca.edu for details.

MASTER OF ARCHITECTURE AT CAL[

CCA

last name, first name, m.i.

street address

city

state/zip code

home phone

email

Please send me more
information about
graduate programs in:
○ Architecture
○ Curatorial Practice
○ Design
○ Fine Arts
○ Visual Criticism
○ Writing
○ I already have a catalog

I first learned of
CCA graduate
programs through:
○ Mailing
○ Advertisement
○ Internet
○ Referral
○ Other

very strong
somewhat strong

(SAN FRANCISCO
(OAKLAND

CALIFORNIA COLLEGE OF THE ARTS

IS VISITING:

DATE:

TIME:

LOCATION:

18 programs in

ART
ARCHITECTURE
DESIGN

800.447.1ART
enroll@cca.edu
www.cca.edu

FORMERLY
CALIFORNIA COLLEGE OF
ARTS AND CRAFTS
(CCAC)

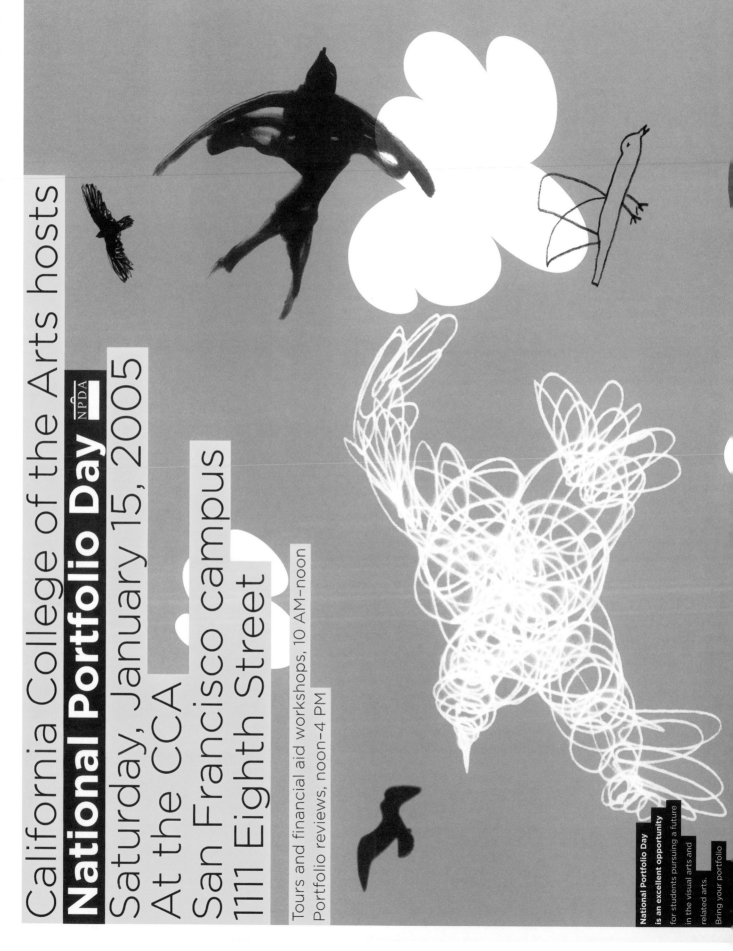

California College of the Arts hosts

National Portfolio Day NPDA

Saturday, January 15, 2005
At the CCA
San Francisco campus
1111 Eighth Street

Tours and financial aid workshops, 10 AM–noon
Portfolio reviews, noon–4 PM

National Portfolio Day
is an excellent opportunity
for students pursuing a future
in the visual arts and
related arts.
Bring your portfolio

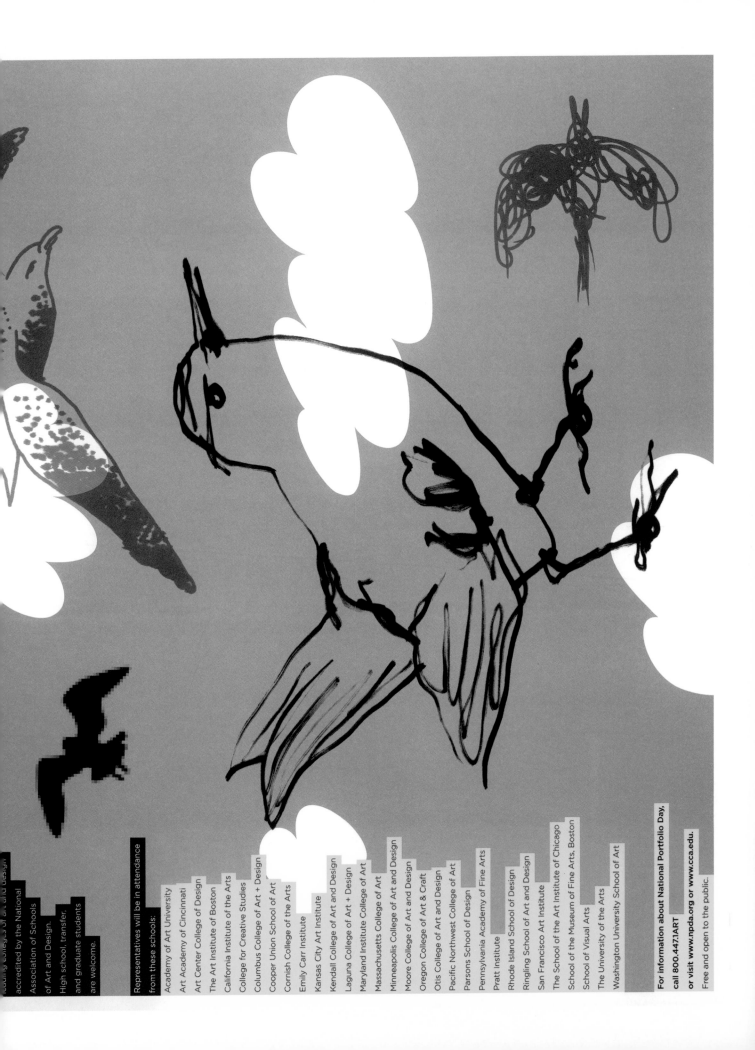

accredited by the National
Association of Schools
of Art and Design.
High school, transfer,
and graduate students
are welcome.

Representatives will be in attendance
from these schools:

Academy of Art University
Art Academy of Cincinnati
Art Center College of Design
The Art Institute of Boston
California Institute of the Arts
College for Creative Studies
Columbus College of Art + Design
Cooper Union School of Art
Cornish College of the Arts
Emily Carr Institute
Kansas City Art Institute
Kendall College of Art and Design
Laguna College of Art + Design
Maryland Institute College of Art
Massachusetts College of Art
Minneapolis College of Art and Design
Moore College of Art and Design
Oregon College of Art & Craft
Otis College of Art and Design
Pacific Northwest College of Art
Parsons School of Design
Pennsylvania Academy of Fine Arts
Pratt Institute
Rhode Island School of Design
Ringling School of Art and Design
San Francisco Art Institute
The School of the Art Institute of Chicago
School of the Museum of Fine Arts, Boston
School of Visual Arts
The University of the Arts
Washington University School of Art

**For information about National Portfolio Day,
call 800.447.1ART
or visit www.npda.org or www.cca.edu.**
Free and open to the public.

CCAC hosts

(California College of Arts and Crafts)

NATIONAL
PORTFOLIO
DAY

Saturday, January 19, 2002

At CCAC's San Francisco campus.

PORTFOLIO DAY is an excellent opportunity for students pursuing a future in the visual arts and related fields.

Bring your portfolio and questions and meet with representatives from over thirty leading colleges of art and design accredited by the National Association of Schools of Art and Design. College representatives will offer you guidance on portfolio development and information about visual arts programs.

High school, transfer, and graduate students are welcome.

Representatives will be in attendance from these schools:

Academy of Art College
Art Academy of Cincinnati
Art Center College of Design
The Art Institute of Boston
Art Institute of Southern California
College for Creative Studies
Columbus College of Art & Design
The Cooper Union School of Art
Cornish College of the Arts
Emily Carr Institute of Art + Design
Kansas City Art Institute

Kendall College of Art and Design
The Maryland Institute College of Art
Massachusetts College of Art
Minneapolis College of Art and Design
Moore College of Art and Design
Mount Ida College
Oregon College of Art & Craft
Otis College of Art and Design
Pacific Northwest College of Art
Parsons School of Design
Pennsylvania Academy of the Fine Arts

Pratt Institute
Rhode Island School of Design
Ringling School of Art and Design
San Francisco Art Institute
The School of the Art Institute of Chicago
School of the Museum of Fine Arts, Boston
School of Visual Arts
University of Michigan School of Art & Design
The University of the Arts
Washington University School of Art

Tours and financial aid workshops, 10 am–noon
Portfolio reviews, noon–4 pm

For information about Portfolio Day call

800.447.1ART
or visit www.npda.org
or www.ccac-art.edu.

NPDA

art that makes a
difference

CCA

cca.edu

CCA | San Francisco/Oakland
800.447.1ART

architecture
ceramics
community arts
fashion design
glass
graphic design
illustration
industrial design
interior design
jewelry/metal arts
media arts
painting/drawing
photography
printmaking
sculpture
textiles
visual studies
wood/furniture
writing and literature

FIDM
College Catalog 2006-07

The Fashion Institute of Design & Merchandising

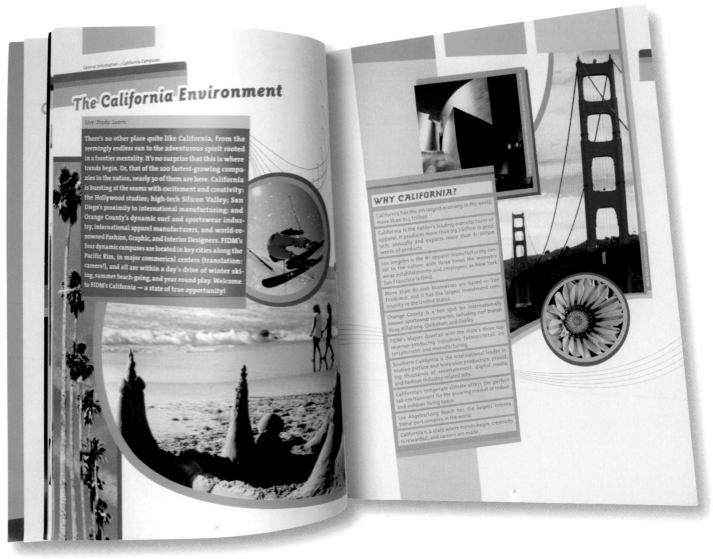

pages 150-153
California College of the Arts
Portfolio Day
dimensions 20 x 32 in 508 x 813 mm
description Posters promoting "Portfolio Days" at the California College of the Arts.
designer Bob Aufuldish
art director Bob Aufuldish
photographers Kathy Warinner (2005), Luis Delgado (2002)
design company Aufuldish & Warinner
country of origin USA

pages 154-155
California College of the Arts
Recruitment Poster
dimensions 16 x 24 in 406 x 610 mm
description Poster promoting the California College of the Arts.
designer Bob Aufuldish
art director Bob Aufuldish
photographers various
design company Aufuldish & Warinner
country of origin USA

this page and overleaf
Fashion Institute of Design and Merchandising College Catalog
dimensions approximately 9 x 12 in 229 x 305 mm
description College prospectus with angled edges to reflect a sense of globalism and perspectives, inspired by a world map's latitute and longitude lines. Inside the book, there are two layered grids rotated at 3.5° from center and color is used to code different sections.
designers Danielle Foushée, Gabrielle Morgan
photographer Brian Sanderson
art director Danielle Foushée
design company Danielle Foushée Design
country of origin USA

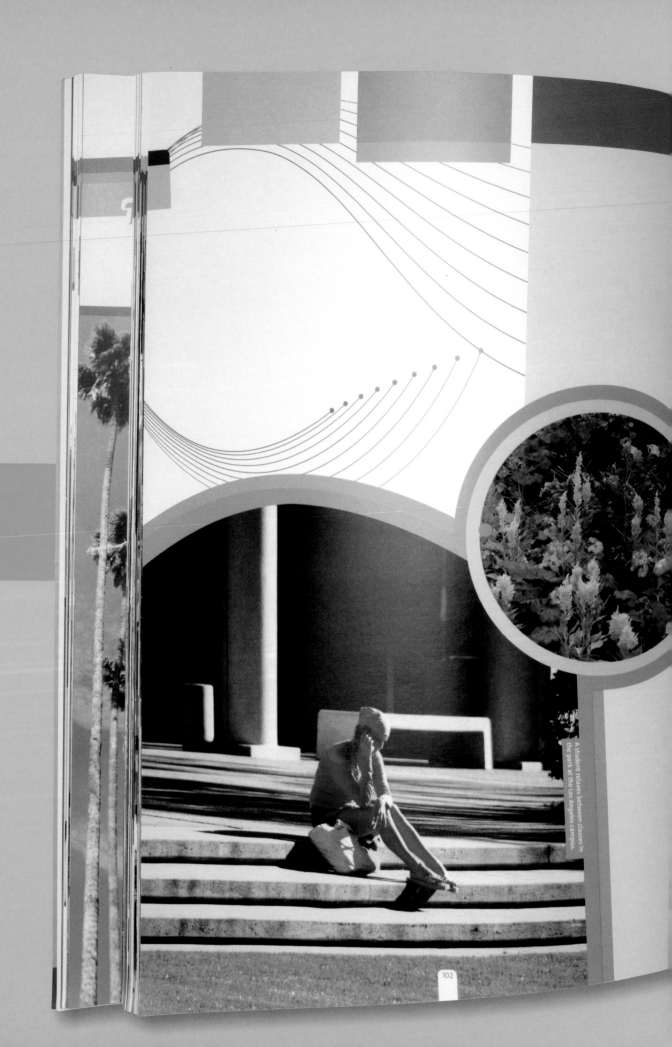

A student relaxes between classes in the park at the Los Angeles campus.

Course Descriptions

Courses are designed to give students the best possible foundation for building careers in their field of choice.

Business Administration

BUAD 1100
Selling Techniques
3 Units

A course designed to introduce students to the behavioral and motivational techniques used in professional presentations.

BUAD 2000
Organizational Behavior & Management
3 Units

A comprehensive overview of the issues in human relations encountered in business by today's leaders and managers. Students learn about company objectives, policies and procedures, and employee needs, as well as to the interaction among these elements. Provides students with problem solving and discussion opportunities. Prerequisite: BUAD 2100

BUAD 2100
Management Concepts
3 Units

An introductory class in management concepts and fundamentals, including principles of managing, managing techniques, team interaction, team solutions, and other management and leadership issues. In addition, students learn the concept behind the job descriptions, analyze case studies, and gain experience in management interviews.

BUAD 2850
Entrepreneurship
3 Units

This course explores the student's persona as an entrepreneur or an intrapreneur. Students learn to develop a business plan to start a new retail venture or revitalize an existing operation. This includes identifying opportunities and establishing objectives, matching customer profile to site locations, analyzing competitors' practices, and developing a competitive marketing mix. Students also learn to prepare the necessary forms and budget projections to secure capital or financing. Prerequisites: BUAD 2000, MMKT 2380

Business Management

BUMT 3000
Introduction to Global Management Concepts & Entrepreneurship
3 Units

This survey of key business functions provides an overview of business management, ethics, international business, and various forms of ownership. The course explores why these functions are necessary, and how they interconnect and can be structured to produce positive results.

BUMT 3010
Management of Business Information Technology
3 Units

This course explores the use of information technology in today's economy. Students learn how to acquire timely and accurate information especially in the areas of marketing and product development.

BUMT 3020
Ethical Issues in Business Technology & Financial Management
3 Units

This course addresses the importance of ethical issues and practices on business success, and the costs and consequences of failing to act ethically. Students learn strategies to solve real life dilemmas. Students explore the importance of ethics as a dimension of social responsibility, the impact of Sarbanes-Oxley, and business ethics in the global economy.

BUMT 3400
Accounting Basics for the Business Manager
3 Units

Students study the accounting cycle through financial statements, understanding inventory controls, tangible and intangible assets, and budgets. This course covers the role accounting statistics plays in business forecasting and decision making. It demonstrates and explains the performance of hypothesis testing. The student gains an understanding of assets and liabilities, revenue and expenses, debits and credits, accruals, depreciation, constructing a financial statement, and accounting cycles.
Prerequisite: GNST 3020

BUMT 3500
Legal Issues & Business Strategies for Import/Export
3 Units

A basic overview of the legal rights, structures, and responsibilities of being in business, with emphasis on principles and practical applications of contract negotiations, business activity, and commercial liability. Students examine the foundations of law and ethics, the basics of contract law, sale and lease contracts, employment and labor laws, business organization law, and business regulation law.

BUMT 3600
Management Theory & Principles
3 Units

This course presents an introduction to management concepts and strategies used by modern businesses, and is designed to familiarize students with the accepted standards, procedures, and techniques employed by senior, middle, and operational managers. It provides the student with an understanding of the financial impact of management and how to plan to optimize performance and achieve organizational goals.

BUMT 3700
Management Strategy & Innovative Management Techniques
3 Units

This course is a study and analysis of success and failure in today's business environment with emphasis on creating value through innovative

CALIFORNIA COLLEGE
OF THE ARTS

San Francisco/Oakland

→ OFFICE *of* ENROLLMENT SERVICES

1111 Eighth Street
San Francisco, CA 94107
800.447.1ART
www.cca.edu

stationery for California College of the Arts
dimensions various
description Letterhead and announcement cards designed for the enrollment office of an art college.
designer Bob Aufuldish
art director Bob Aufuldish
design company Aufuldish & Warinner
country of origin USA

stationery for California College of the Arts
dimensions various
description Letterhead and announcement cards designed for the enrollment office of an art college.
designer Bob Aufuldish
illustrator Kathy Warinner
art director Bob Aufuldish
design company Aufuldish & Warinner
country of origin USA

pages 164-167

California College of the Arts Viewbook

dimensions 5 3/4 x 8 1/4 in 146 x 210 mm
description Information brochure promoting California College of the Arts.
designer Bob Aufuldish
photographers Karl Petzke, James Tilly, TaSin Sabir, Douglas Sandberg, Suzanne LeGasa
art director Bob Aufuldish
design company Aufuldish & Warinner
country of origin USA

CALIFORNIA
COLLEGE OF
THE ARTS

SAN FRANCISCO
OAKLAND

ART
ARCHITECTURE
DESIGN
WRITING

CALIFORNIA COLLEGE OF THE ARTS WWW.CCA.EDU

cca

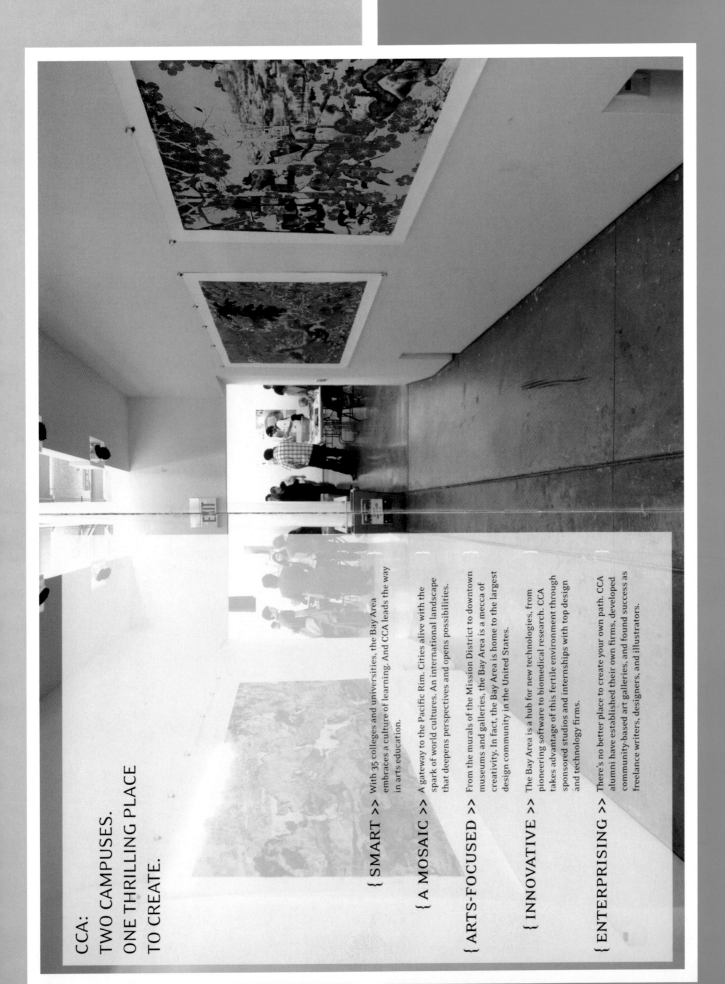

CCA:
TWO CAMPUSES.
ONE THRILLING PLACE
TO CREATE.

{ SMART >> With 35 colleges and universities, the Bay Area embraces a culture of learning. And CCA leads the way in arts education.

{ A MOSAIC >> A gateway to the Pacific Rim. Cities alive with the spark of world cultures. An international landscape that deepens perspectives and opens possibilities.

{ ARTS-FOCUSED >> From the murals of the Mission District to downtown museums and galleries, the Bay Area is a mecca of creativity. In fact, the Bay Area is home to the largest design community in the United States.

{ INNOVATIVE >> The Bay Area is a hub for new technologies, from pioneering software to biomedical research. CCA takes advantage of this fertile environment through sponsored studios and internships with top design and technology firms.

{ ENTERPRISING >> There's no better place to create your own path. CCA alumni have established their own firms, developed community-based art galleries, and found success as freelance writers, designers, and illustrators.

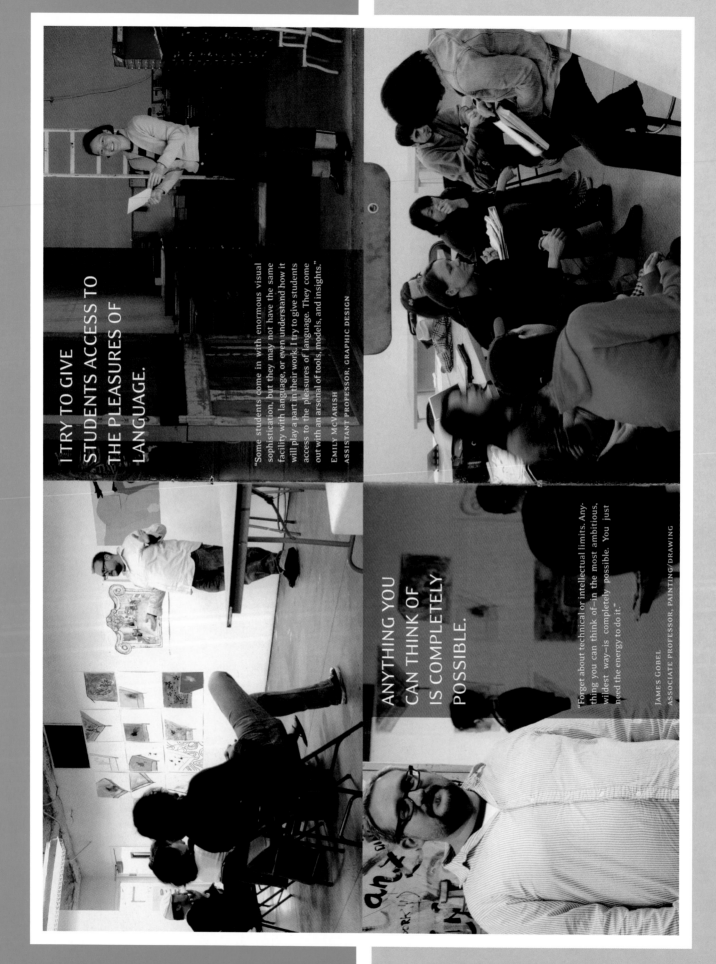

I TRY TO GIVE
STUDENTS ACCESS TO
THE PLEASURES OF
LANGUAGE.

"Some students come in with enormous visual sophistication, but they may not have the same facility with language, or even understand how it will play a part in their work. I try to give students access to the pleasures of language. They come out with an arsenal of tools, models, and insights."

EMILY MCVARISH
ASSISTANT PROFESSOR, GRAPHIC DESIGN

ANYTHING YOU
CAN THINK OF
IS COMPLETELY
POSSIBLE.

"Forget about technical or intellectual limits. Anything you can think of—in the most ambitious, wildest way—is completely possible. You just need the energy to do it."

JAMES GOBEL
ASSOCIATE PROFESSOR, PAINTING/DRAWING

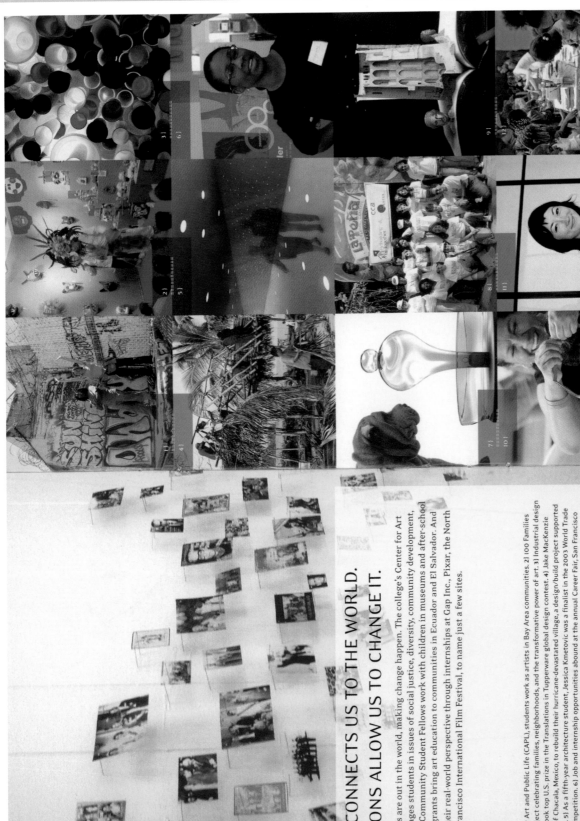

OUR ART CONNECTS US TO THE WORLD.
OUR ACTIONS ALLOW US TO CHANGE IT.

At CCA, our students are out in the world, making change happen. The college's Center for Art and Public Life engages students in issues of social justice, diversity, community development, and education. Our Community Student Fellows work with children in museums and after-school programs. Student grants bring art education to communities in Ecuador and El Salvador. And students sharpen their real-world perspective through internships at Gap Inc., Pixar, the North Face, and the San Francisco International Film Festival, to name just a few sites.

1) Through the Center for Art and Public Life (CAPL), students work as artists in Bay Area communities. 2) 100 Families Oakland: a year-long project celebrating families, neighborhoods, and the transformative power of art. 3) Industrial design student Tony Meredith took top U.S. prize in the Translations in Tupperware global design contest. 4) Jake MacKenzie worked with the people of Chacala, Mexico, to rebuild their hurricane-devastated village, a design/build project supported by a CAPL student grant. 5) As a fifth-year architecture student, Jessica Kmetovic was a finalist in the 2003 World Trade Center Site Memorial Competition. 6) Job and internship opportunities abound at the annual Career Fair, San Francisco campus. 7) Industrial design meets man's best friend: student-designed pet products go on the market through a studio sponsored by Turkish firm Gaia & Gino. 8) Building partnerships with local schools, nonprofits, and community groups. 9) Work in progress for 2006 Sundance Film Festival by motion designer Lindsay Daniels '03. 10) Through CAPL, students work at the intersection of art, education, and community. 11) Alice Sladek gains real-world graphic design experience with an internship at Volume Design, San Francisco. 12) Exploring teaching and art education careers through youth mentorship.

CALIFORNIA COLLEGE OF THE ARTS
ARCHITECTURE PROGRAM
1111 EIGHTH STREET
SAN FRANCISCO, CA 94107-2247 | CCa

CCA
ARCHITECTURE
LECTURE
SERIES
SPRING 2005

/01/31/ **STEPHANE PRATTE / ATELIER IN SITU**

/02/07/ **DETLEF MERTINS / UNIVERSITY OF PENNSYLVANIA**

/02/14/ **JOHANNA GRAWUNDER / MILAN, SAN FRANCISCO**

/02/21/ **MICHAEL SPEAKS / SOUTHERN CALIFORNIA INSTITUTE OF ARCHITECTURE**

/02/28/ **MARCELO SPINA / PATTERNS**

/03/07/ **SULAN KOLATAN / KOL/MAC STUDIO**

/03/28/ **CHRISTOS MARCOPOULOS & CAROL MOUKHEIBER / STUDIO (N-1)**

/04/04/ **LISA FINDLEY / CALIFORNIA COLLEGE OF THE ARTS**

/04/11/ **AN TE LIU / UNIVERSITY OF TORONTO**

/04/18/ **ANTHONY BURKE / UC BERKELEY**

WE WOULD LIKE TO ACKNOWLEDGE THE GENEROUS SUPPORT OF DONORS TO THE ARCHITECTURE LECTURE SERIES IN THE LAST TWELVE MONTHS TITANIUM LEVEL: GRANTS FOR THE ARTS/SAN FRANCISCO HOTEL TAX FUND; LEF FOUNDATION. GRANITE LEVEL: GORDON H. CHONG & PARTNERS; JENSEN & MACY ARCHITECTS; MCCALL DESIGN GROUP. CONCRETE LEVEL: BARBARA SCAVULLO DESIGN; BEVERLY PRIOR ARCHITECTS; CCS ARCHITECTURE, INC.; DAVID BAKER + PARTNERS, ARCHITECTS; DONALD A. CROSBY, AIA; LEVY DESIGN PARTNERS; MBT ARCHITECTURE. TIMBER LEVEL: ELS ARCHITECTURE AND URBAN DESIGN; KAVA MASSIH ARCHITECTS. CCA WOULD ALSO LIKE TO THANK THE FOLLOWING FIRMS AND FOUNDATIONS FOR THEIR GENEROUS SUPPORT OF THE ARCHITECTURE PROGRAM: FONG & CHAN ARCHITECTS, GENSLER FAMILY FOUNDATION, LEF FOUNDATION, ANSHEN+ALLEN, GENSLER, IDEO, AND OVE ARUP AND PARTNERS CALIFORNIA LIMITED

All lectures Monday evenings at 7 PM in Timken Lecture Hall. Free and open to the public. Speakers are subject to change. For more information call 415.703.9562. CCA MONTGOMERY CAMPUS, 0000 EIGHTH STREET, SAN FRANCISCO

CCA ARCHITECTURE

page 168

**CCA Architecture Spring 2005
Lecture Series
dimensions** 16 x 24 in
406 x 610 mm
description Poster for California
College of the Arts architecture lecture
series.
designer Bob Aufuldish
art director Bob Aufuldish
photographer Christos Marcopoulos
design company Aufuldish & Warinner
country of origin USA

page 169

**CCA Architecture
dimensions** 6 x 24 in 406 x 610 mm
description Poster promoting
the California College of the Arts
architecture department.
designer Bob Aufuldish
art director Bob Aufuldish
design company Aufuldish & Warinner
country of origin USA

In recognition of your generous support as a

Benefactor of Art Auction 2006

The Modern Art Council
invites you to attend the exclusive West Coast premiere of

A Musical Portrait of Chuck Close

Written by composer Philip Glass
Performed by pianist Bruce Levingston

Wednesday, February 1, 2006
6 to 10 p.m.

Evelyn and Walter Haas Jr. Atrium, SFMOMA
Concert seating no later than 7:15 p.m.

Cocktails and hors d'oeuvres
Exhibition viewing of *Chuck Close: Self-Portraits 1967–2005*

RSVP by January 20 to guarantee seating
415.357.4125 or bmart@sfmoma.org

Valet parking
Cocktail attire

Wine generously donated by
Chalk Hill Estate Vineyards and Winery

SFMOMA

SFMOMA Benefactor Art Auction
Invitation
dimensions 5 x 7 in (folded); 15 x 7 in (flat)
127 x 178 mm (folded); 178 x 381 mm (flat)
description Invitation to a San Francisco
Museum of Modern Art auction.
designer Bob Aufuldish
photographer Chuck Close
art directors
Bob Aufuldish (Aufuldish & Warinner),
Jennifer Sonderby (SFMoMA)
design company Aufuldish & Warinner
country of origin USA

pages 174–179
CROP
dimensions 19 ⁷/₈ x 26 ⁵/₈ in
505 x 675 mm
description "CROP" is a
large format product catalog
series for Corbis Stock
Photography. There have
been seven produced to date
(Crop-2 is pictured here).
The catalog comes in a
rubber-plate-printed micro-
flute cardboard portfolio with
a built-in cardboard handle.
The main catalog has several
additional catalog inserts.
art director Carlos Segura
design company Segura, Inc.
country of origin USA

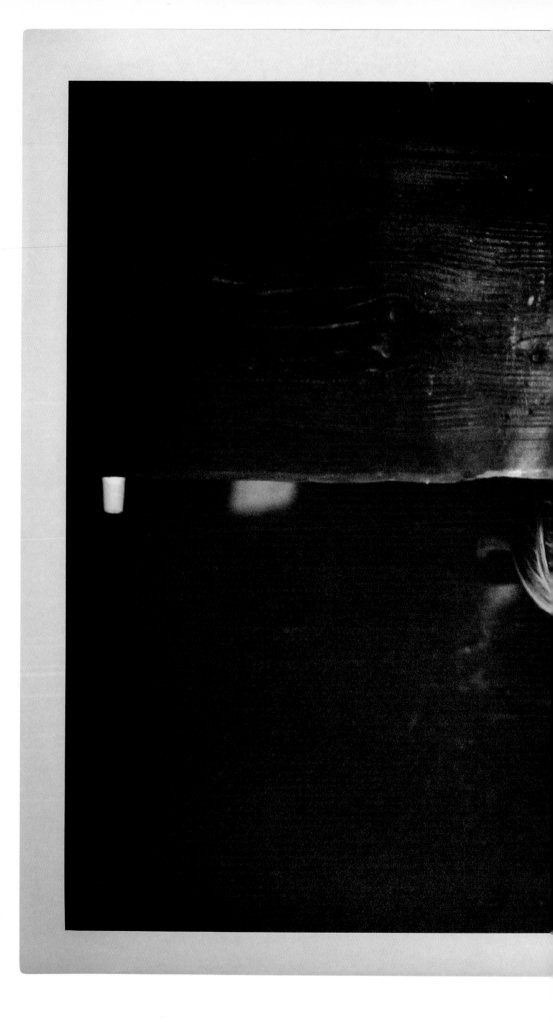

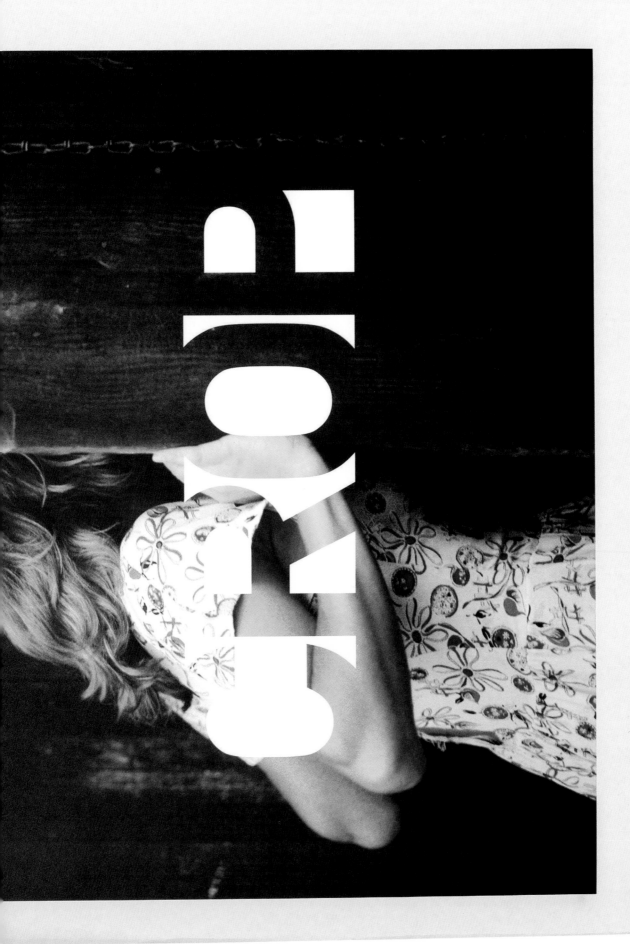

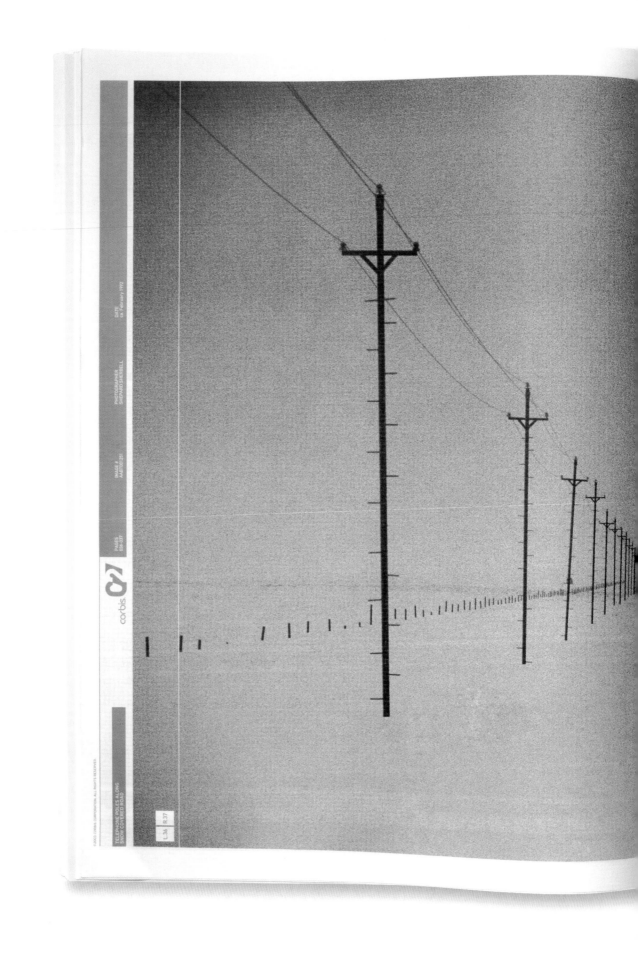

TELEPHONE POLES ALONG
SNOW COVERED ROAD

PHOTOGRAPHER:
SHEPARD SHERBELL

DATE:
ca. February 1992

IMAGE #
AABT001281

PAGES
036-037

corbis

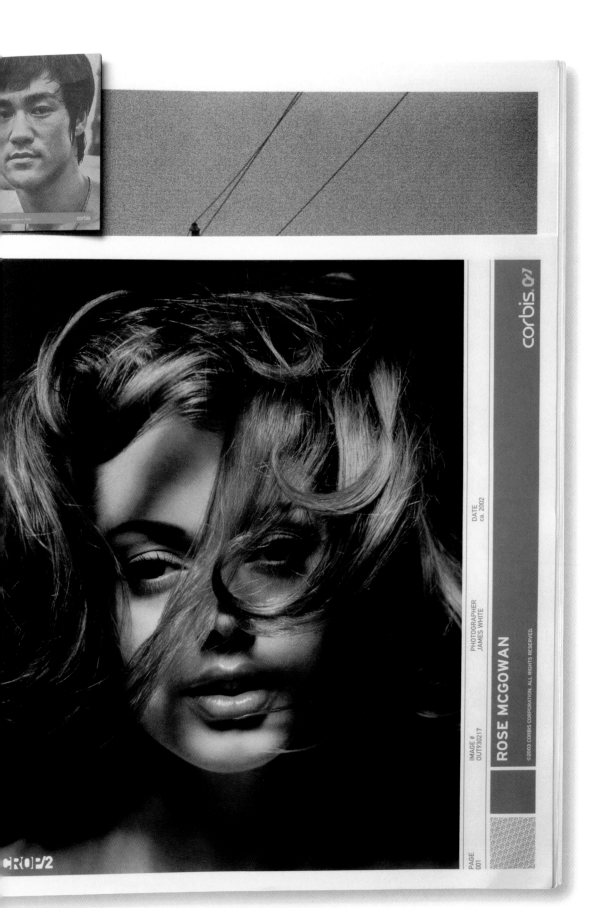

CROP/2

IMAGE #
OUT930217

PHOTOGRAPHER
JAMES WHITE

DATE
ca. 2002

ROSE MCGOWAN

©2003 CORBIS CORPORATION. ALL RIGHTS RESERVED.

corbis.o7

PAGE
001

corbis

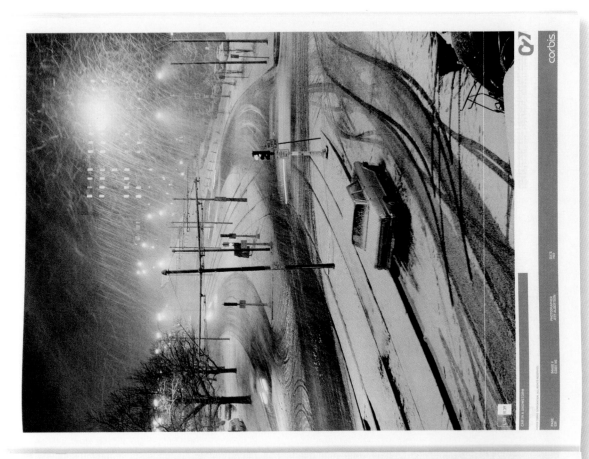

pages 180-185
Amelia's Magazine
dimensions 7 ⁷/₈ x 9 ⁵/₈ in 200 x 245 mm
description Magazine design.
art director Amelia Gregory
country of origin UK

this page, below left
Issue 6 glow-in-the-dark cover.
illustrator Jim Stoten

this page, below right
Issue 2 laser-cut cover.
illustrator Rob Ryan

facing page, top row
Issue I and Issue 6 covers using found images.
facing page, bottom left
Issue 4 scratch'n'sniff cover.
illustrator Amelia Gregory

facing page, bottom right
Issue 5 cover.
photographer Bruce Gregory

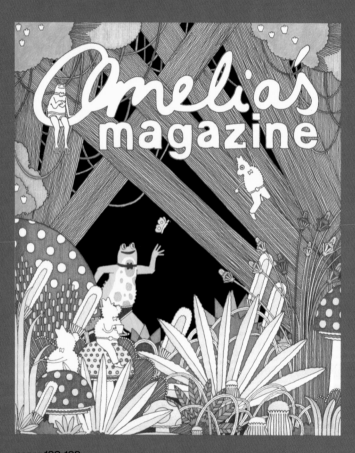

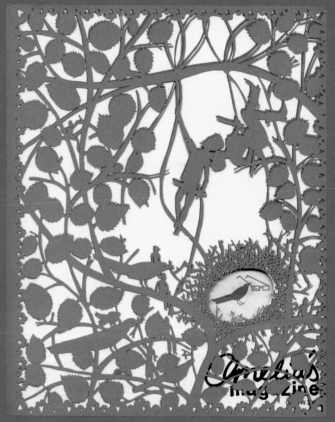

pages 182-183
Illustrations from Issue 5, "Flow Your Own Way"
advertorial for Drench Water
illustrators
page 182 Josephine Engstrom (top), Mike Perry (bottom)
page 183 onesidezero (top), Eugenia Tsimiklis (bottom)

pages 184-185
Pages from Issue 6 of Amelia's Magazine.
illustrators and photographers
page 184 found image (Contents)
Hannah Barton ("Enchanted Forest" themed illustration)
page 185 Annie Collinge ("I Love to Ride My Bicycle")
Amelia Gregory ("New China")

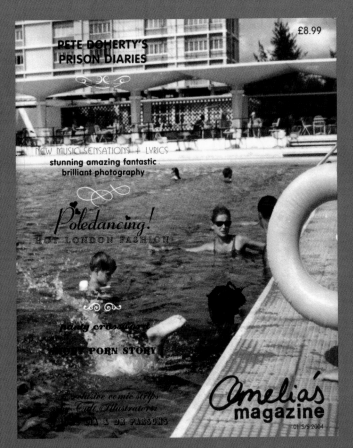

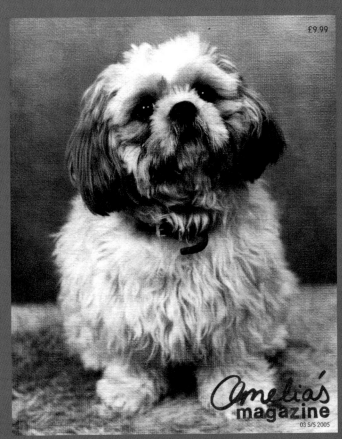

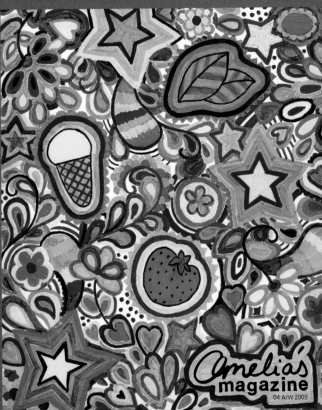

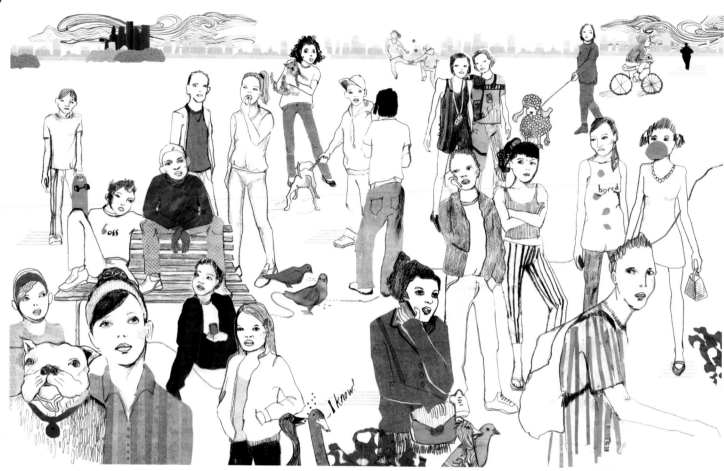

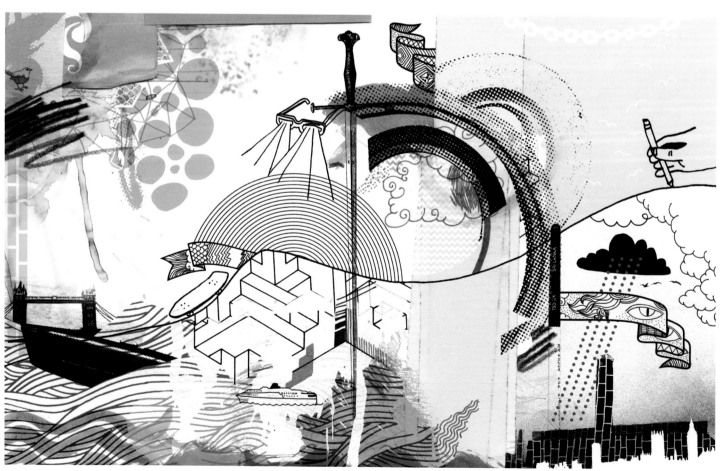

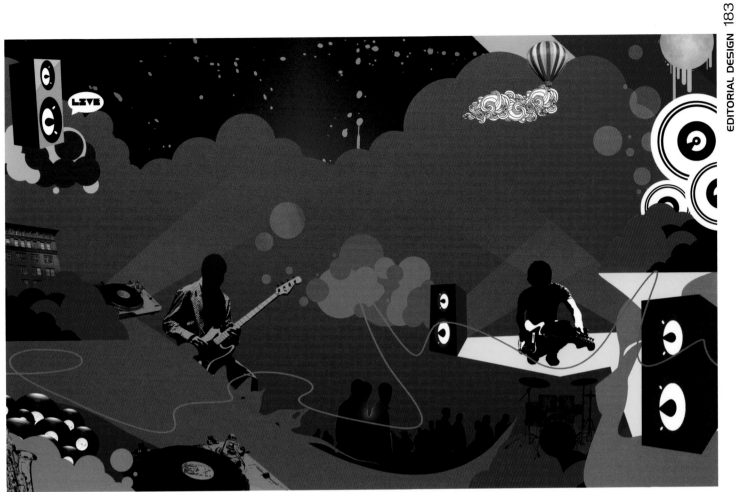

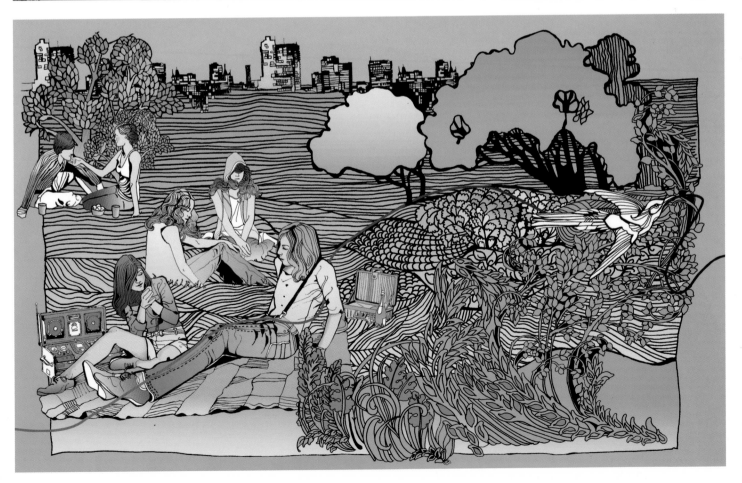

CONTENTS

"Amelia's Magazine" is a biannual creative magazine featuring the best in upcoming art, music, fashion, illustration, and photography. Special covers have taken advantage of laser-cutting, glow-in-the-dark and scratch'n'sniff printing techniques, to name just a few. With a focus on the personal, it is lovingly edited and designed by Amelia from her house in London.

AMELIA'S MAGAZINE

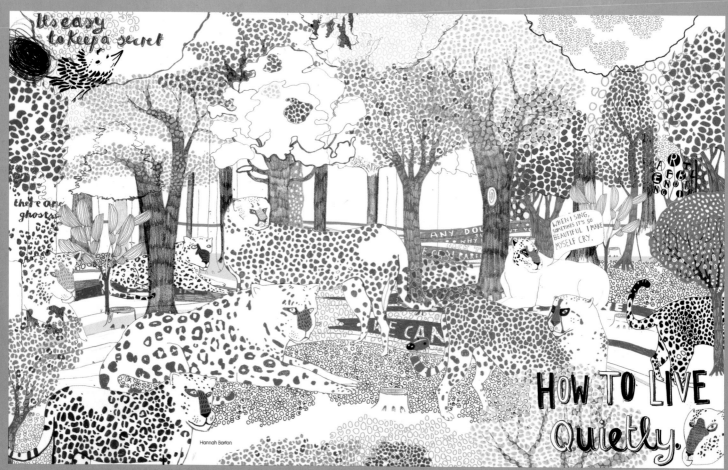

Hannah Barton

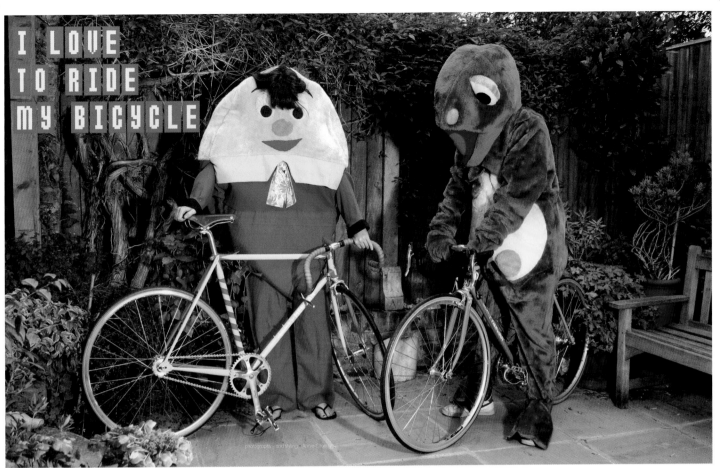

I LOVE
TO RIDE
MY BICYCLE

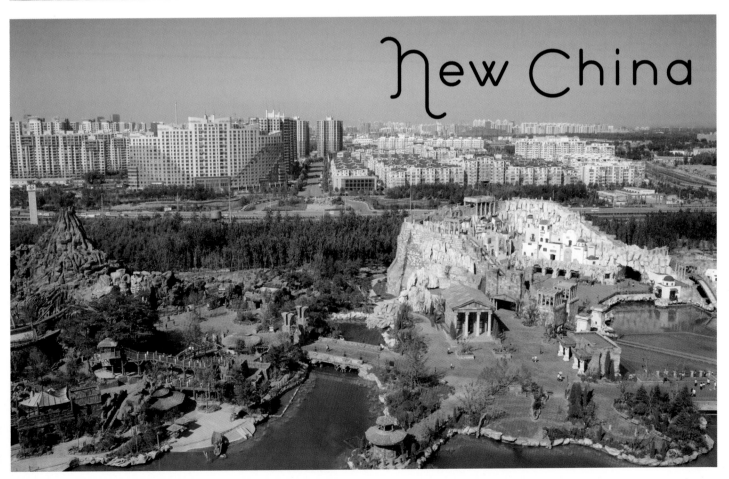

New China

Ampersand magazine

description Design for D & AD (British Design & Advertising) members' magazine, Ampersand. D & AD is an educational charity established to set creative standards, educate, inspire, and promote good design and advertising. The magazine's content includes news and views, industry-related features and profiles celebrating the world's most inspiring creatives.

designers Vince Frost, Anthony Donovan, Ben Backhouse

art director Vince Frost

design company Frost Design

country of origin Australia

this page and pages 198–199
Volume 2, Issue 2
Global Issue: France
February 2007

pages 188–189
Volume 1, Issue 1
March 2006

pages 190–191
Volume 1, Issue 2
May 2006

pages 192–193
Volume 1, Issue 3
June 2006

pages 194–195
Volume 1, Issue 4
October 2006

pages 196–197
Volume 2, Issue 1
Global Issue: China
December 2006

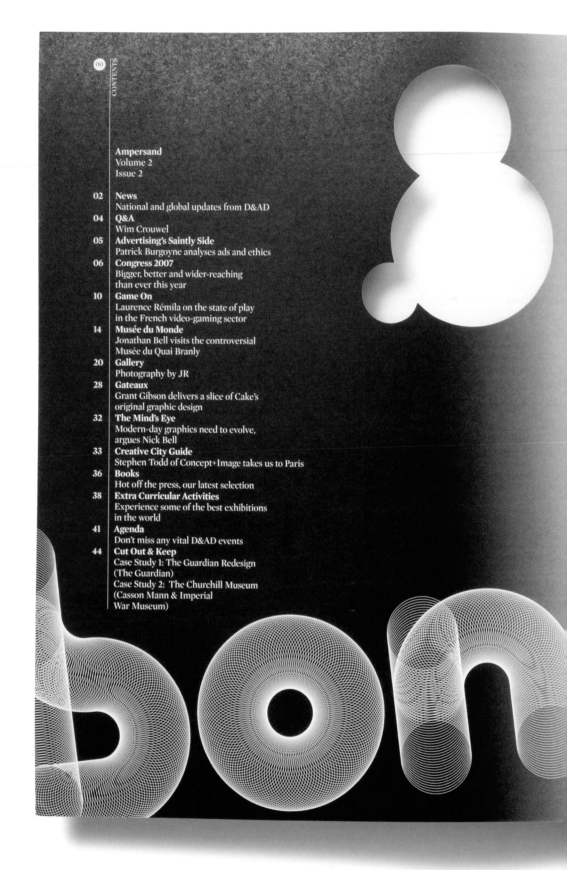

CONTENTS

00

Ampersand
Volume 2
Issue 2

The Global Issues 2. France

Editor
Lakshmi Bhaskaran
lakshmi@dandad.co.uk

Sub Editor
Hester Lacey

Design & Art Direction
Vince Frost,
Anthony Donovan &
Ben Backhouse
Frost Design, Sydney
www.frostdesign.com.au

Advertising
Katherine Howells
katherine@dandad.co.uk

'&', D&AD
9 Graphite Square,
Vauxhall Walk
London SE11 5EE
T: +44 (0)20 7840 1111
E: ampersand@dandad.co.uk
W: www.dandad.co.uk

Printed by Beacon Press
using *pureprint*
environmental print
technology

'&' is printed on
100% Recycled Paper

©D&AD 2006

Cover Image
J.R.

Contributors
Jonathan Bell
Nick Bell
Patrick Burgoyne
Grant Gibson
J.R.
Laurence Rémila
Stephen Todd
Rachel Wood

In this edition, we head across the channel to France, to bring you the second of our Global issues. Laurence Rémila looks at the future of France's gaming industry (p10), Jonathan Bell takes us on a tour of Jean Nouvel's controversial Musée du Quai Branly (p14) and Grant Gibson gets graphic with Cake Design (p28). We are also delighted to introduce the brilliant, if 'almost always illegal' talent of French street artist and photographer, JR (p20) in the Gallery. ● With its wealth of architecture and design, Paris has always been a playground for the creative set – and in recent years the French capital has attracted a number of established designers to settle in what is fast becoming Europe's leading design destination. Stephen Todd takes us on a guided tour of his adopted city (p33). ● Elsewhere, Patrick Burgoyne uncovers advertising's saintly side (p05), Wim Crouwel gets Q&A'd in advance of his forthcoming President's Lecture (p04) and with Congress 2007 just around the corner, we bring you the latest news about this year's not-to-be-missed event (p06).
Lakshmi Bhaskaran, Editor
If you've any thoughts or comments about this issue, do drop me a line at lakshmi@dandad.co.uk

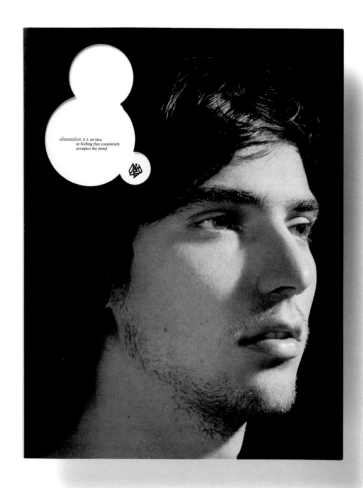

obsession n 1. an idea
or feeling that completely
occupies the mind

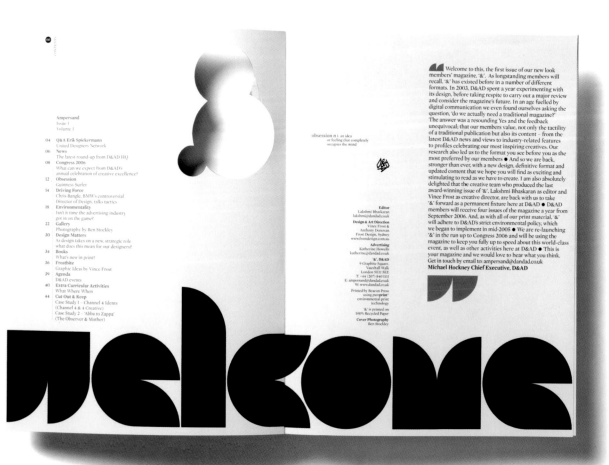

obsession n 1. an idea
or feeling that completely
occupies the mind

Editor
Lakshmi Bhaskaran
lakshmi@dandad.co.uk

Design & Art Direction
Vince Frost &
Anthony Donovan
Frost Design, Sydney
www.frostdesign.com.au

Advertising
Katherine Howells
katherine@dandad.co.uk

'&', D&AD
9 Graphite Square,
Vauxhall Walk,
London SE11 5EE
T: +44 (207) 840 1111
E: ampersand@dandad.co.uk
W: www.dandad.co.uk

Printed by Beacon Press
using **pureprint**
environmental print
technology

'&' is printed on
100% Recycled Paper

Cover Photography
Ben Stockley

❝ Welcome to this, the first issue of our new look members' magazine, '&'. As longstanding members will recall, '&' has existed before in a number of different formats. In 2003, D&AD spent a year experimenting with its design, before taking respite to carry out a major review and consider the magazine's future. In an age fuelled by digital communication we even found ourselves asking the question, 'do we actually need a traditional magazine?' The answer was a resounding Yes and the feedback unequivocal; that our members value, not only the tactility of a traditional publication but also its content – from the latest D&AD news and views to industry-related features to profiles celebrating our most inspiring creatives. Our research also led us to the format you see before you as the most preferred by our members ● And so we are back, stronger than ever, with a new design, definitive format and updated content that we hope you will find as exciting and stimulating to read as we have to create. I am also absolutely delighted that the creative team who produced the last award-winning issue of '&', Lakshmi Bhaskaran as editor and Vince Frost as creative director, are back with us to take '&' forward as a permanent fixture here at D&AD ● D&AD members will receive four issues of the magazine a year from September 2006. And, as with all of our print material, '&' will adhere to D&AD's strict environmental policy, which we began to implement in mid-2005 ● We are re-launching '&' in the run up to Congress 2006 and will be using the magazine to keep you fully up to speed about this world-class event, as well as other activities here at D&AD ● This is your magazine and we would love to hear what you think. Get in touch by email to ampersand@dandad.co.uk
Michael Hockney Chief Executive, D&AD ❞

welcome

Perhaps the best-known car designer of his generation, Chris Bangle is known as much for his divisive designs as his visionary approach. Jonathan Bell takes time out to meet BMW's controversial Director of Design.

Christopher E. Bangle is in an animated mood. Ensconced with tea and biscuits in the cosy Georgian sitting room of Hazlitt's Hotel in Soho, BMW's Director of Design is enthusing about work in progress at the company's Designworks/USA outpost in California. The designer is en-route from the US to his Munich office, temporarily swapping BMW's sleek 1970s HQ for Hazlitt's squishy sofas before he faces tonight's D&AD-invited audience. Bangle is one of the best-known car designers of his generation, despite the fact that his current role involves very little hands-on design work. His is also a peculiar type of fame, the kind that arises off the back of controversy. His name evokes fierce emotions amongst car enthusiasts; to listen to his detractors you'd think he was responsible for heinous crimes against good taste. Typically, he is accused of turning BMW from a sober purveyor of Teutonic excellence into a brash, attention-seeking brand that's aesthetically all at sea.

> **To listen to his detractors you'd think he was responsible for heinous crimes against good taste**

Born in 1956, Christopher Edward Bangle began his higher education with a Liberal Arts degree at the University of Wisconsin, and had a vague idea of becoming a Methodist preacher. By 1977 he was enrolled at Pasadena's celebrated Art Centre College of Design, and graduated just as the automobile industry was bottoming out at the end of an economically tough decade. Toying with Hollywood as a career, he instead joined GM, travelling to Germany for four years at Opel. This was followed by seven years at Fiat's Centro Stile, where he eventually became Director. From there, he joined BMW in 1992 as Head of Design Development. His current role is that of design steward, steering BMW and its sub-brands and ensuring the company's long-term design strategy is coherent. As someone who rarely wields a pen, pushes a mouse or sculpts clay, he admits it's been a long time since he was personally responsible for 'every single line' on an automobile. That car was Fiat's elegant little coupé of 1994, which arose from Bangle's stint as head of the company's internal design team, a frustrating period during which he went head to head with all the iconic Italian design houses and usually lost. That the Fiat was

New environmental brands have been causing a quiet revolution over the past five years. Now it's time the advertising industry got in on the game, says Liz Hancock.

Cool, green companies such as Smile, Ecover, Green & Blacks, Innocent Drinks, American Apparel and Clipper Teas have improved the image of environmentalism beyond belief, becoming household names in the process. But this transformation doesn't stop with the brands themselves. As the first crop of new, green companies turn into big-business brands, their impact is not only spreading wider, it is influencing the corporate practices of their suppliers. This is more prevalent than ever in the advertising industry, where clients increasingly require an agency's commitment to environmental policy to go hand-in-hand with its creative output.

Late last year, Innocent Drinks announced the appointment of Lowe London as its advertising agency ahead of a £7m campaign, partly due to the agency's pledge to implement environmental change. "The decision to appoint Lowe London was a combination of creativity and values," says Innocent's Head of Communications, Charlotte Rawlins, who was responsible for appointing Lowe. "First and foremost what drove our decision was finding an agency that would help us continue to develop amazing relationships with potential and existing Innocent drinkers. But we were also really pleased with Lowe's commitment to making their business more sustainable." That Lowe's willingness to become more environmentally friendly makes them more attractive to brands like Innocent

> **Agencies that ignore the drive towards sustainability will eventually find themselves missing out**

emphasises a shift towards a new business climate that expects ethics along with its bottom line. "We try to lead by example and use the things that we have learnt to help educate and encourage other businesses to act more responsibly," comments Rawlins. "We want our suppliers to think about the long term consequences of their actions because it is important to us to work with people who share our values." From Lowe's point of

In a nutshell, Ampersand
magazine is obsessed by ideas.
The Ampersand name came
about for a number of reasons.
First, it was at the heart of
the D&AD logo. Secondly, it
expressed connection—the
glue that could hold an infinite
diversity of content together.
Lastly, within a masthead, the
ampersand could portray the
home of all great ideas—the
thought bubble.

 Printed on 100% recycled
paper and using vegetable inks,
Ampersand lives up to D&AD's
goal of environmental best
practice.

FROST DESIGN

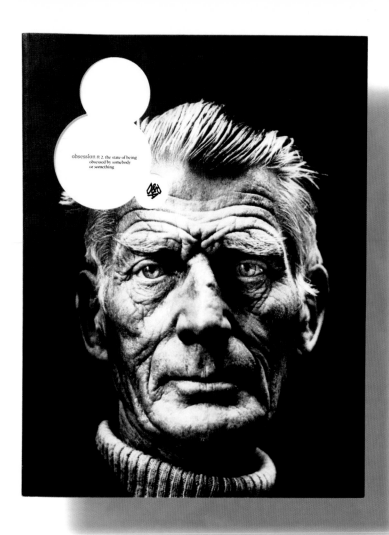

obsession *n* 2. the state of being
obsessed by somebody
or something

If you had to describe *i-D* magazine in three words, what would they be? Individual, independent, indescribable, idiotic, idiosyncratic, ideal. What impact do you think the magazine has had on contemporary culture? It's hard to quantify, because of the ideas, numerous contributors and personalities that began their careers at *i-D* and have now become recognised, or now contribute to mainstream contemporary culture, along with people behind the scenes who look to *i-D* for inspiration and food for their brains. What do you think is lacking in magazines and magazine design today? I don't study other magazines and I don't consider myself an authority on what's actually happening. I'm a random reader and don't spend much time analysing what other people do. As an art director and editor in chief, what do you look for in potential contributors? A hunger for knowledge, a skill that comes from a personal passion and a commitment to go that extra mile and to do what's right for the magazine. What has been your favourite issue or *i-D* moment to date? I still find it difficult to choose a single cover or issue that represents a favourite for a year, but I do have favourite issues: one, two, three, 50, 100, the fifteenth birthday issues – in fact, every birthday issue. The Fast Forward issue, the New Day issue, the New Dawn issue, the Elevator issue, the 250th issue, the Rebel issue, the Mia cover issue: the list can go on and on ... Twenty-six years on, what is the magazine's lasting appeal? Re-invention is more an organic process with *i-D*. Design has always been part of the magazine's identity. Type and technique in image manipulation is part of our history. Design evolution progressed with computers, scanners and digital downloads. As photographers and fashion stylists started their careers with *i-D*, their input into the mix of the magazine was a big part of the visual communication and style. As an art director I treat each issue like a movie, with themes that give focus to each edition. This is part of our original identity and has now been copied by many different international titles. The themes throughout 2005 related to identity and, like the visa or passport, all twelve issues can be bound into a single year's worth of ideas. If you hadn't started *i-D* what would you be doing now? Gardening in Wales or daydreaming in LA. What is your favourite thing about London? My home, which is a 10-minute drive from Hampstead Heath and the range of things that you can do there – if you ever have the time. What can we expect in your forthcoming President's Lecture? A retrospective ramble around the endeavour of catching the moment in most of my projects to date and the concept of chasing deadlines and planes.

Terry Jones, founder and editor in chief, *i-D* magazine
18 May, 1900 Logan Hall, Bedford Way, London WC1H 0AL
Tickets: D&AD members £10, non-members £15, students £5. For bookings contact:
+44 (0)20 7840 1127, lectures@dandad.co.uk www.dandad.org/shop/presidents-lectures
Sponsored by Framestore CFC

Q&A Terry Jones
i-D magazine

I have
just finished the design of
a catalogue for a forthcoming exhibition
at Tate Modern of the work of two polymaths from
the Bauhaus: Laszlo Moholy-Nagy and Josef Albers. The
catalogue is hefty with their designs for adverts, glass paintings,
books, chairs, exhibitions, logos, films and colour studies. And I thought:
"Why don't they make them like that any more?" The era is past of such
giants of the visual imagination, of creative minds that can flit between
disciplines without inhibition. The argument is that the creative world is so much
more complicated today than it was in the twenties. It is harder to join one area to
another. It takes so long now to master the intricacies of graphic design that it is well-nigh
impossible to then move into exhibition design or film. If this is true, then we are all destined
to remain pygmies. Or perhaps not all of us ... It's hard to describe Massimo and Lella Vignelli.
He is essentially a graphic designer and she an interior designer, but by enhancing their powers
in a personal and professional pairing, the Vignellis have spent a 50-year career designing almost
everything there is to design. The exact nature of their partnership is hard to fathom. You can't
really tell who designs what, and they won't say. Which is surely part of the point: we have all worked
in creative teams where the origin of an idea is shared. By joining their names, the Vignellis show
that, even before a project has begun, they are a team. You can fly to New York in a plane with a
Vignelli-designed livery, rattle through New York's subway system looking at Vignelli signs, pray in
Saint Peter's Church on Lexington Avenue on Vignelli pews, stride about in Vignelli suits, carrying
Bloomingdale's bags by Vignelli. And then you could go home, pull up a Vignelli-designed
handkerchief chair to a Vignelli table, eat dinner off Vignelli plates and pour wine from Vignelli
bottles, a sparkling Vignelli ring on your finger, as you thumb through a Vignelli book in a Vignelli
typeface. There are also Vignelli trains, factories, newspapers and candles. All this is achieved
with just three or four typefaces, a very limited colour palette and a passion for elementary
geometry. And the remarkable thing is that these fonts, colours and shapes are readily
available to all of us. While most designers struggle to develop never-seen-before jiggery-
pokery for "personal expression", the Vignellis prove that it is a simple approach and
focus that make design great. (This use of simple means is a sure way to identify the
really great, from Achille Castiglione and his flowerpot lamps to Josef Müller-
Brockmann and his single typeface.) The Vignellis care about the quality of
design discourse, education and ethics. Massimo edited and designed
Zero, a magazine exploring design issues, some decades before
anything else similar appeared. In part it is the undeniable
dignity and durability of their work that has made
them influential, but Massimo in
particular has always been
vocal
about what makes good design. He fought a
very noble campaign (and was called all sorts of
dreadful names) in the pages of design magazines
during the nineties. It is clearer now, with a
little distance, to see whose argument had more
weight. While advocates of trendy typography,
busy designing a self-funded leaflet or maybe
a poster that would never be printed, poured
scorn on Massimo's apparent rigidity, he
was designing the identity and literature
system for the cutting-edge Guggenheim
Museum. An American critic wrote:
"In many ways, the Vignellis are
considered to have given graphic
design its stature in
contemporary society."
A giant claim for two
old-style, modern
giants.

The World According
to Massimo and Lella
**Quentin Newark salutes
the Vignellis and their rare
and extraordinary versatility**

Design Is One: Massimo and Lella Vignelli, hosted by Mike Dempsey, CDT Design
04 May, 19:00 Old Billingsgate, 16 Lower Thames Street, London EC3
Tickets: D&AD members £10, non-members £15, students £5.
For bookings contact: +44 (0)20 7840 1127, lectures@dandad.co.uk
www.dandad.org/shop/presidents-lectures
Sponsored by Framestore CFC

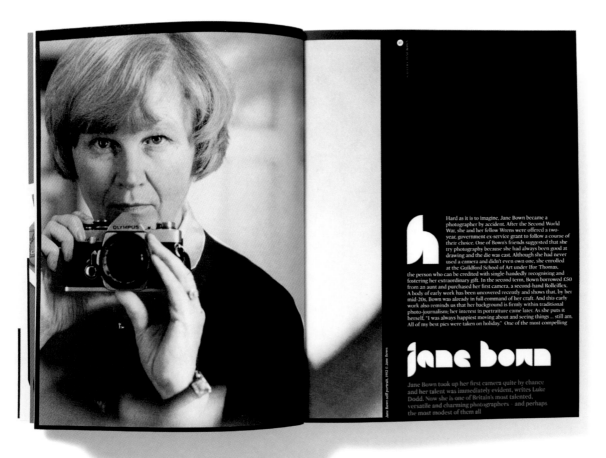

Hard as it is to imagine, Jane Bown became a photographer by accident. After the Second World War, she and her fellow Wrens were offered a two-year, government ex-service grant to follow a course of their choice. One of Bown's friends suggested that she try photography because she had always been good at drawing and the die was cast. Although she had never used a camera and didn't even own one, she enrolled at the Guildford School of Art under Ifor Thomas, the person who can be credited with single-handedly recognising and fostering her extraordinary gift. In the second term, Bown borrowed £50 from an aunt and purchased her first camera, a second-hand Rolleiflex. A body of early work has been uncovered recently and shows that, by her mid-20s, Bown was already in full command of her craft. And this early work also reminds us that her background is firmly within traditional photo-journalism; her interest in portraiture came later. As she puts it herself, "I was always happiest moving about and seeing things ... still am. All of my best pics were taken on holiday." One of the most compelling

jane bown

Jane Bown took up her first camera quite by chance and her talent was immediately evident, writes Luke Dodd. Now she is one of Britain's most talented, versatile and charming photographers – and perhaps the most modest of them all

Jane Bown self portrait, 1952 © Jane Bown

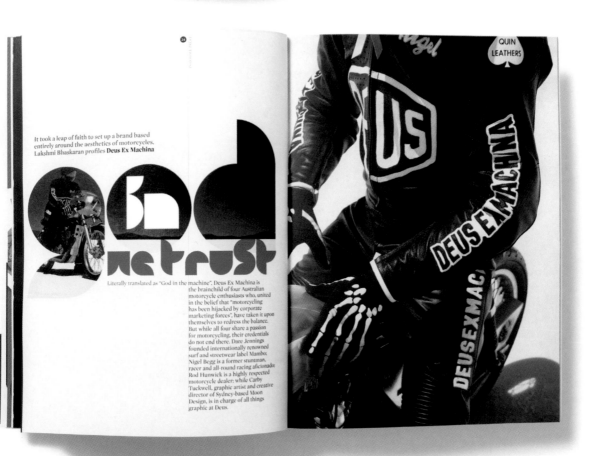

It took a leap of faith to set up a brand based entirely around the aesthetics of motorcycles. Lakshmi Bhaskaran profiles **Deus Ex Machina**

God we trust

Literally translated as "God in the machine", Deus Ex Machina is the brainchild of four Australian motorcycle enthusiasts who, united in the belief that "motorcycling has been hijacked by corporate marketing forces", have taken it upon themselves to redress the balance. But while all four share a passion for motorcycling, their credentials do not end there. Dare Jennings founded internationally renowned surf and streetwear label Mambo; Nigel Begg is a former stuntman, racer and all-round racing aficionado; Rod Hunwick is a highly respected motorcycle dealer; while Carby Tuckwell, graphic artist and creative director of Sydney-based Moon Design, is in charge of all things graphic at Deus.

obsession *n* 3. the uncontrollable persistence of an idea or emotion in the mind, sometimes associated with psychiatric disorder

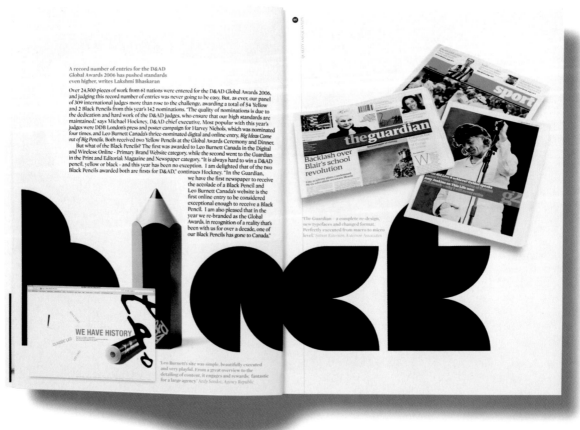

A record number of entries for the D&AD Global Awards 2006 has pushed standards even higher, writes Lakshmi Bhaskaran

Over 24,500 pieces of work from 61 nations were entered for the D&AD Global Awards 2006, and judging this record number of entries was never going to be easy. But, as ever, our panel of 309 international judges more than rose to the challenge, awarding a total of 54 Yellow and 2 Black Pencils from this year's 142 nominations. 'The quality of nominations is due to the dedication and hard work of the D&AD judges, who ensure that our high standards are maintained,' says Michael Hockney, D&AD chief executive. Most popular with this year's judges were DDB London's press and poster campaign for Harvey Nichols, which was nominated four times, and Leo Burnett Canada's thrice-nominated digital and online entry, *Big Ideas Come out of Big Pencils*. Both received two Yellow Pencils at the Global Awards Ceremony and Dinner.

But what of the Black Pencils? The first was awarded to Leo Burnett Canada in the Digital and Wireless Online - Primary Brand Website category, while the second went to the Guardian in the Print and Editorial: Magazine and Newspaper category. 'It is always hard to win a D&AD pencil, yellow or black - and this year has been no exception. I am delighted that of the two Black Pencils awarded both are firsts for D&AD,' continues Hockney. "In the Guardian, we have the first newspaper to receive the accolade of a Black Pencil and Leo Burnett Canada's website is the first online entry to be considered exceptional enough to receive a Black Pencil. I am also pleased that in the year we re-branded as the Global Awards, in recognition of a reality that's been with us for over a decade, one of our Black Pencils has gone to Canada."

'Leo Burnett's site was simple, beautifully executed and very playful. From a great overview to the detailing of content, it engages and rewards: fantastic for a large agency.' *Andy Sandoz, Agency Republic*

'The Guardian - a complete re-design, new typefaces and changed format. Perfectly executed from macro to micro level.' *Simon Esterson, Esterson Associates*

WE HAVE HISTORY

CLASSIC LED

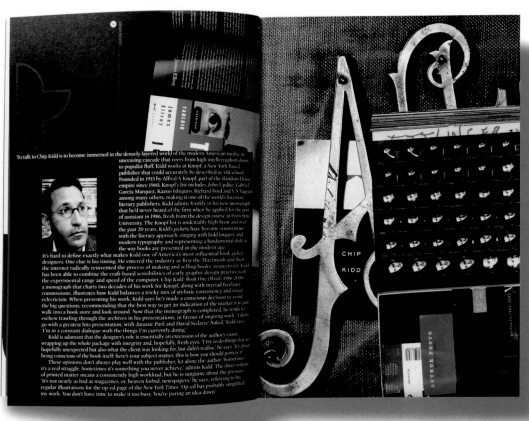

obsession *n* 3. the uncontrollable persistence of an idea or emotion in the mind, sometimes associated with psychiatric disorder

To talk to Chip Kidd is to become immersed in the densely-layered world of the modern American media, an unceasing cascade that veers from high intellectualism down to populist fluff. Kidd works at Knopf, a New York based publisher that could accurately be described as 'old school'. Founded in 1915 by Alfred A Knopf, part of the Random House empire since 1960, Knopf's list includes John Updike, Gabriel Garcia Marquez, Kazuo Ishiguro, Richard Ford and V S Naipaul among many others, making it one of the world's foremost literary publishers. Kidd admits frankly in his new monograph that he'd never heard of the firm when he applied for the post of assistant in 1986, fresh from the design course at Penn State University. The Knopf list is undeniably high brow and over the past 20 years, Kidd's jackets have become synonymous with the literary approach, zinging with bold imagery and modern typography and representing a fundamental shift in the way books are presented in the modern age.

It's hard to define exactly what makes Kidd one of America's most influential book jacket designers. One clue is his timing. He entered the industry as first the Macintosh and then the internet radically reinvented the process of making and selling books, respectively. Kidd has been able to combine the craft-based sensibilities of early graphic design practice with the experimental range and speed of the computer. *Chip Kidd: Book One (Work: 1986-2006)*, a monograph that charts two decades of his work for Knopf, along with myriad freelance commissions, illustrates how Kidd balances a tricky mix of stylistic consistency and visual eclecticism. When presenting his work, Kidd says he's made a conscious decision to avoid the big questions, recommending that the best way to get an indication of the market is to just walk into a book store and look around. Now that the monograph is completed, he tends to eschew trawling through the archives in his presentations, in favour of ongoing work. 'I don't go with a greatest hits presentation, with *Jurassic Park* and David Sedaris' *Naked*,' Kidd says. 'I'm in a constant dialogue with the things I'm currently doing.'

Kidd is adamant that the designer's role is essentially an extension of the author's vision, wrapping up the whole package with integrity and, hopefully, fresh eyes. 'I try to do things that are hopefully unexpected but also what the client was looking for, but didn't realise,' he says. 'It's about being conscious of the book itself: here's your subject matter, this is how you should portray it.'

These opinions don't always play well with the publisher, let alone the author. 'Sometimes it's a real struggle. Sometimes it's something you never achieve,' admits Kidd. The sheer volume of printed matter means a consistently high workload, but he is sanguine about the pressure. 'It's not nearly as bad as magazines, or, heaven forbid, newspapers,' he says, referring to his regular illustrations for the op-ed page of the *New York Times*. 'Op-ed has probably simplified my work. You don't have time to make it too busy. You're paring an idea down.'

obsession *n* 4. an irrational motive
for performing repetitive actions
against one's will

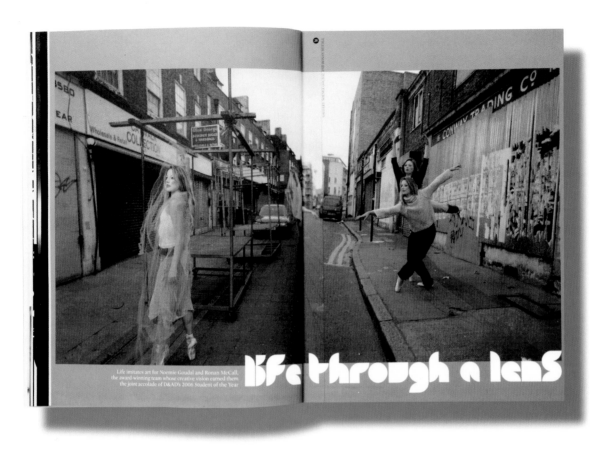

life through a lens

Life imitates art for Noemie Goudal and Ronan McCall, the award-winning team whose creative vision earned them the joint accolade of D&AD's 2006 Student of the Year

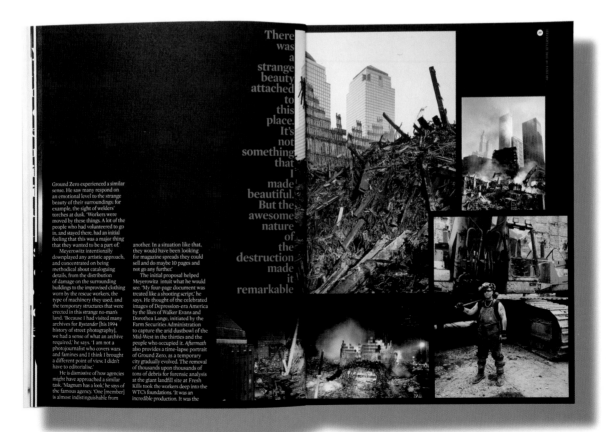

Ground Zero experienced a similar sense. He saw many respond on an emotional level to the strange beauty of their surroundings: for example, the sight of welders' torches at dusk. 'Workers were moved by these things. A lot of the people who had volunteered to go in, and stayed there, had an initial feeling that this was a major thing that they wanted to be a part of.'

Meyerowitz intentionally downplayed any artistic approach, and concentrated on being methodical about cataloguing details, from the distribution of damage on the surrounding buildings to the improvised clothing worn by the rescue workers, the type of machinery they used, and the temporary structures that were erected in this strange no-man's land. 'Because I had visited many archives for *Bystander* [his 1994 history of street photography], we had a sense of what an archive required,' he says. 'I am not a photojournalist who covers wars and famines and I think I brought a different point of view. I didn't have to editorialise.'

He is dismissive of how agencies might have approached a similar task. 'Magnum has a look,' he says of the famous agency. 'One [member] is almost indistinguishable from another. In a situation like that, they would have been looking for magazine spreads they could sell and do maybe 10 pages and not go any further.'

The initial proposal helped Meyerowitz intuit what he would see. 'My four-page document was treated like a shooting script,' he says. He thought of the celebrated images of Depression-era America by the likes of Walker Evans and Dorothea Lange, initiated by the Farm Securities Administration to capture the arid dustbowl of the Mid-West in the thirties and the people who occupied it. *Aftermath* also provides a time-lapse portrait of Ground Zero, as a temporary city gradually evolved. The removal of thousands upon thousands of tons of debris for forensic analysis at the giant landfill site at Fresh Kills took the workers deep into the WTC's foundations. 'It was the incredible production. It was the

There was a strange beauty attached to this place. It's not something that I made beautiful. But the awesome nature of the destruction made it remarkable

The Global Issues 1. China

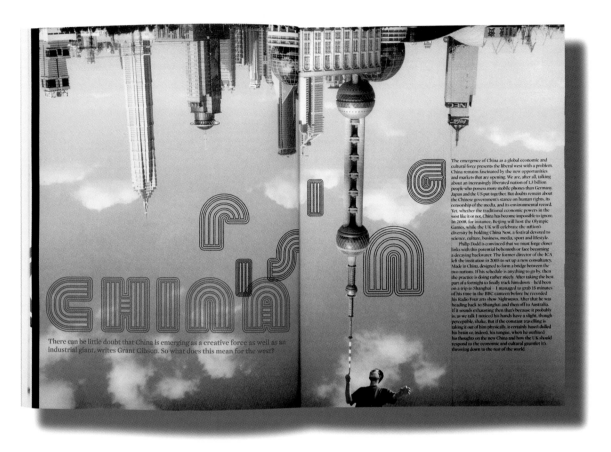

The emergence of China as a global economic and cultural force presents the liberal west with a problem. China remains fascinated by the new opportunities and markets that are opening. We are, after all, talking about an increasingly liberated nation of 1.3 billion people who possess more mobile phones than Germany, Japan and the US put together. But doubts remain about the Chinese government's stance on human rights, its censorship of the media, and its environmental record. Yet, whether the traditional economic powers in the west like it or not, China has become impossible to ignore. In 2008, for instance, Beijing will host the Olympic Games, while the UK will celebrate the nation's diversity by holding China Now, a festival devoted to science, culture, business, media, sport and lifestyle.

Philip Dodd is convinced that we must forge closer links with this potential behemoth or face becoming a decaying backwater. The former director of the ICA left the institution in 2005 to set up a new consultancy, Made in China, designed to form a bridge between the two nations. If his schedule is anything to go by, then the practice is doing rather nicely. After taking the best part of a fortnight to finally track him down – he'd been on a trip to Shanghai – I managed to grab 15 minutes of his time in the BBC canteen before he recorded his Radio Four arts show Nightwaves. After that he was heading back to Shanghai and then off to Australia. If it sounds exhausting then that's because it probably is; as we talk I noticed his hands have a slight, though perceptible, shake. But if the constant travelling is taking it out of him physically, it certainly hasn't dulled his brain or, indeed, his tongue, when he outlined his thoughts on the new China and how the UK should respond to the economic and cultural gauntlet it's throwing down to the rest of the world.

There can be little doubt that China is emerging as a creative force as well as an industrial giant, writes Grant Gibson. So what does this mean for the west?

December

Design
Ningbo International Poster Biennial @ Ningbo Museum of Art Until 10 December
Now in its fourth year, the Ningbo International Poster Biennial promotes high-level graphic design, propelling convergence and communication of international design, encouraging outstanding young designers, encouraging graphic designs with development trend and new expression, thus advancing professional levels of graphic design in China and promoting the development of Chinese education in graphic design. The Biennial is held in the beautiful port city of Ningbo, China, where the newly completed Ningbo Museum of Art will be the showplace for the exhibition.
Ningbo Museum of Art, 122 Renmin Rd, Ningbo, China
www.tgdb-ningbo.com

January

Art
Robert Rauschenberg: Combine (1953–1964) @ Centre Pompidou
Until 15 January
In 1964 Robert Rauschenberg won the prize for painting at the Venice Biennial, which had been dominated for years by the Paris School. American art, having finally shed its mantle of abstract expressionism, won the day, via an artist who is known for incorporating everyday objects into his work. Pieces of fabric or paper, ties, postcards, fragments of parachutes, copies of great masters, stuffed animals are all combined and jumbled with paint and canvas to create imposing and highly alternative works: the Combines.
Gallery 2, Centre Pompidou, Paris www.cnac-gp.fr

Photography
In the Face of History: European Photographers in the 20th Century @ Barbican
Until 28 January
From the First World War to the Cold War, from the sexual revolution to the Velvet Revolution, from communism to capitalism, In the Face of History brings together the work of many of the greatest photographers of this period, such as Eugène Atget, Josef Sudek and Brassaï, alongside contemporary artists such as Boris Mikhailov, Jitka Hanzlová and Wolfgang Tillmans. The exhibition also includes a number of photographers from the former Eastern bloc, with many works being shown in the UK for the first time.
Barbican Art Gallery, Barbican Centre, Silk Street, London EC2

Art
Candice Breitz: Working Class Hero (A Portrait of John Lennon) @ Baltic
Until 28 January
During a recent residency at Baltic, artist Candice Breitz invited a diverse community of dedicated John Lennon fans to pay tribute to their hero in a recording studio in Newcastle upon Tyne. The 40 selected fans were each given the opportunity to re-perform Lennon's first solo album Plastic Ono Band (1970), from beginning to end. The result is a 25-channel video installation, with a looping duration of 39 minutes and 55 seconds, matching the length of the original album. Working Class Hero synchronises 25 intimate portraits of the fans in a kaleidoscopic portrait of Lennon, on plasma screens staggered spirally around Baltic's seven-story-high public stairway.
www.balticmill.com
Baltic Centre for Contemporary Art, Gateshead Quays, South Shore Road, Gateshead NE8

Design
Alan Fletcher @ Design Museum
Until 18 February
London-born Alan Fletcher, one of the most inspiring designers of our time, defined modern graphic design in Britain by synthesising the graphic traditions of Europe and North America into his own spirited, witty and very personal style. This is the first retrospective of Fletcher's work. It celebrates the donation of his archive to the Design Museum Collection by exploring the wit and ingenuity of his commercial work for Reuters, Lloyds of London and the V&A, as well as the personal projects in lettering, collage and illustration with which he has entertained himself, and us, over the years. Read Quentin Newark's tribute to Alan Fletcher on page 06.
Design Museum, Shad Thames, London SE1 www.designmuseum.org
D&AD members can buy one ticket and get one free at Design Museum exhibitions.

February

Fashion
Sixties Fashion @ V&A
Until 25 February
The 1960s were a time of sweeping changes in society, politics and culture as fashion, together with pop music, became Britain's most spectacular export. Like music, fashion flouted the rules of propriety and gender. It plundered the past, invented the future and travelled the world to find new ways of dressing. This exhibition explores the development of Sixties fashion from the mid-1950s to the early 1970s, linking it to London's different fashion districts and celebrating the contribution made by young British designers to a world-wide fashion revolution.
Victoria and Albert Museum, Cromwell Road, London SW7
www.vam.ac.uk D&AD members receive half-price tickets at V&A exhibitions

Architecture
OMA in Beijing @ MoMA
Until 27 February
OMA in Beijing: China Central Television Headquarters by Ole Scheeren and Rem Koolhaas presents one of the most innovative architectural projects under construction today. Scheduled to open for the Beijing Olympics in 2008, the complex, which comprises three buildings and a media park on a site east of Beijing's Forbidden City, embodies a proposal for social and urban change that rethinks the tall building. This immersive installation explores the project's internal complexity and richness, its integration of public and private uses, and its structural innovation. These are interpreted via an array of graphics, renderings and explanatory texts as well as large-scale and small-scale models, many presented publicly here for the first time. A selection of architectural drawings from MoMA's collection will situate the project as one of the most visionary undertakings in the history of modern architecture.
Architecture & Design Galleries, MoMA, 11 West 53rd Street, New York www.moma.org

Extra Curricular Activities

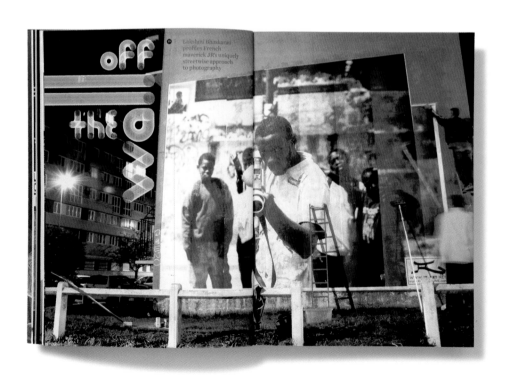

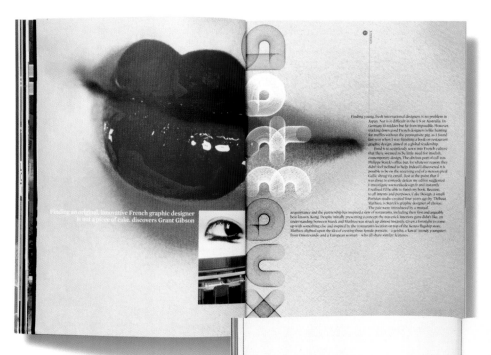

Finding an original, innovative French graphic designer is not a piece of cake, discovers Grant Gibson

Rachel Wood explains how the partnership between
D&AD and Royal Mail works for both sides
Reaching out with Royal Mail

France's once-thriving video game industry
has hit the doldrums, but there is hope on the
horizon, writes Laurence Rémila

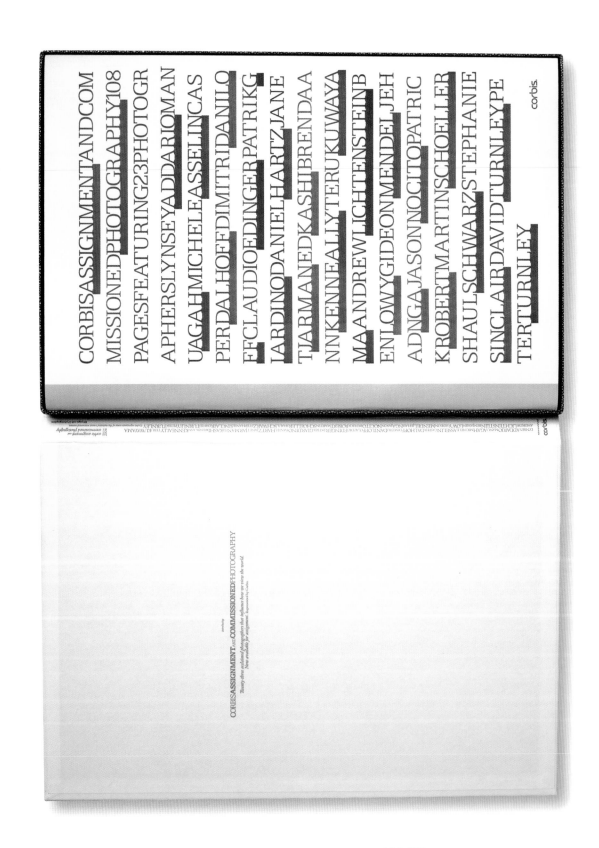

pages 200-207

Corbis Assignment and Commissioned Photography

dimensions 13 3/4 x 20 1/2 in 350 x 520 mm
art director Carlos Segura
design company Segura, Inc.
country of origin USA

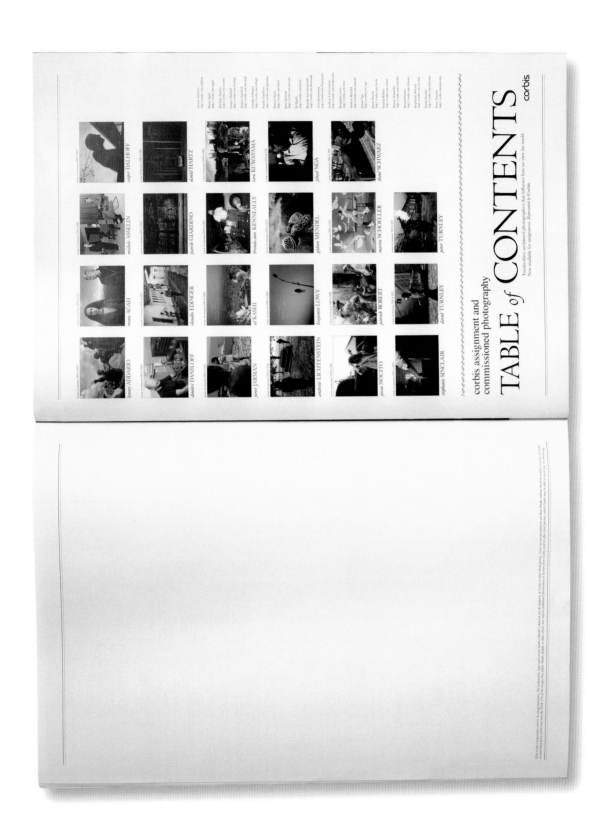

description Catalog announcing the "Corbis Assignment and Representation Services," showcasing the talents of editorial and commercial photographers, ordinarily only available as "stock," which can be booked for assignment work through Corbis. All exterior components of the catalog (O-ring, cover, case, carrier, box, and base) were letterpressed by Chicago's Rohner Letterpress. The box was handmade with special textured materials. The internal manually bound 112-page catalog was printed at Sioux Printing, using Stocastik printing with multiple image processes including 4-to 6-color, grayscale, halftones, duotones, and double blacks. The papers used include lustra dull cream 80# coated dull bk, mohawk 80# offset smt, utopia ivory 80# coated dull bk, and 80# utopia two text coated gloss bk.

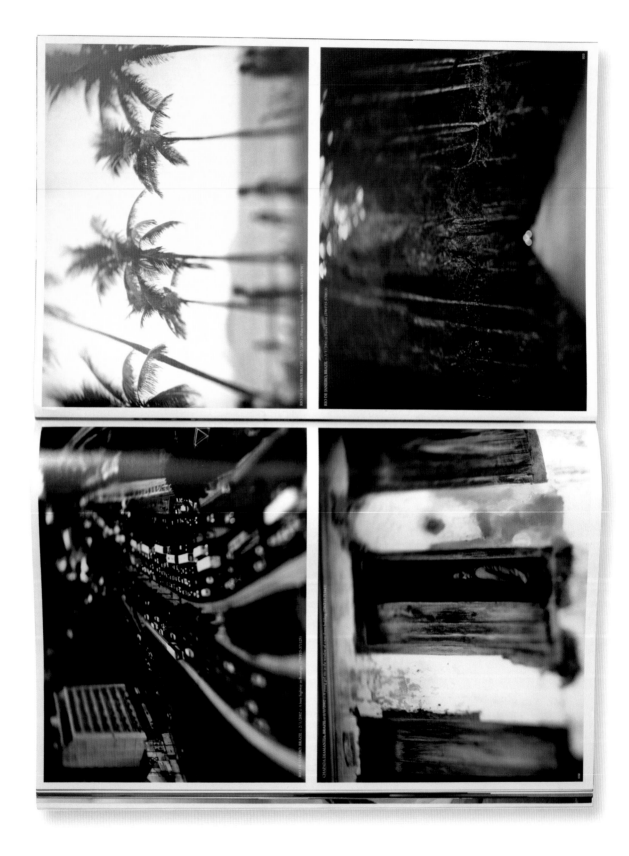

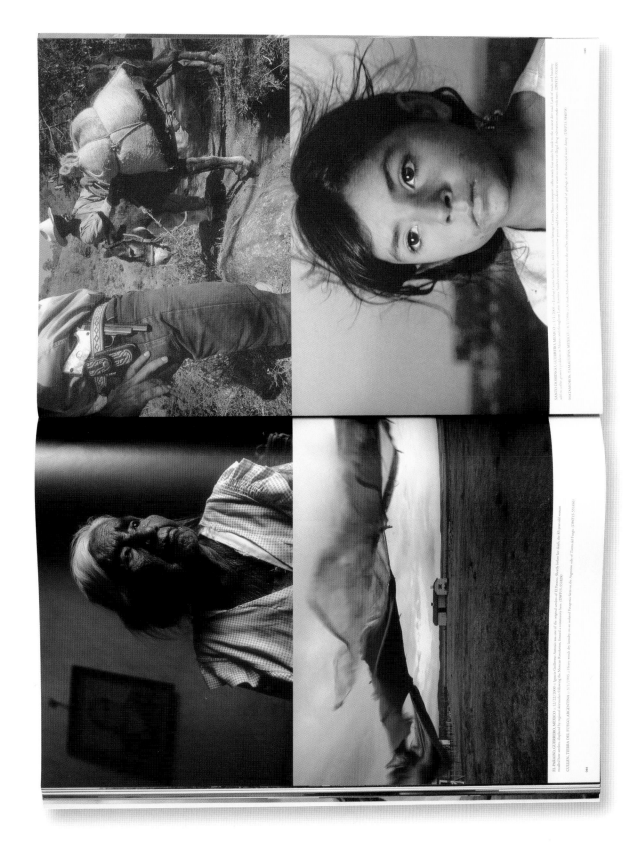

SANTO DOMINGO, GUERRERO, MEXICO • 11/3/2000 – Liliana Lares Mecino ("L," and her cousin Salvador) are Amuzgo Indians whose different tasks make fleeing the outside world. Lack of roads, and families will no codebe green's production in Mexico and throughout Latin America. Audio-harvesters make some trouble involved from town markets in contrast to residence in illegal drug substances to make with meat. [DW/TS-50A00]

MATAMOROS, TAMAULIPAS, MEXICO [8/11/2006 – Michelle Maxie] A duplication in the air has always over her another land at garbage in the twenty-five meter dump. [DW/TS-50A00]

EL PARAÍSO, GUERRERO, MEXICO • 12/22/2000 – Ignacio Guillermo Antonio was one of the original settlers of El Paraíso. Shortly before his death, the 80-year-old woman made a few smiles, displaced by regional depressions following the Mexican Revolution, formed a community here. [DW/TS-50A00]

CULLEN, TIERRA DEL FUEGO, ARGENTINA – 3/1/1995 – A heavy winds dry landscape on an isolated Patagonia farms on the Argentine side of Tierra del Fuego. [DW/TS-50A00]

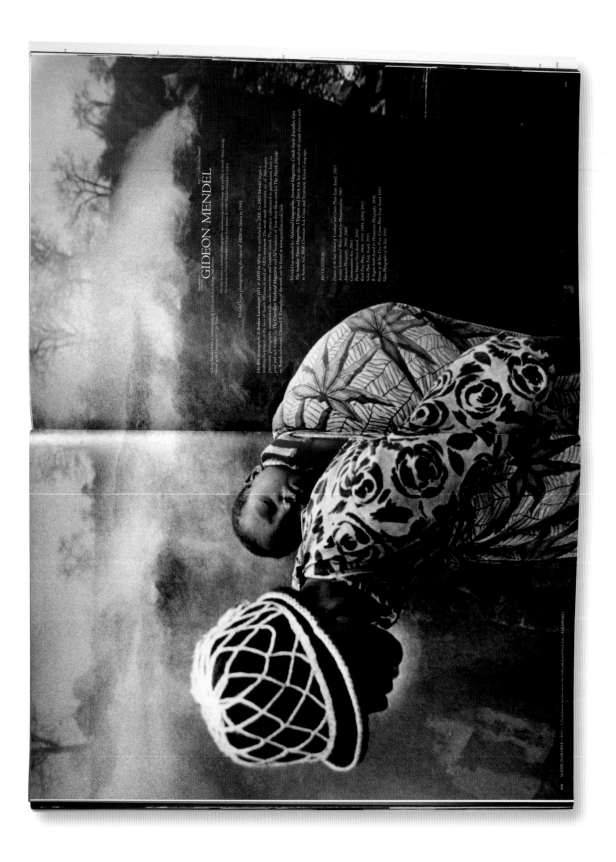

GIDEON MENDEL

Mendel began photographing the topic of AIDS in Africa in 1993.

His monograph *A Broken Landscape: HIV & AIDS in Africa* was published in 2001. In 2003 Mendel began a multimedia project on the lives of South Africans in need of AIDS treatment. The work, made to promote one of MSF's generic pneumonia photographic campaigns, contained stills, audio interviews and location sound. The project culminated in publication, both in print and web formats in *The Guardian Weekend Magazine* and the broadcast of four short films entitled *The Hands Divide* on British television Channel 4. Examples of the work can be found at www.guardian.co.uk/aids.

Mendel has worked for *National Geographic*, *Fortune Magazine*, *Condé Nast Traveller*, *Geo*, *The Sunday Times Magazine*, *L'Express* and *Stern*. He has also worked with many charities such as Amnesty International, MSF, Christian Aid, Crisis and Treatment Action Campaign.

RECOGNITION

Pictures of the Year Award of Excellence and Canon Photo Essay Award, 2003
Amnesty International Media Award — Photojournalism, 2003
Jamestown Photography, 2004, 2002
Communication Arts, 2002
Best Feature Story Award, 2002
World Press Photo, 2000, 1999, 1998, 1994, 1992
Nikon Photo Essay Award, 1995
W Eugene Smith Award for Humanistic Photography, 1996
Picture of the Year First Prize, Canon Photo Essay Award 1995
Nikon Photographer of the Year, 1993

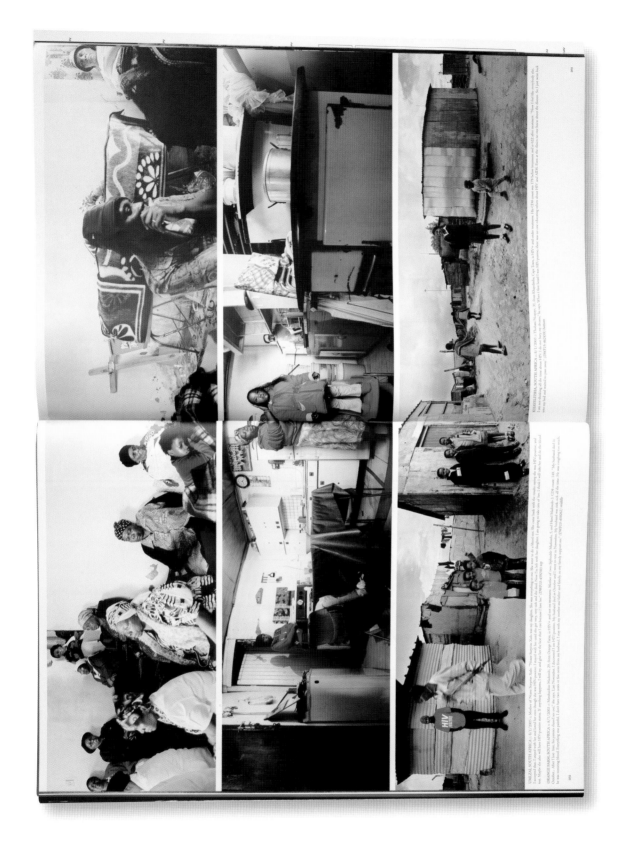

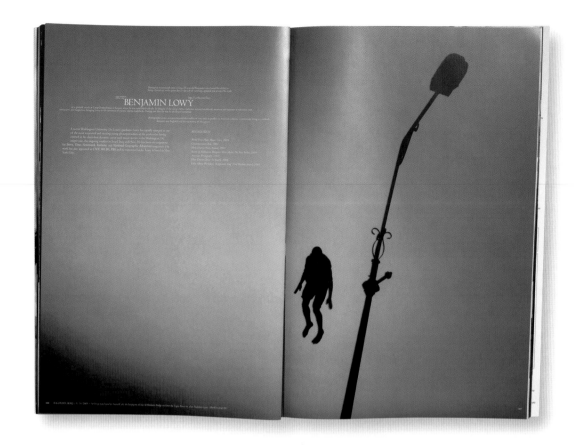

BENJAMIN LOWY

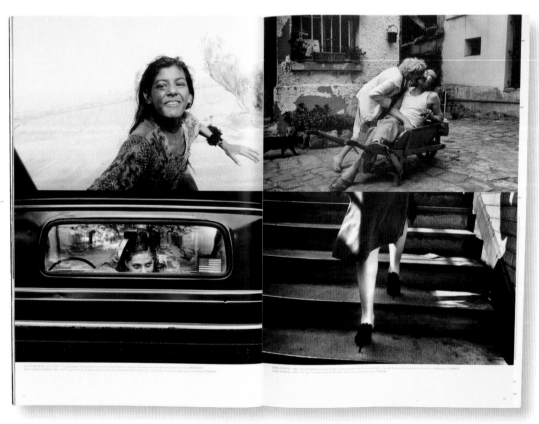

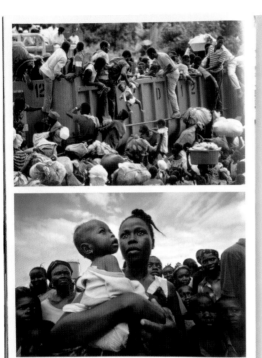

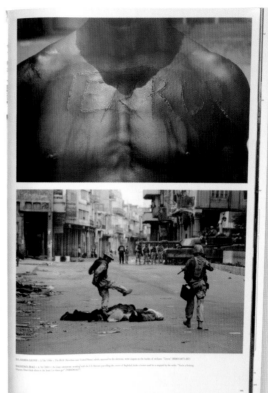

MONROVIA, LIBERIA

MONROVIA, LIBERIA

FREETOWN, SIERRA LEONE

BAGHDAD, IRAQ

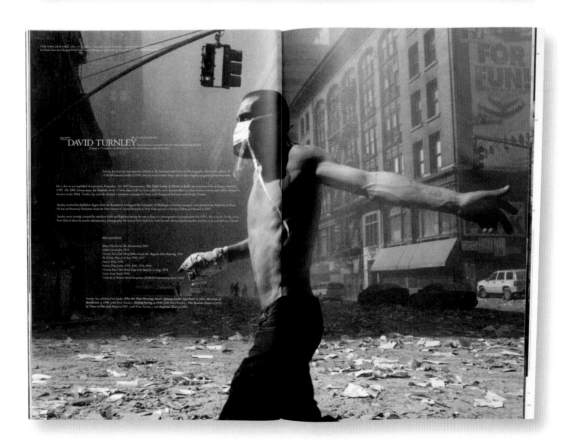

NEW YORK, NEW YORK, USA

DAVID TURNLEY

RECOGNITION

Miami Film Festival, Best Documentary, 2002
Golden Core finalist, 1995
Overseas Press Club Olivier Rebbot Award, Best Magazine Photo Reporting, 1996
World Press Photo of the Year, 1990, 1987
Pulitzer Prize, 1990
Pulitzer Prize finalist, 1995, 1991, 1988, 1986
Overseas Press Club's Robert Capa Gold Medal for Courage, 1988
Canon Essay Award, 1996
University of Missouri Special Recognition-The World Understanding Award, 1988

Ⓒ Rachael Thomas

The Venice Biennale
2001
Plateau of Humankind

30

*Pryd maer Ddraig
yn codi... When the
dragon wakes*

The 2001 *Venice Biennale* was marked by a substantial expansion of countries and artists in attendance. The scale and magnetism of the event challenged readings of it as being a "charming anachronism"[1] or merely a "trade fair"[1]. In reality it became a succession of exhibitions, interventions and manifestations that contributed to an ever-changing dynamic of displays, propositions, opportunities and exposures.

Six months prior I realised that my own country, Wales, did not even have its own pavilion, nor a system of funds to set up an intervention. I felt this was the moment to take action, and with guerilla tactics of pushing forward for support, and with no funds to speak of, I approached the Welsh artist Cerith Wyn Evans to see if we could set up the first-ever intervention at the *Venice Biennale* and actually interrogate government and Arts Council of Wales policy towards establishing an independent Welsh Pavilion. Wyn Evans graduated from the Royal College of Art in 1984 and began his career as a video and film-maker working as assistant to Derek Jarman. In the early 1990s Wyn Evans started making sculptures and installations. His work deals with the phenomenology of time, language and perception and employs a variety of media including firework texts, horticulture, film, photography and sculpture. He has exhibited extensively in Europe and America, including the Hayward Gallery, London (1995) and the British School in Rome (1998), while other solo exhibitions have included Deitch Projects in New York (1997), Tate Britain (2000) and the touring exhibition *The British Art Show* (2000).

The challenge was duly accepted by Wyn Evans, and support was offered from the British Pavilion, *The Art Newspaper*, white cube and the editor of *Art in America*. Wyn Evans and I then had to come up with a concept. We decided the work would take on a political aspect. The work was entitled *'Pryd maer Ddraig yn codi.. (When the dragon wakes)'*.

Acknowledging the conceptual tradition of Marcel Broodthaers and Dan Graham on the discursive nature of art, the project *Pryd Ddraig yn codi* was inserted in *The Art newspaper*. It replicated in translation an entire page from a previous issue. Wyn Evans questioned the use of language – what is lost and gained by the act of translation, how it informs and transforms meaning. This appropriation of the original article ('When the dragon wakes') re-inscribes national boundaries divided by identity and history. The article reports on the insecurities facing the West's leading auction houses as China enters the World Trade Organisation and the financial and ideological threat this poses to them. The intervention seeks to expose how the language of symbols determines cultural identity and how they proscribe multiple interpretations. The symbol of the dragon is significant in

the text as both China and Wales have a rich and very different legacy associated with this emotive, mythological creature. The Welsh word for dragon is 'draig' in the sense of 'warrior' or 'leader'; the dragon is seen as a symbol of national independence. From ancient times, it was the Chinese emblem of the Imperial family and represented a beneficent creature. Until the founding of the republic in 1911, it adorned the national flag. In Wales, the symbol represents spiritual energy and is a bringer of good fortune.

The project exposed the seemingly arbitrary yet concrete relationship between two cultures. It also raised the issue of cultural capital through the references to global economies. The project was housed at the British Pavilion and distributed by *The Art newspaper*. After Venice I then had talks with members of the Arts Council who were working towards setting up a fixed site for the Welsh Pavilion. This has gone from success to success and it's great to see Welsh artists established as part of an international dialogue.

31

1 Charles Esche, Audio arts magazine, Vol 20, Issue 1 & 2, 2000.
2 Jon Thompson, International Round Table Conference, Venice Biennale, 2001.

Rachael Thomas is Head of Exhibitions at the Irish Museum of Modern Art.

Ⓒ Cherry Smyth

*Jaki Irvine:
A retrospective*

40

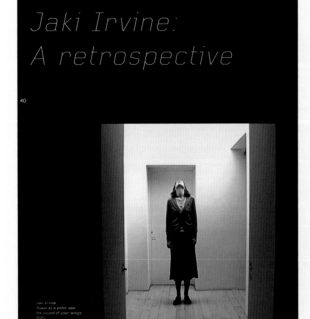

Jaki Irvine
*Towards a polar sea:
the sound of your wings*
2005.
DVD still
courtesy this artist

Polish poet Szymborska describes the gap between her empty inner world and the over-populated outer world with surprise: "My imagination is as it was... like a torch or a beam... it's still moved by singularity." Watching the impressive body of Jaki Irvine's short films gives you the sense that what she hasn't focused on, as she tries to distinguish the important from the unimportant, the extraordinary from the everyday, hovers at the edge of the frame, and is perhaps the unseen core of the film.

Having participated in two Venice Biennales and several landmark exhibitions, Irvine is celebrating four solo shows this year at Frith Street Gallery, London, the Irish Museum of Modern Art, Dublin, and the Henry Moore Institute, Leeds and the *Paradise* project space at the Douglas Hyde Gallery, Dublin. Through split narration and ellipsis, carefully chosen scores and constructed characters, Irvine shapes beautiful, compelling stories about intimacy, about losing our instincts, about how we are tamed by love, by waiting. Her narratives are often submerged, like fish underwater, and her metaphors discreet. The mood, while melancholic, never slips into bathos or sentimentality. Her special confluence of sound and image remains both subtle and distinctive.

Towards a polar sea at Frith Street develops Irvine's concerns with beauty, loss and artistic endeavour, using characters that inhabit a story, or fragment of a story, that may or may not be their own. This five-part video installation was triggered by the diaries of nineteenth-century explorer John Franklin, who failed in his attempts to find the Northwest Passage and once lived where the gallery is housed. In a moving and sparse invocation, Irvine blends extracts from his diaries with her own text, spoken in voice-over by gallery staff and filmed in situ, so that the house itself emerges as a character in the work. The voices, at the halting pace common to Irvine's work, and the mournful musical soundtrack, ghost the rooms. In one sequence, rain falls behind the broken surface of a blacked-out windowpane, recalling the texture of *Fireflies at 3am* from 1999'. "Showers of snow fell through the night. Everything hurts – the trees, the

Rejecting I chose, there's no other way,
but what I do reject more numerous is,
and denser and more than ever insistent.
Wisława Szymborska, Big numbers ⁴

sky, the air and you're not here." T
the exquisitely rendered pain of sep
off, 1999', in which the runway is filn
perhaps leaving the beloved behind. t
searing torch song *Io vivrò senza te* ('I
you'), by seventies diva, Mina: "What's [
to me from tomorrow onwards? I will liv
I will cry. Yes, I will cry..."

In another sequence, *Towards a polar sea: it*
a member of staff sorts and repacks Irvine's
and views a strip of film from *Portrait of Danie*
the companion piece to *The take-off*. Played to
Mina song, this black-and-white love poem show
beloved sitting in a lounger in the sun, smoking,
with love into the camera, blowing kisses, teasing,
looking up, as if at the plane in the sky. The pieces
simultaneously, telling a tale of heartache: the love t
hurts with the fear of losing it and the separation that
makes the love object sweeter, fixed in the memory like
a home movie on a hot afternoon. Irvine's and Franklin
relationship to the past's painful lessons merge in the
narration of *Towards a polar sea*: "If the earth moves and
swallows me up, this doesn't prove that my trust in it
was misplaced. What better place for my trust could
there be?"

In sifting through Franklin's diary – "Drank tea...
between hope and fear... we went silently forward" –
Irvine finds self-evidence, evoking conversations at
kitchen tables in *Eyelashes*, 1996, and *Ivana's answers*,
2001, and recalling questions the artist asks herself
about how stories work, and how to define questions
themselves.

The sequence *Towards a polar sea: whenever the ice
shifts* is the most eloquent and profound of the
installation. As one member of staff tells how "the
party is reduced to four persons," all four sit on the floor
of the empty gallery, backs to the wall, each voice
recounting a tale of exhaustion, persistence and failure.
"F. could go no further, overwhelmed with grief. The
whole party shed tears." The piece binds the gallery
staff into a team facing challenges on a life-and-death
level, heroic in the face of blank expanses of whiteness –
the start to every art.

The sorrowfulness, exacerbated by The Eels' soundtrack,
is tempered by the resolute attempt to find a way
through: "There was not one single passage, rather the
intricate maze... provided a number of potential
passages whenever the ice shifted to open the door." In
the slow dissolves from one close up face to another, the
piece is a testimony to the commitment and dedication
that keeps art galleries themselves open and delicately
conjures the artist as explorer of the uncharted.

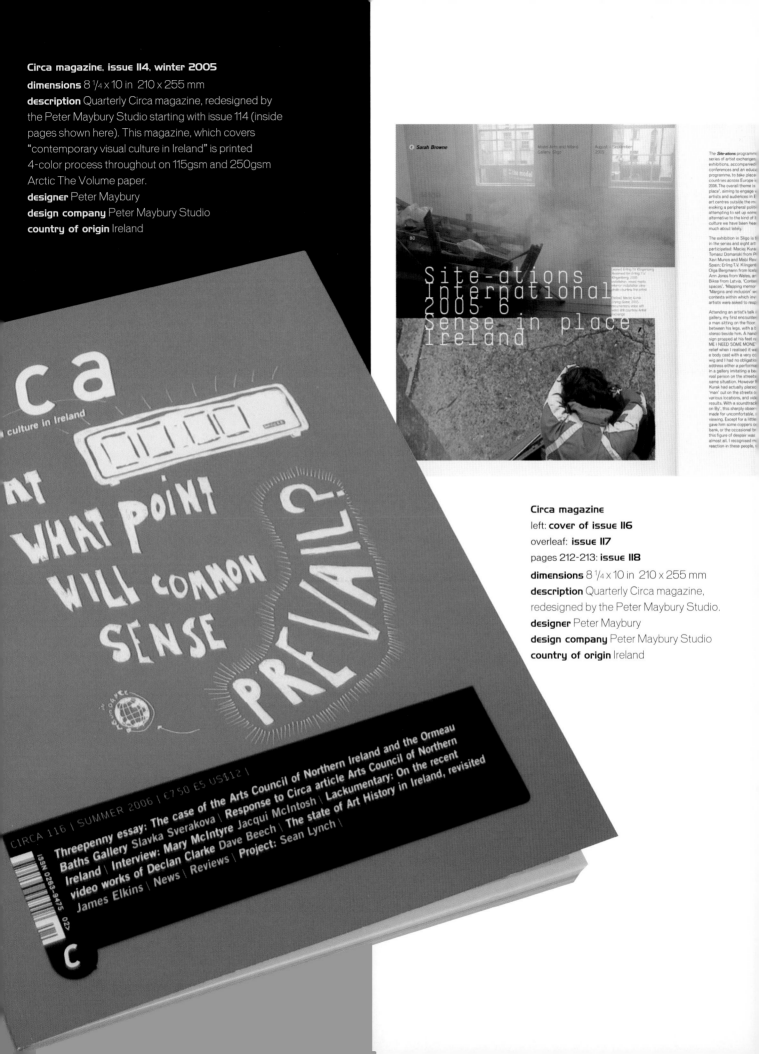

Circa magazine, issue 114, winter 2005

dimensions 8 1/4 x 10 in 210 x 255 mm

description Quarterly Circa magazine, redesigned by the Peter Maybury Studio starting with issue 114 (inside pages shown here). This magazine, which covers "contemporary visual culture in Ireland" is printed 4-color process throughout on 115gsm and 250gsm Arctic The Volume paper.

designer Peter Maybury

design company Peter Maybury Studio

country of origin Ireland

Circa magazine

left: **cover of issue 116**

overleaf: **issue 117**

pages 212-213: **issue 118**

dimensions 8 1/4 x 10 in 210 x 255 mm

description Quarterly Circa magazine, redesigned by the Peter Maybury Studio.

designer Peter Maybury

design company Peter Maybury Studio

country of origin Ireland

c. **Mark Garry**

48

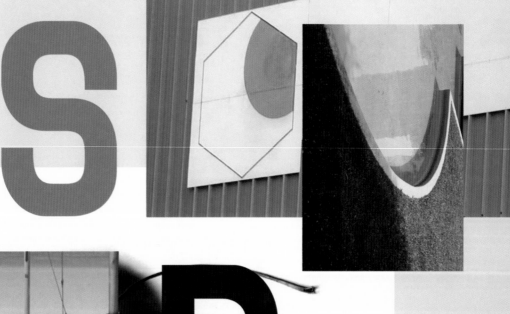
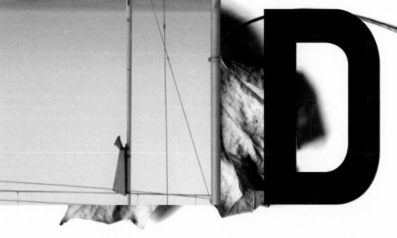

The purpose of this essay is to investigate a number of the processes and motivations of contemporary artists who work with sound. This particular field has expanded and taken many forms over the past three decades. This essay in no way attempts to serve as an overview of contemporary sound art, but it is simply four particular practitioners responding to a sequence of questions from me. I have chosen these artists from a range of geographic, sociological and educational backgrounds; they are **Dennis McNulty**, **Slavek Kwi**, **Jody Elff**, and **Randall Packer**.

Later in this piece the participants will expand on how they employ contemporary technologies, but on quite a basic level I wasn't aware of any fundamental difference between two types of musical endeavour. One was experimental music and the field of music categorised as Abstract Electronica – acts such as Autechre, Oval, Murmer among others. The other was focused more within galleries, in terms of the processes employed or the outcomes achieved. Therefore I was concerned with isolating if and where any differentiation occurs between musicians and sound artists, and in particular whether the participants could isolate any difference.

THE STATE OF
ART HISTORY IN IRELAND,
REPLIES AND RESPONSE

Reply: *Joan Fowler*

It is *not* the business of art to save Art History. James Elkins shifts from Art History to Visual Studies to Art Criticism and back (indicating his own predilections *en route*), but fundamentally he advocates a discipline(s). This, I would suggest, is antithetical to art practice. It *is* the business of those involved in and with art to ward off advances from those who propose an academic discipline within art education. Once ensconced, a discipline, with its rigid methodologies, has the capacity to destroy the education art students have enjoyed for the past generation and which, in its prime, was revered across the world. I refer to that open-ended, tutorial-based system with origins in the Bauhaus, revised in Britain in the1960s, and adopted in Ireland in the 1970s.

I should be clear that my concern is with education engaged in art practice. I should also say that I take Elkins's remarks at face value and assume he is honourable in what he puts forward. I say this because there are quasi-managers and opportunists within the Irish third-level system who are only too willing to adopt Elkins's language, because this is the language that most effortlessly dovetails with government policy. Rationalisations, partnerships, and modularisation: this is talking the talk that facilitates career paths but does nothing to advance the education of art students. There is an increasing disjunction occurring between studio floors and boardrooms. This is redolent of the split between the traditional intimacy of the tutorial system in art education and the larger conglomerates which conduct education largely through lecture auditoriums.

Elkins says that art students should receive a "systematic understanding" in art theory. I don't think so, not only because art students are rightly pre-occupied in trying to cope with art, but because partial understanding *is* a desirable goal, indeed it is the only goal available. Further, 'understanding' is not just partial, it is momentary. Where could 'systematic' begin or end? There are no fixtures or borders here. Once "systematic understanding" is uttered, there lurks the proposition that theory frames art. It doesn't. This isn't to say that art theory (I use the term vaguely, but I refer to an area that I think is loosely understood) is irrelevant; 'it' can be and should be a significant contribution to art practice. In this context at least, art theory should not be an end in itself, and this I think is the crux. This theory's home is integral to art colleges/ departments and shouldn't be consumed by academia.

Elkins cites practical issues and makes comparison between Art History in Ireland and many other countries. But I wonder if he acknowledges the potential for imperialism in what he says. While he advances links and integrations in higher education, it should be remembered that large institutions acquisition small institutions such as art colleges, and enforce their culture as well as their fiscal policy. Again, Elkins presumes a universal modular structure, despite the fact that in this part of the world educators of art students have argued against it and with good reason. A global university system (which is essentially how modularisation is being advanced in Europe) should not be assumed by default; the homogenisation involved should be sufficient warning.

Elkins will point to the insularity and defensiveness of my comments. He is right to highlight the cultural, social, and economic realities that confront us. He indirectly reminds us that Ireland is an overtly philistine society within which its colleges and universities often aspire to little other than mediocrity. The role of art history/ theory/ criticism in art education has been and continues to be a contentious issue, but one that is usually stuffed under the carpet. Elkins, I think, implies that with the help of university relatives, it could be stronger in regard to practice. I would need an awful lot of convincing. As far as practice-based art education is concerned, this is a juncture where the specific aims and requirements of art colleges/ departments need to be articulated in contemporary terms (led by educators, artists, students, and critics, rather than Boards), and we need to communicate these loudly and clearly.

Joan Fowler teaches at the National College of Art and Design, Dublin

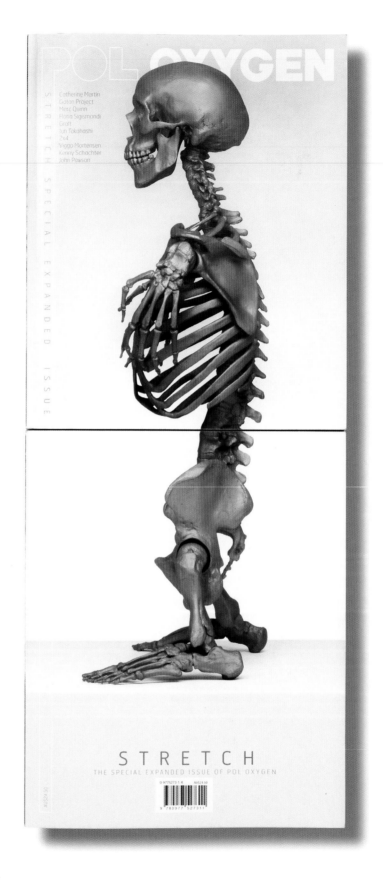

POL Oxygen (Stretch) magazine
description POL Oxygen
magazine—special edition with
Vince Frost as guest art director.
This issue is devoted to people
who move effortlessly between
different creative fields. It is
called "Stretch"—stretching the
boundaries of magazine design at
21 5/8 in (550mm) tall, double the
height of a standard edition, with
a horizontal split down the middle
so it folds to fit on a library shelf.
designers Vince Frost,
Anthony Donovan
art director Vince Frost
design company Frost Design
country of origin Australia

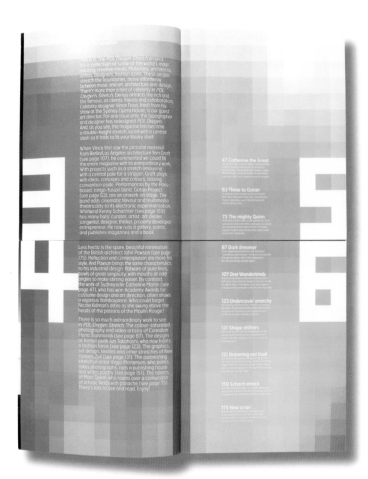

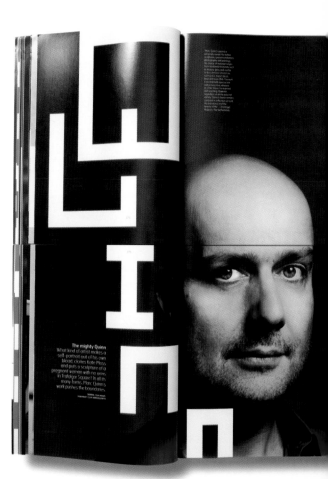

The split changes the way the reader interacts with the magazine, breaking conventional ways of reading. The bronzed skeleton sculpture by Marc Quinn used on the cover unfolds to reveal a midget—a stretch on reality that is only revealed once you open the cover.

FROST DESIGN

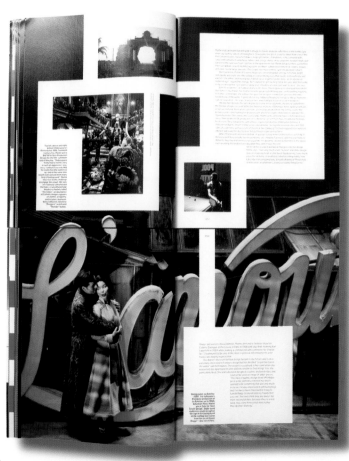

Print Magazine
dimensions 9 x 11 in 229 x 305 mm
designer Marian Bantjes
illustrator Marian Bantjes
art director Kristina DiMatteo
country of origin Canada

above

Print Magazine, The Vivid Word (cover)
description Custom type and ornament designed for the July-August 2006 issue of Print Magazine.

facing page

Print Magazine, W.M. de Majo
description One of eight pages designed for the July-August 2006 issue of Print Magazine. This series features predictions by graphic designers from about 50 years ago. The design uses custom type and illustration.

W.M. de Majo

design consultant May/June **1962**

With distances between countries growing ever smaller, more people traveling and economic and political barriers between nations gradually being broken down, it seems inevitable that designs will gradually become more "international" in concept and style. In certain fields such as industrial design, transportation, packaging and magazine design, as well as furniture and architecture, national characteristics are already fast being replaced by a new, generally acceptable modern style. Graphic designs will have to communicate easily and understandably in export markets, which will result in simplifications, cleaning up with a general improvement. Standardization of sizes of both paper and type, on an international scale, is bound to result, and

eventually we may even achieve that a 12-pt. Bodoni letter is the same size in the U.S.A. as in England or France.

I am sure that eventually English or some other language will be established as the No. 1 world language and while individual nations will still be taught their own native tongue—

if we survive to live as long as that—

we shall all be able to read and communicate in one universally accepted language. This in itself, while imposing a certain amount of standardization, will on the other hand result in better economics, which should bring forth greater prosperity and result in a better cultural upbringing and improved design standards.

FALL MOVIE PREVIEW

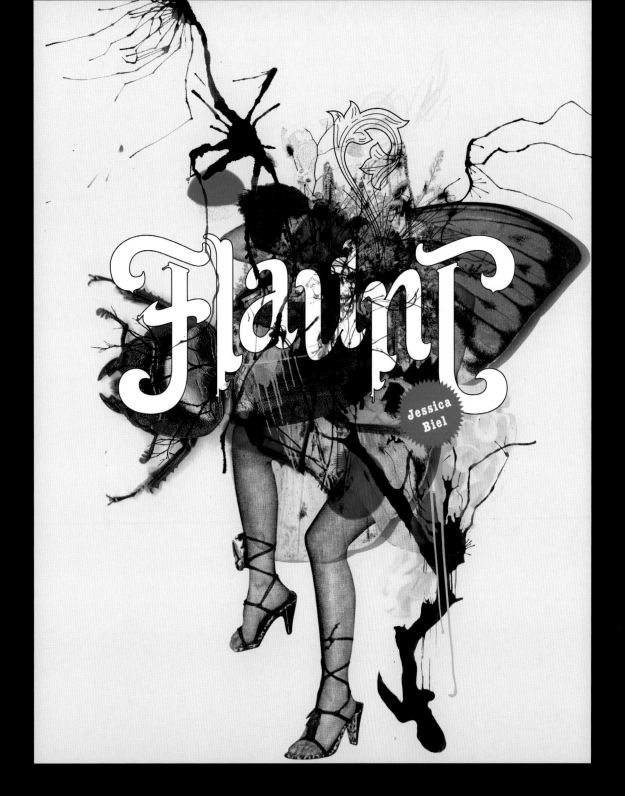

facing page

Entertainment Weekly

dimensions 16 x 10 ½ in 406 x 267 mm

description Double-page editorial spread.

designers John Glasgow, Jonathan Kenyon

art director Brian Anstey

above

Flaunt

dimensions 9 x 12 in 229 x 305 mm

description Embossed magazine cover.

designers John Glasgow, Jonathan Kenyon

art director Jim Turner

Barry Flanagan: Sculpture 1965–2005
dimensions 9 x 11 ¼ in 230 x 285 mm
description A 232-page book published to accompany the British sculptor's exhibition at the Irish Museum of Modern Art. The catalog features a flexible 4-color embossed cover and inside pages printed on varying stock in 4 color with 8 metallic spots sections and corners cut at a 45° angle.
designer Peter Maybury
design company Peter Maybury Studio
country of origin Ireland

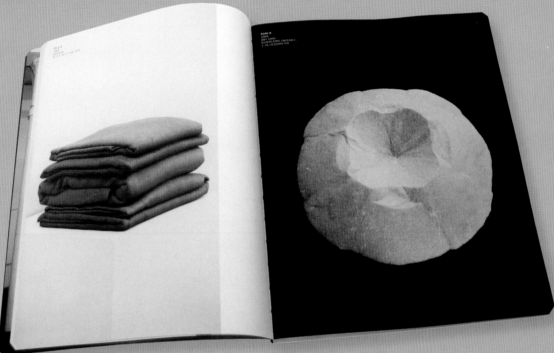

Sign Kommunikation
for
Arctic Paper

Blanko

Universitätsdruckerei
H. Schmidt
Corporate Books

Blanko (above)
dimensions 7 7/8 x 10 1/4 in 200 x 260 mm
description A booklet commissioned by the paper company
Arctic Paper (Germany). It features blank pages and illustrations –
providing a space onto which you can project your own ideas.
designer Antonia Henschel
art director Antonia Henschel

illustrators Antonia Henschel, Karl W.Henschel,
Jörn Hofmann, Martin Kaufmann
photographer Kiril Golovchenko
design company SIGN Kommunikation GmbH
country of origin Germany

Switch

Von der Kultur des Schaltens
The culture of switching

ISBN 3-00-018639-5
ISBN 978-3-00-018639-4 (ab 2007)

Archetype: 1. A very typical example of a certain person or thing. 2. An original that has been imitated

Typology: 1. Classification according to genre or type.

-Oxford Dictionary

Each product we encounter has its own history, its own family tree. The cell phone for example, has its parents in land line telephones and walkie talkies; its grandparents in horns and trumpets. After a new product is established in society the first models of that product often take on an iconic stature. These images become part of the public's consciousness of what that particular product looks like. They become Archetypes.

Typologies emerge from the periphery of products that surround them. However, a new iconic product must have defined for itself its own language, its own order and its own purpose, all of which will distinguish it from its relatives.

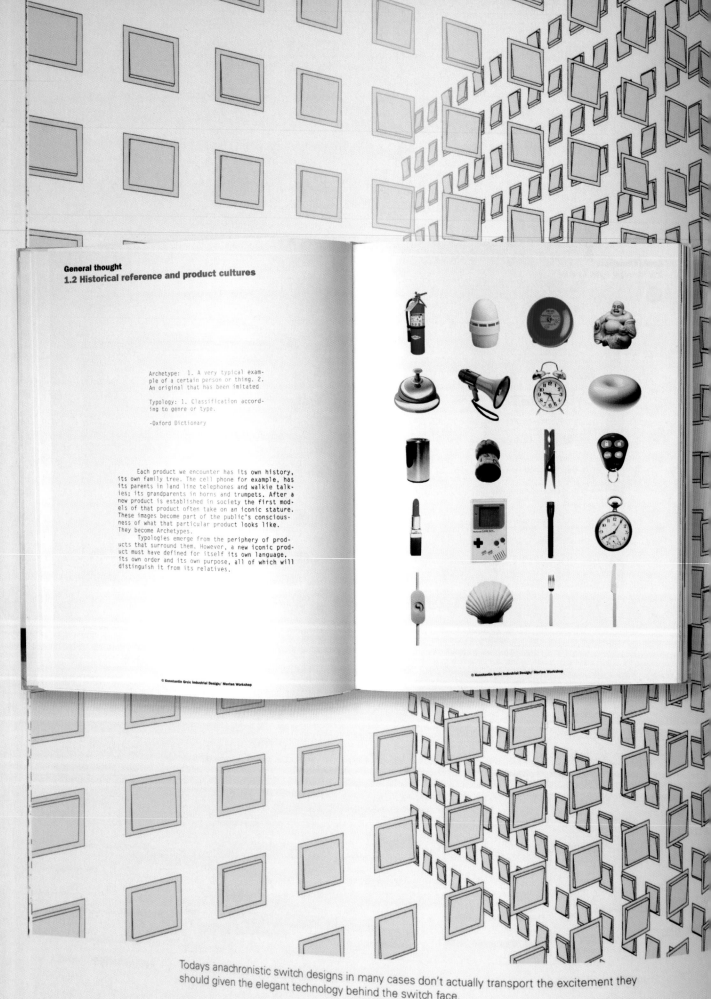

Todays anachronistic switch designs in many cases don't actually transport the excitement they should given the elegant technology behind the switch face.

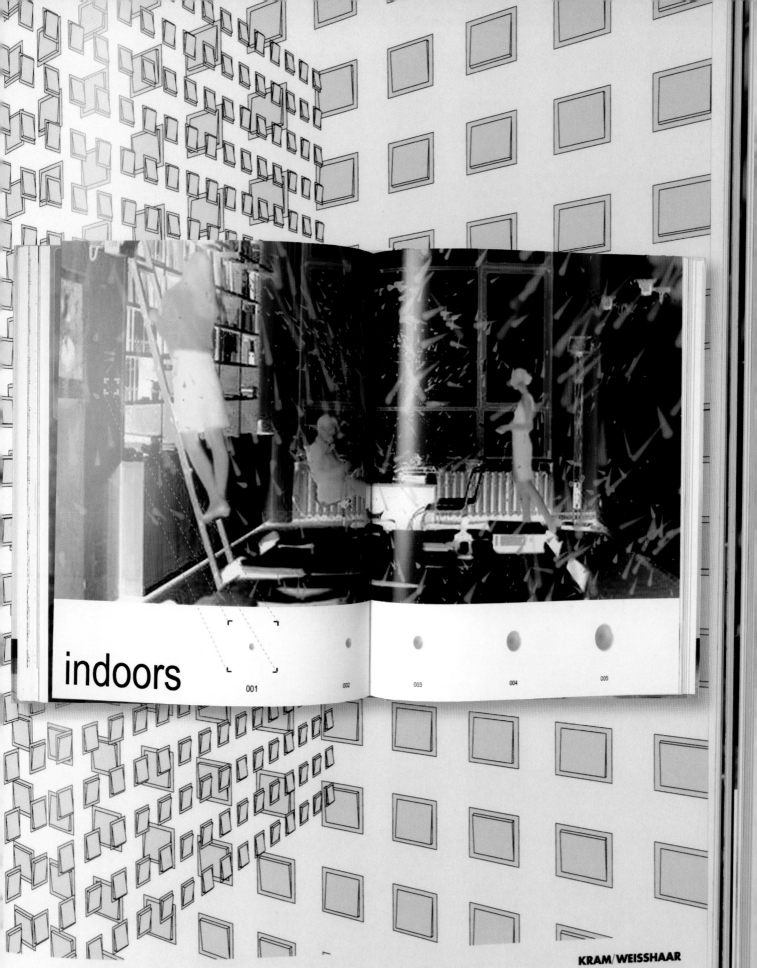

indoors

001 002 003 004 005

KRAM/WEISSHAAR

index

druchschalter

iris-scanner

iris-scanner

aroma-pore

052

053

054

notschalter

dreh-schalter

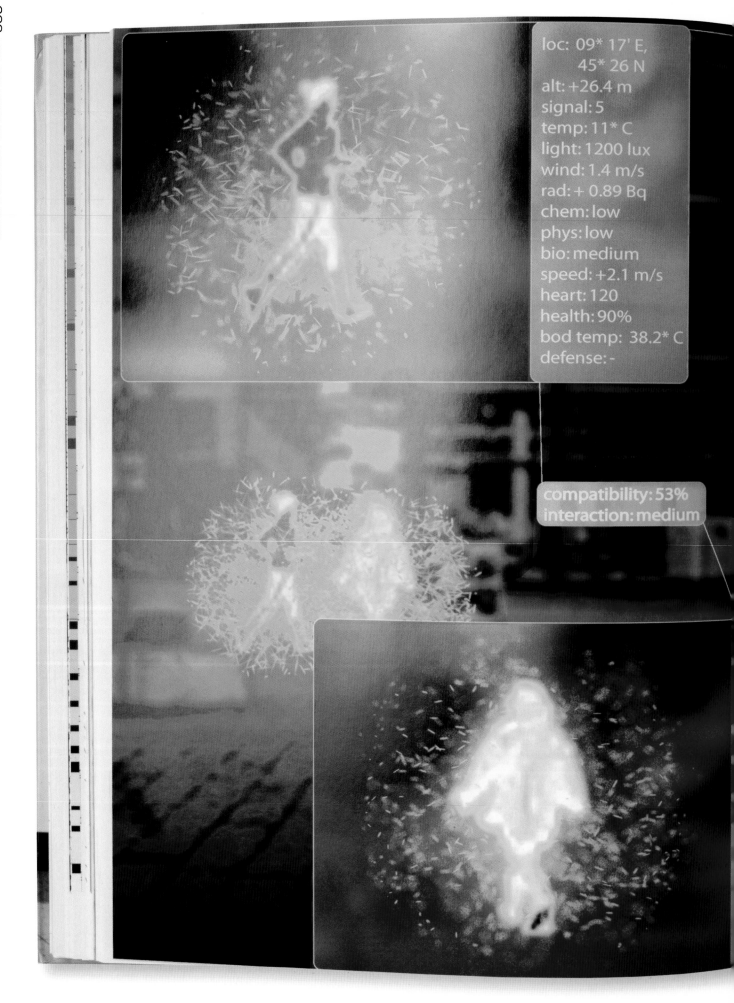

loc: 09* 17' E,
 45* 26 N
alt: +26.4 m
signal: 5
temp: 11* C
light: 1200 lux
wind: 1.4 m/s
rad: + 0.89 Bq
chem: low
phys: low
bio: medium
speed: +2.1 m/s
heart: 120
health: 90%
bod temp: 38.2* C
defense: -

compatibility: 53%
interaction: medium

compatibility: 64%
interaction: low

loc: 09* 17' E,
 45* 26 N
alt: +26.4 m
signal: 6
temp: 11* C
light: 1200 lux
wind: 1.4 m/s
rad: + 0.89 Bq
chem: low
phys: medium
bio: medium
speed: +4.2 m/s
heart: 84
health: 72%
bod temp: 37.1* C
 defense: -

compatibility: 38%
interaction: low

outdoors

The "Switch—von der Kultur des Schaltens" publication received one of the 30 coveted iF gold awards within the context of the iF communication design award 2006 ceremony. This award, also known at the "Design Oscar," was presented by an international jury in the print media corporate communication category. The book, designed by SIGN Kommunikation in Frankfurt am Main, was published on the occasion of the "Switch—Intuition im Raum" exhibition at the Museum für Angewandte Kunst

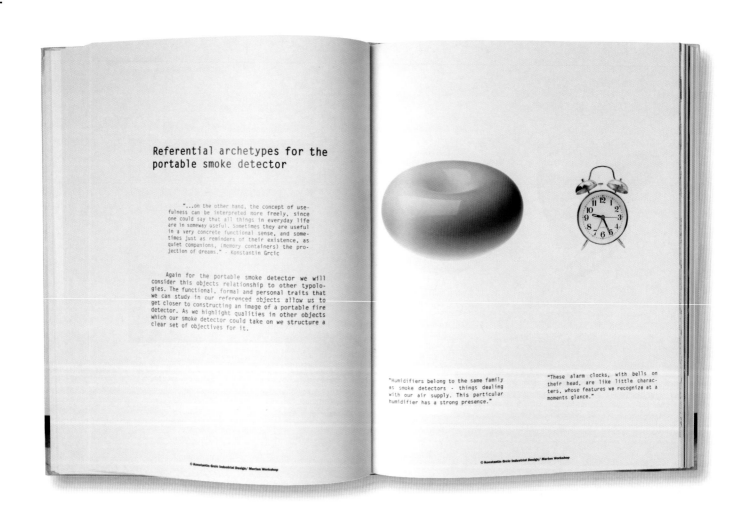

Frankfurt and was selected from among 1,240 submissions from 23 countries. The jury was convinced by the implementation of the light switch and switching topic: "This book is something that is most exhilarating—despite having been created by an industrial company, despite it dealing with light switches, which initially does not sound very sexy. But the book is wonderfully open and clear, with a beautiful range of graphics and inspiring pictures. Simply a wonderful text and picture book."

MERTEN PRESS OFFICE

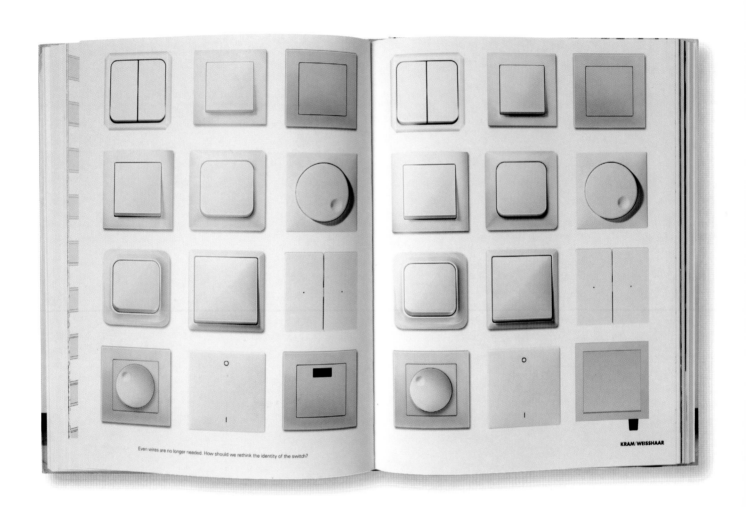

pages 223-231
Switch
dimensions 8 x 10 ¹/₂ in 205 x 265 mm
description A book about the culture of switching, to accompany an exhibition by Merten, a building design solutions company. It features essays on the subject, as well as the output of three workshops at the German company Merten with Konstantin Grcic, Jürgen Mayer H., Antonia Henschel, Reed Kram, and Max Ratjen.
designer Antonia Henschel
art director Antonia Henschel
photographer Ingmar Kurth
design company SIGN Kommunikation GmbH
country of origin Germany

A word is worth a thousand pictures (cover)

dimensions 5 7/8 x 8 1/4 in 148 x 210 mm (A4)

description A book designed to show fonts from the Linotype Gold Collection. Inside, various "four-letter words" are shown in different styles to highlight the difference a choice of typeface can make.

designer Antonia Henschel

art director Antonia Henschel

design company SIGN Kommunikation GmbH

country of origin Germany

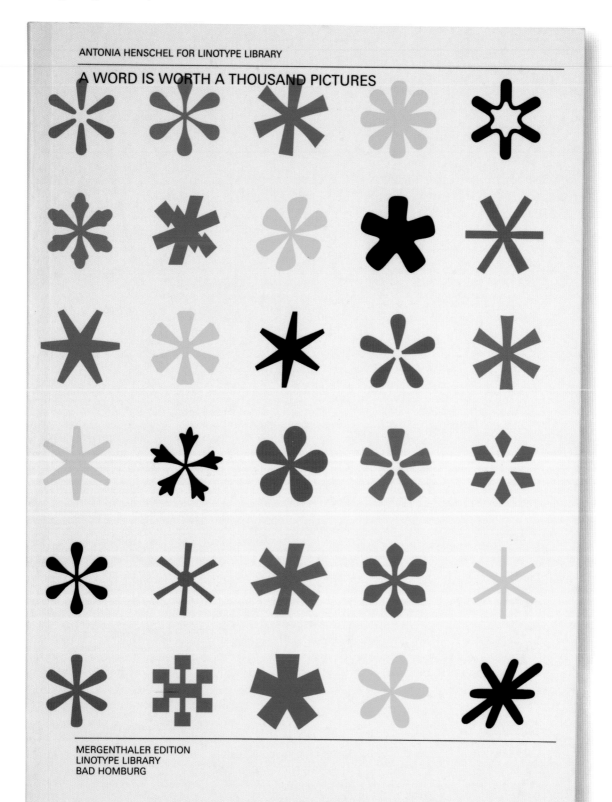

This monograph celebrates the pioneering work of Jennifer Steinkamp, an artist for the digital age. Steinkamp's work consists largely of installations: abstract and figurative projections that blur the lines between the virtual and the concrete. Trained in animation and computer graphics, Steinkamp's art exists only in code, her computer serving as the paint, the palette and the brush.

SAN JOSE MUSEUM OF ART

pages 233-241
Jennifer Steinkamp
dimensions 8 ¹/₂ x 11 ¹/₄ in 216 x 286 mm
description Exhibition catalog for Jennifer Steinkamp.
designers Gail Swanlund (Stripe/LA) and Geoff Kaplan (General Working Group)
design company Stripe/LA and General Working Group
country of origin USA

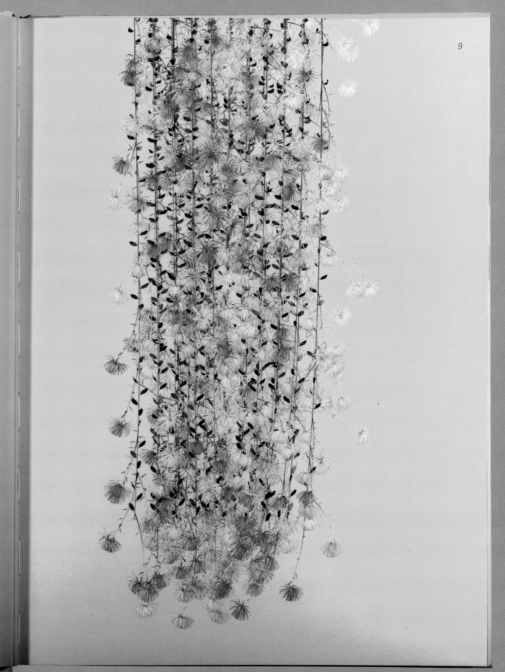

9

The yellow rose will turn to cinder
and New York City will fall in
before we are done so hold me,
my young dear, hold me.
Put your pale arms around my neck.
Let me hold your heart like a flower
lest it bloom and collapse.
Give me your skin
as sheer as a cobweb,
let me open it up
and listen in and scoop out the dark.
Give me your nether lips
all puffy with their art
and I will give you angel fire in return.
We are two clouds
glistening in the bottle glass.
We are two birds
washing in the same mirror.
We were fair game
but we have kept out of the cesspool.
We are strong.
We are the good ones.
Do not discover us
for we lie together all in green
like pond weeds.
Hold me, my young dear, hold me.

They touch their delicate watches
one at a time.
They dance to the lute
two at a time.
They are as tender as bog moss.
They play mother-me-do
all day.
A woman
who loves a woman
is forever young.

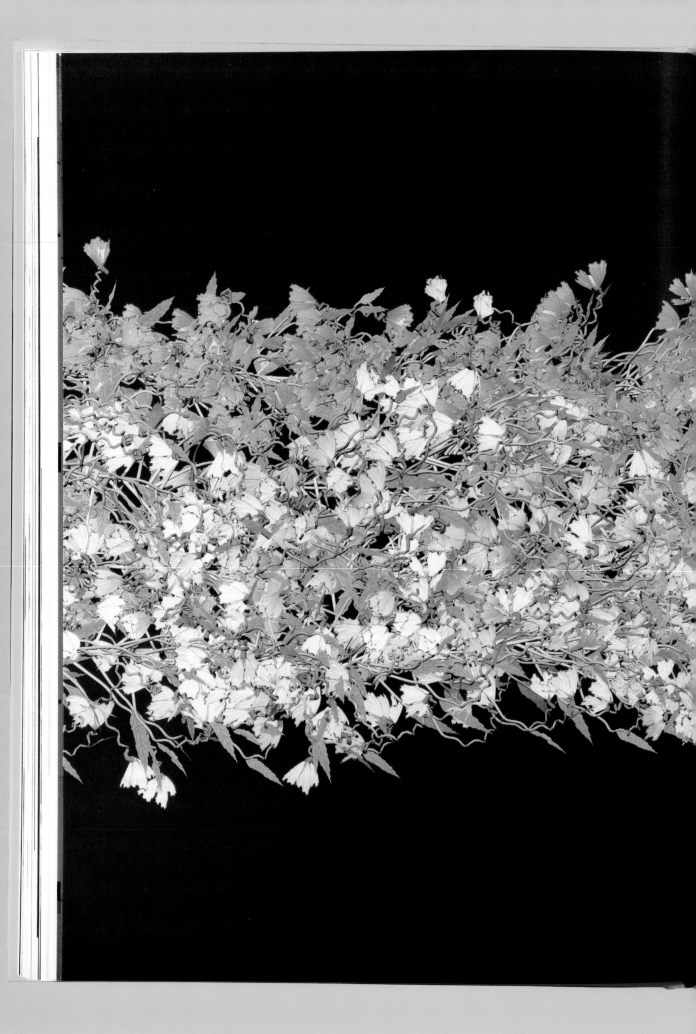

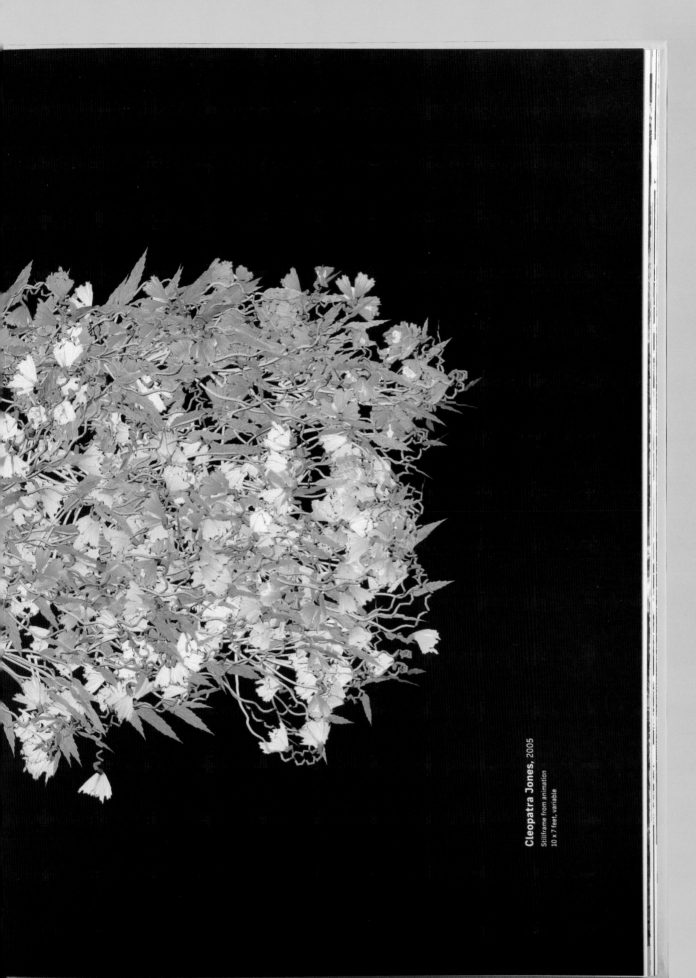

Cleopatra Jones, 2005
Stillframe from animation
10 x 7 feet, variable

JUNIPER JoAnne Northrup

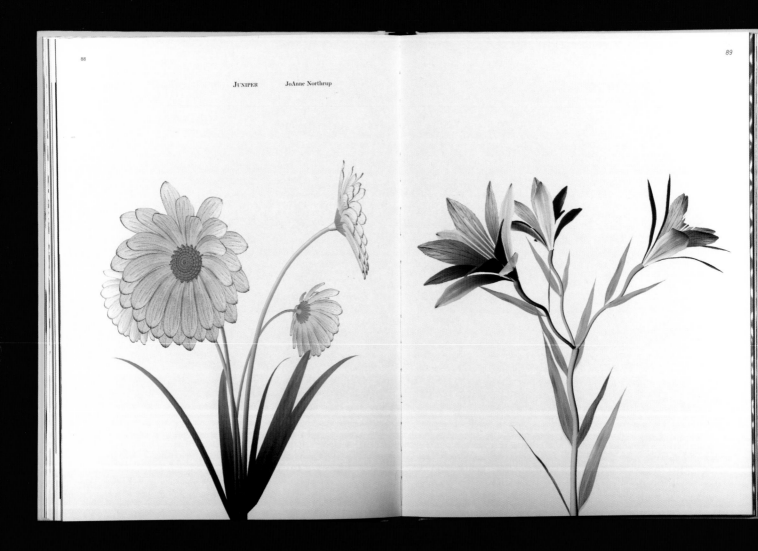

THE PAINTED SEA Dan Cameron

nature itself. This illusion was enhanced by
the visual dialogue between the trees and
the legendary pair of monumental Medusa
heads (one upside done) that form the basis
for the cistern's role in popular myth (and
tourism). Steinkamp even programmed the
smaller tree branches to move faster and
more purposefully than their trunks swayed,
suggesting the hideous writhing of the mythic
snakes that fill the place of Medusa's hair.

 Having achieved the seamless
fusion of movement, color and light that *Eye
Catching* exemplifies, Steinkamp has recently
begun giving free reign to natural forms
and archetypes in her work. Not content
to merely imitate nature, her relentlessly
perfectionist drive has resulted in recent
projections that promote the illusion of
flowers and trees to the point of describing
a form of hyper-reality flowers so intensely
luminous that they can actually be examined
in more precise detail than nature allows
with the unaided eye. Unlike her earlier
work, Steinkamp's recent tree and flower
projections do not merely hover on the
surface of the wall, but seem to bore into it,
reducing the area surrounding the projections
to a shadowy afterthought of its previously
solid self.

 In a sense, Steinkamp has reached
the stage in her artistic development where
she can begin considering possibilities of scale
that dwarf anything that painters of the past
have even been able to envision. As her work
moves further from recording and storing
forms which have been directly transcribed
from nature, and more fully embraces the
use of shapes, surfaces and volumes that
are rendered in real space and time by

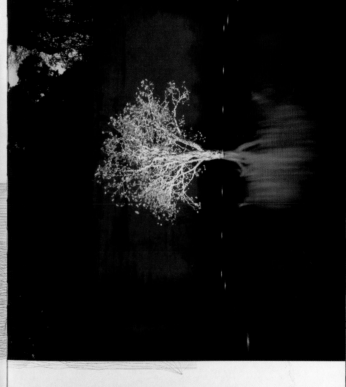

Eye Catching, 2003
Computer animation, video projection, and a cistern
20 × 14 feet (each)
Installation at a private residence, Dallas, Texas
Photograph Robert Wedemeyer

APPENDIX OF DRAWINGS

detail from *The Trip* film poster

Feel Purple, Taste Green
Poster copy for Roger Corman's *The Trip*, starring Peter Fonda, Susan Strasberg, Bruce Dern, Dennis Hopper, Salli Sachse. "Touch the Scream that Crawls Up the Wall!"

Annie Oakley
gun/partridge/sparrow
bow & arrow/pie/50 cents
dig/liquor/bread & cheese

Anything You Can Do
"Anything You Can Do, I Can Do Better" by Irving Berlin, from *Annie Get Your Gun*. JS: "This is an Ethyl Merman tune that my mother often sings."

Hermaphroditus/Valkyrie/the witch's guard

Gender Specific
1. In the film, *The Wizard of Oz*, the Witch's guards or "Winkies," chant while patrolling the grounds of her castle. According to various interpretations, the guards sing, "Ho He Oh Yo Ho" or perhaps, "All we owe, we owe her." Or as the screenplay reputedly reads, "O-Ee-Yah! Eoh-Ah!"

2. Richard Wagner's Valkyries sing "Hi Yo To Ho."

3. Androgyny: Roland Barthes *S/Z* and *Orlando*.

4. An homage to Hermaphroditus, son of Hermes and Aphrodite. While bathing he becomes transformed into a single body by the nymph Salmacis,

Dance Hall Girl

Dance Hall Girl
An archaic term for a woman whose job was to charm and entertain saloon patrons in order to prolong their time in the bar drinking and gaming. In the western movie genre, the dance hall girl often wears a hitched-up skirt with colorful frothy petticoats and fussy derriere detail.

hurdy gurdy/lilacs

tooth decay/sauerkraut/scared fish

river

Hurdy Gurdy
1. "Hurdy Gurdy Man" by Donovan.
2. The hurdy-gurdy is a stringed and keyed instrument. It is played by turning a crank attached to a rosin-covered wheel.
3. During the California and Canadian gold rush, Hessen hurdy gurdy girls were employed to dance with men in saloons. These workers were believed to possess loose morals. Also known as "soiled" or "fallen" women.

Tra La La Boom
"Tra La La Boom Di-ay"

A River Of No Return
The River of No Return, the film directed by Otto Preminger, starring Robert Mitchum and dance hall girl Marilyn Monroe. A kittenish Monroe, and later in the film, Tennessee Ernie Ford, croon the title love song.

cowboy/cowgirl/mechanical bull/Stetson hat

sailor/hat/parrot

I Want to Be A Cowboy
"Urban Struggle" by The Vandals

A Sailor's Life is a Life for Me
"A Sailor's Life is a Life for Me" by Bob Hilliard and Sammy Fain.

singing bird in nest/scissors/mad cat/cut long braids/
thorns in eyes and tears/twins/rampions/root and berries

Rapunzel
The Brothers Grimm fairy tale of the same name.

boat

Lillian and Jimmy Carter

Jimmy Carter
And his mother, Lillian.

The Wreck of the Dumaru
Jennifer Steinkamp's great uncle Ernest Hedinger was a seaman on the Dumaru during WWI. In 1918, the ship carrying weapons and fuel was struck by lightning scarcely a couple hours outside of Guam. Powerful currents carried the helpless lifeboats out to sea. There were not enough provisions in the over-crowded boat. Only 19 years old, Uncle Ernest died after 13 days. Out of desperation he had been drinking seawater, which caused him to imagine a nail stuck in his head. Soon after his death, two of the shipmates were cannibalized. The crew was trapped out at sea for 24 days total.

self pro

these pages and overleaf

Frost*(sorry trees)

description Self-promotional 500-page "ideas book" published to coincide with an exhibition on Frost at the Sydney Opera House, showing where ideas come from and how they are realized through the design process. It features case studies of a wide range of projects: magazine and book design, stamps, exhibitions, corporate literature, signage, online design, and many more.

designers Vince Frost, Anthony Donovan

art director Vince Frost

design company Frost Design

country of origin Australia

Each project is shown against a backdrop of Frost's own personal photography, creating an extra layer that turns up the volume so the book acts as a design piece in its own right. With 500 pages of ideas and insights, the book throws open the design process and is accessible and entertaining for everyone.

FROST DESIGN

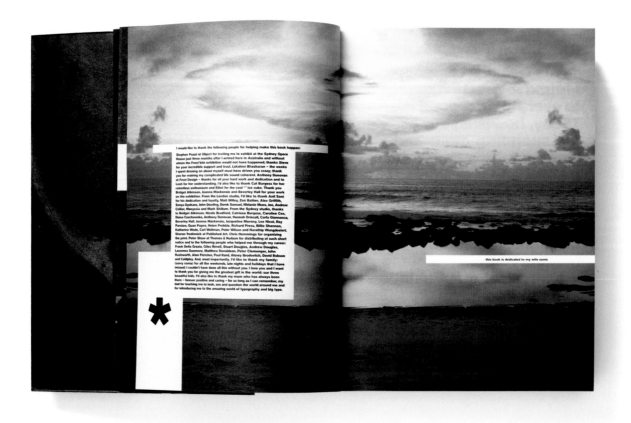

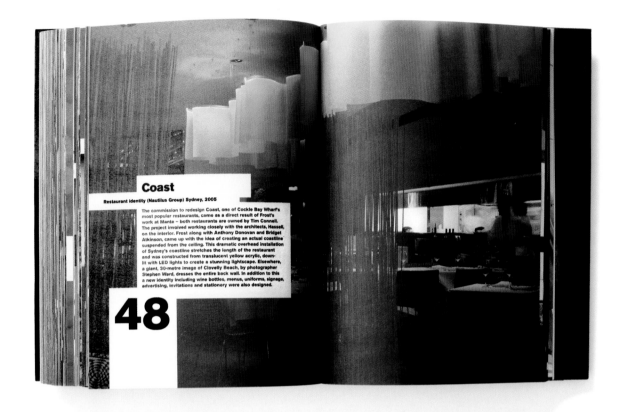

Coast

Restaurant identity (Nautilus Group) Sydney, 2005

The commission to redesign Coast, one of Cockle Bay Wharf's most popular restaurants, came as a direct result of Frost's work at Manta – both restaurants are owned by Tim Connell. The project involved working closely with the architects, Hassell, on the interior. Frost along with Anthony Donovan and Bridget Atkinson, came up with the idea of creating an actual coastline suspended from the ceiling. This dramatic overhead installation of Sydney's coastline stretches the length of the restaurant and was constructed from translucent yellow acrylic, down-lit with LED lights to create a stunning lightscape. Elsewhere, a giant, 30-metre image of Clovelly Beach, by photographer Stephen Ward, dresses the entire back wall. In addition to this a new identity including wine bottles, menus, uniforms, signage, advertising, invitations and stationery were also designed.

48

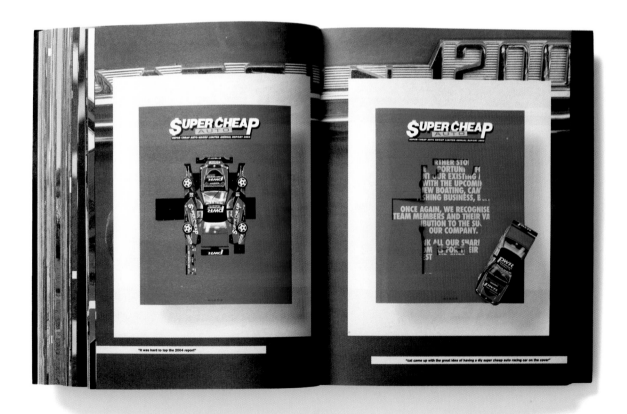

"the images for this catalogue were shot at london's kings cross"

Laurence King Publishing
Spring 2003

LAURENCE KING PUBLISHING LTD

71 Great Russell Street
London WC1B 3BP
Telephone 020 7430 8863
Mobile 07932 785 809
Fax 020 7430 8880
www.laurenceking.co.uk
laura@laurenceking.co.uk

Laura Willis
Publicity Manager

"photograph of a beautiful old building in melbourne with an unnatural number of wires coming out of it"

Represented by
WildeHague

T +44 (0) 20 7384 3444
F +44 (0) 20 7384 3449

info@wildehague.com
www.wildehague.com

info@yachtassociates.com
www.yachtassociates.com

Art Direction
& Design

YACHT ASSOCIAT

Yacht Associates Promotional Cards

dimensions 5 ⁷/₈ x 8 ¹/₄ in 148.5 x 210 mm (A5)

description Set of twenty promotional cards, showcasing various
projects undertaken by Yacht Associates. The cards come in a black
slipcase (pictured above).

designer Richard Bull

art director Richard Bull

design company Yacht Associates

country of origin UK

Martina Topley-Bird, Quixotic.

YACHT ASSOCIATES · Art Direction & Design · Richard Bull at Yacht Associates · Represented by WildeHague · T +44 (0) 20 7384 3444 / F +44 (0) 20 7384 3449 · info@wildehague.com www.wildehague.com

Ferrari 575 Maranello. Ferrari 575 Maranello. Bentley Continental. Rolls Royce Phantom.

125 Magazine

YACHT ASSOCIATES · Art Direction & Design · Richard Bull at Yacht Associates · Represented by WildeHague · T +44 (0) 20 7384 3444 / F +44 (0) 20 7384 3449 · info@wildehague.com www.wildehague.com

WOWBOW
LONDON

YACHT ASSOCIATES · Art Direction & Design · Richard Bull at Yacht Associates · Represented by WildeHague · T +44 (0) 20 7384 3444 / F +44 (0) 20 7384 3449 · info@wildehague.com www.wildehague.com

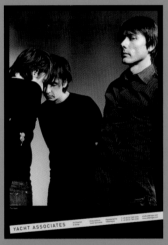

YACHT ASSOCIATES

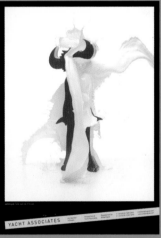

YACHT ASSOCIATES

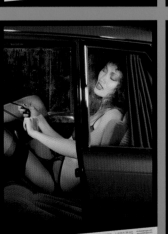

YACHT ASSOCIATES

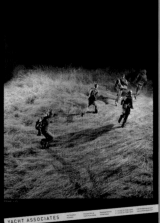

YACHT ASSOCIATES

The anthemic song deals with the mental state of desperate, spiralling longing. We visualized that state of confusion with elements culled from psychoanalysis, mid-century design theory and abstract expressionism. The video won the MVPA Awards for Best Effects in 2005.

BRAND NEW SCHOOL

Muse: Hysteria

dimensions 12 x 12 in 305 x 305 mm
description The artwork was generated for a music video by Muse, "Hysteria," directed by Brand New School. It is composed of fragments of memories, thoughts, and dreams. The artwork was animated and projected around the band, immersing them completely.
illustrators Jens Gehlhaar, Doug Lee, Jon Santos, Jonathan Cannon
art director Jens Gehlhaar
design company Brand New School
country of origin USA

overleaf
BNS stickers
dimensions 5 1/2 x 8 1/4 in 140 x 210 mm
description A collection of self-adhesive communication marks for internal and promotional usage.
designers Jonathan Notaro, Jens Gehlhaar
design company Brand New School
country of origin USA

Brand New School
Academic Visual Lexicon

Brand New School
Academic Organizations & Privileges

DRAMA	ART	SURF CLUB	THEORY	METAL SHOP
PHOTO	DEBATE	TENNIS	GYM	LUNCH
WOOD SHOP	BOAT	GLEE CLUB	VIDEO	DIVE TEAM
CPU LAB	BAND	CHESS	WATER POLO	2005 2006
SPACE	SPEECH	AV CLUB	ASTRO NOMY	2006 2007
BUS PASS	GERMAN	LUNCH	SOCCER CLUB	LIBRARY
OFF CAMPUS	KARATE	SPIRIT	YEAR BOOK	CLASS PREZ

Voice Issue 2

dimensions 8 1/4 x 11 3/4 in 210 x 297 mm

description This company newsletter is distributed to existing and prospective clients updating them on the company's developments, such as projects, industry recognition, and new appointments. In each issue, the designers concentrate on a specific theme, idea, or graphic treatment that they want to investigate.

designer Anthony Deleo

photographers Toby Richardson, David Solm

art directors Anthony Deleo, Scott Carslake

design company Voice

country of origin Australia

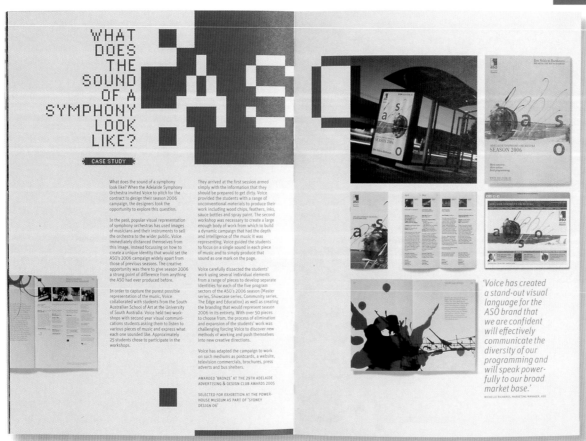

BVD

VARIED PROJECTS AND INTERESTING CHALLENGES

Acting as the design consultancy for a new house and land development brings many varied projects and interesting challenges. Voice's work with Barossa Valley Developments, a joint venture between established property development companies Prodec and Daycorp, provided no exception. Last year, Voice began working with the company on their development, Peppertree Grove at Stockwell in the Barossa Valley. To date, Voice has created and delivered the Peppertree Grove branding, various marketing collateral, environmental signage and press advertising campaigns.

Appealing to the development's target audience was the key consideration when creating all elements of the project. The development features very large blocks providing people with the opportunity to create a specific home and lifestyle package. Therefore the development was primarily targeted at first homebuyers and young families seeking space and lifestyle changes.

One of the developer's main priorities was to create a community at Peppertree Grove, and not just a land development. All of the elements Voice created for Peppertree Grove were centered around this priority. The design is friendly, fresh and warm, giving the development an atmosphere of comfort, safety and togetherness.

Development Manager, Olivia Burke, applauds Voice's work in creating a unique look for Peppertree Grove that has successfully captured their target audience. 'Land in itself is a difficult commodity to promote in a fun and creative manner whilst still capturing your target audience and trying to create a point of difference from all of the other land subdivisions on the market. Voice has approached the design of various marketing collateral for Peppertree Grove with a fresh and cutting edge approach. All our advertising, especially the award-winning newsletter, has managed to not only reach the market, but also appeal to the market.'

'The sales within the development have been a resounding success and there is no doubt this is partly attributable to the devotion and flair Voice have given to meeting our complex and often ad hoc briefs.'
OLIVIA BURKE, DEVELOPMENT MANAGER, PEPPERTREE GROVE

One of the most interesting challenges faced was in the development of the street signage for the estate. Using the Australian standards set out for street signage across the country, Voice embarked on a research project with Stuart Gluth, Head of Design at the University of South Australia. The aim of the project was to determine the optimum typeface and font size that could work within the standards' framework to provide maximum legibility. As a result, the signs in Peppertree Grove can be read from as far as double the distance back from the average reading distance of standard street signs in South Australia.

BVD NEWSLETTER, AWARDED 'BRONZE' AT THE 29TH ADELAIDE ADVERTISING & DESIGN CLUB AWARDS 2005

INDUSTRY RECOGNITION

NATIONAL DESIGN AWARDS

Voice's self-initiated project, *Type it Write*, picked up three awards at the 7th Australian Graphic Design Association (AGDA) National Biennial Awards. Work produced over a two-year period is entered in 19 categories to be judged by a panel of professionals representing excellence and depth within the industry.

There are three levels of awards – Finalist, Distinction and Pinnacle. To be eligible to be recognised as a Finalist, the first level of award, entries must receive a minimum average score of 80%. Higher acknowledgement is then awarded to entries that score particularly well. *Type it Write* was awarded Distinction status in three categories – Books (Instructional), Typography (Publication) and Self-Promotion (Books).

FROM MELBOURNE TO MILAN

Scott Carslake was recently named as one of 17 finalists in the City of Milan 2005 Award for Young Foreign Designers. In 2004, Melbourne and Milan formed a sister city relationship with design identified as a link between the two cities and the Young Foreign Designers project was an initiative of this relationship.

60 young Australian designers representing a variety of fields including architecture, jewellery design, graphic design, digital media and industrial design were invited to participate in this project. The designers were asked to respond to a specific brief from the City of Milan to develop an immersion kit that would open the city of Milan up to visitors, welcoming them and offering them the opportunity to participate in many of the social and cultural aspects of life in Milan.

Scott's submission was selected as one of 17 finalists that were exhibited at the Fondazione Triennale De Milano design gallery during the celebrated Milan International Furniture Fair (Salon Del Mobile) in April. Of the 17 finalists, 14 were based in Victoria and two in NSW, with Scott being South Australia's only representative.

VOICE IMPRESS IN ASIA

Voice received an Award of Excellence in the category of Institutional Marketing Literature at the 2005 Hong Kong Designers Association Awards, widely acknowledged as the most important multi-disciplinary design event in the Asian region. The winning work was a prospectus designed for Adelaide-based beauty training college, Colour Cosmetica. The Awards attracted nearly 2,700 entries from 40 cities within the region of which 700 entries were selected by a panel of international designers.

US MAGAZINE RECOGNISES VOICE AS LEADING AUSTRALIAN DESIGN STUDIO

Voice received international recognition and exposure when profiled in the company of three well-established, highly regarded Australian studios for a feature on Australian design in the US-based Step Inside Design magazine. Titled 'Wizards of Oz-design down under', the feature was a critique on the Australian design industry examining how it stands up in comparison to the thriving markets in the United Kingdom and the United States. The four studios profiled represented design across the country with businesses located in Sydney, Melbourne, Perth and Adelaide showcasing Australian design to an international audience.

Step Inside Design is a bi-monthly publication exploring the impact of design on all facets of life. It takes readers behind the scenes of the design world, introducing them to the creative problem solvers who impact the way in which we see the world in such a powerful and dynamic way.

VOICE WIN SECOND PRESTIGIOUS N.Y. AWARD

A poster designed for an academic forum hosted by TAFE South Australia has won Voice a second Certificate of Typographic Excellence from the internationally recognised New York Type Directors Club (TDC). This win follows on from their 2004 award for *Type it Write*. The awards attracted 2,035 entries from around the world, including 27 from Australia. Voice was one of only 204 entries awarded in 2006, including just three from Australia.

All winning entries will be exhibited in six travelling shows the US, Canada, Europe and Japan later this year. The works will also be published in the TDC's hardbound colour annual, *Typography 27*. Founded in 1946, TDC is an international organisation for all people devoted to excellence in typography, both in print and on screen.

VOICE'S SHOW AND TELL IN MELBOURNE

In July 2004, Voice was short-listed for Australia's richest design prize, the $40,000 Victorian Premier's Design Award. Australian designers living here and overseas were invited to enter their best work for the inaugural Design 2004 Exhibition and Awards held in Melbourne. From the hundreds of submissions received, a short-list of entries was chosen to exhibit at the Melbourne Museum and to be in the running for the $40,000 award. A distinguished panel of Australian designers judged the work and Voice's award winning publication, *Type it Write*, was one of only 72 projects short-listed and selected to exhibit.

The exhibition and awards formed part of the State of Design Festival, Australia's first multi-disciplinary design festival. Launched by the Victorian Government as part of its Design initiative, the festival included conferences, lectures, street events and forums aimed at promoting the awareness and value of design and celebrating the high standard of design in Australia.

Voice was invited to present at one of the forums in the festival programme, the AGDA (Australian Graphic Design Association) speaker forum titled The Craft and Business of Typography. Scott Carslake presented on behalf of Voice, sharing the podium with design masters Garry Emery and Vince Frost (EmeryFrost), Jack Yan (NZ), Anthony Cahalan and David Pidgeon (Gollings Pidgeon). Scott presented Voice's insight into the process of learning the craft of typography, specifically in terms of studying typeface design in Australia. His presentation examined the resources and training available in Australia and looked at how passion and curiosity influence and drive the creation of letterforms.

Homework
description Unpublished and concept
work created into a fold-out booklet for
self-promotion, showcasing the range of
styles created inhouse by Fluid Design.
design company Fluid
country of origin UK

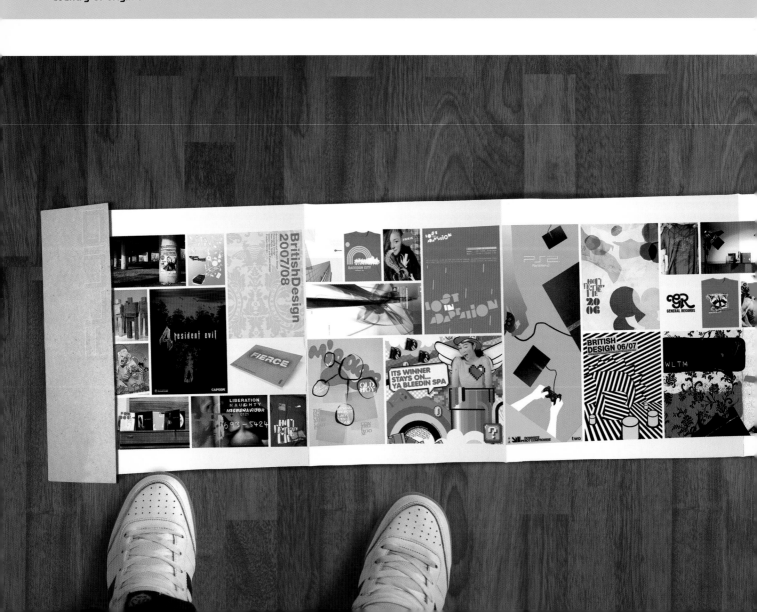

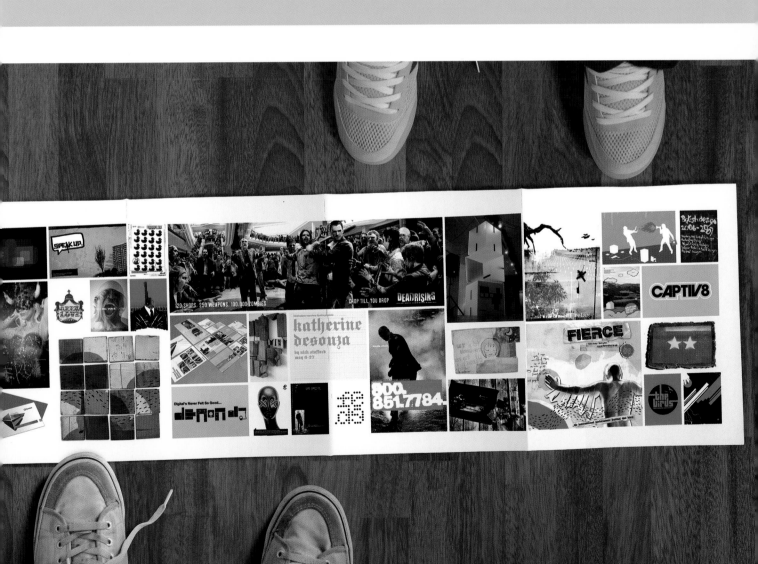

left
Birthday Card for Sophie

below
Birthday Card for Johanna

facing page
Birthday Card for Jake

dimensions 4 ¹/₈ x 5 ⁷/₈ in 104 x 148 mm
description Series of "monster"
birthday cards created for the artist's
friends.
designer Rina Donnersmarck
illustrator Rina Donnersmarck
country of origin UK

All My Creatures
description Invitation to the artist's
exhibition at Euforia, London.
designer Rina Donnersmarck
illustrator Rina Donnersmarck
country of origin UK

1Y CREATURES" AT EUFORiA oN 61b LANCASTER ROAD
1D BROKE GROVE. WORK BY RiNA DONNERSMARCK
TE ViEW: FRiDAY 20. JUNE 2003 FROM 7·00 PM

soularchitecture.com design your life

Soulengines.net

dimensions 11 3/4 x 16 1/2 in 297 x 420 mm
description Promotional posters for the soulengines design network, including Komamako (product design and interiors), Soulengineer (graphic design and art), and Soularchitecture (architecture).
designer Marco Simonetti
photographer Marco Simonetti
art director Marco Simonetti
design company Soulengineer
country of origin Switzerland

designers are ...

designers are alle idioten.
designer sind
alle idioten.
designers are
all idiots.gli

komamako.com forms for life and interiors

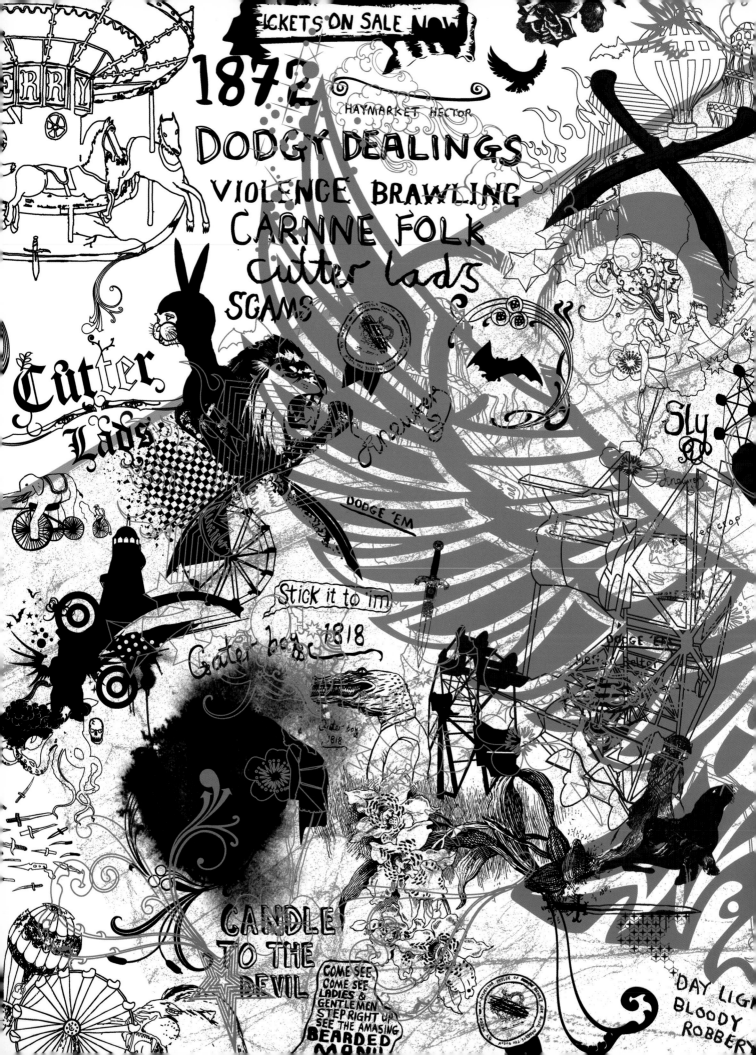

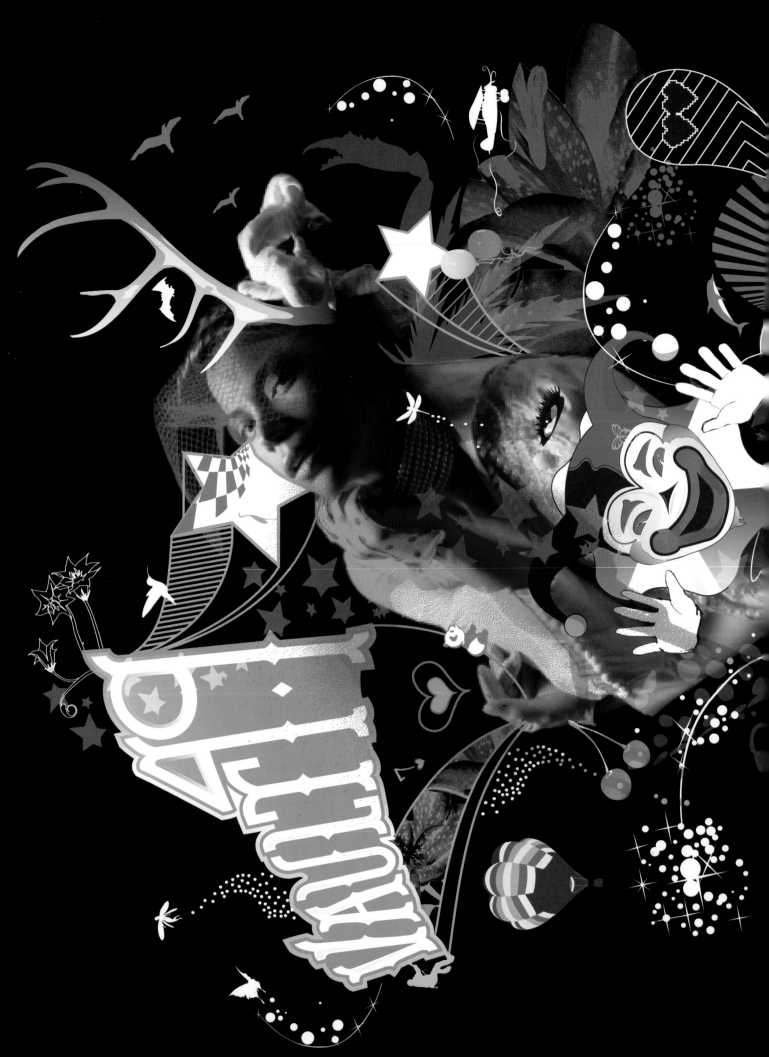

this page
DediCate Magazine
dimensions
9 1/2 x 11 5/8 in 240 x 295 mm
description Vault 49 signal page
editorial for French magazine.
designers John Glasgow,
Jonathan Kenyon
photographer Stephan Langmanis
art direction Vault 49
design company Vault 49
country of origin USA

overleaf
DediCate Magazine
dimensions
18 7/8 x 11 5/8 in 480 x 295 mm
description Vault 49 double-page
editorial spread for French magazine.
designers John Glasgow,
Jonathan Kenyon
photographer Katja Mayer
art direction Vault 49
design company Vault 49
country of origin USA

pages 274-275
DediCate Magazine
dimensions
18 7/8 x 11 5/8 in 480 x 295 mm
description Vault 49 double-page
editorial spread for French magazine.
designers John Glasgow,
Jonathan Kenyon
photographer Stephan Langmanis
art direction Vault 49
design company Vault 49
country of origin USA

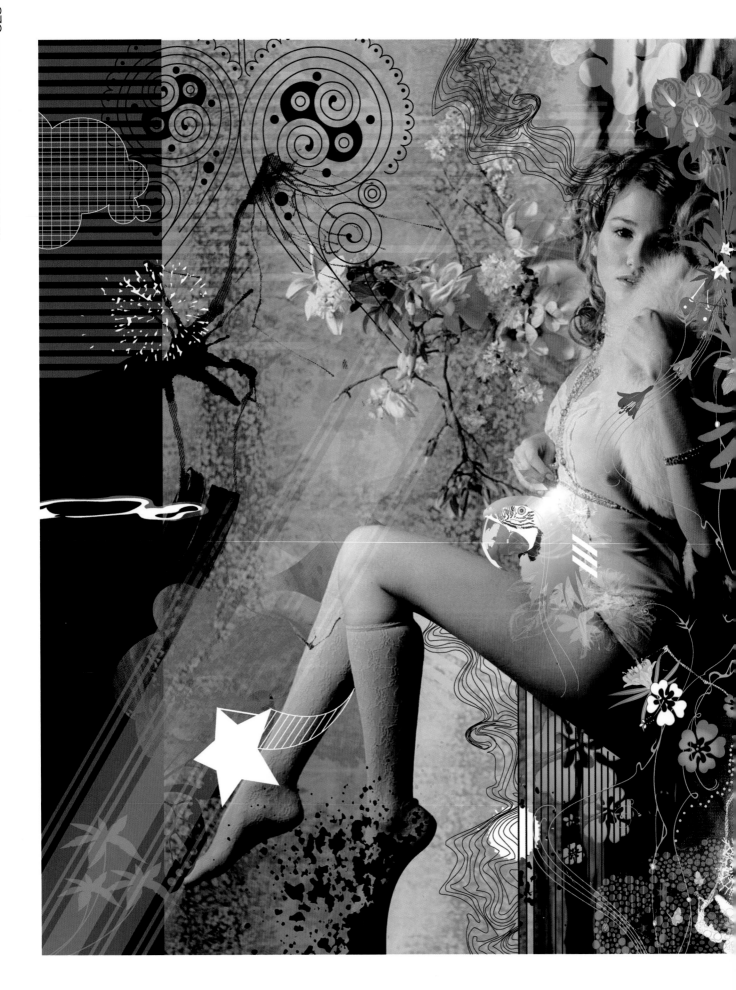

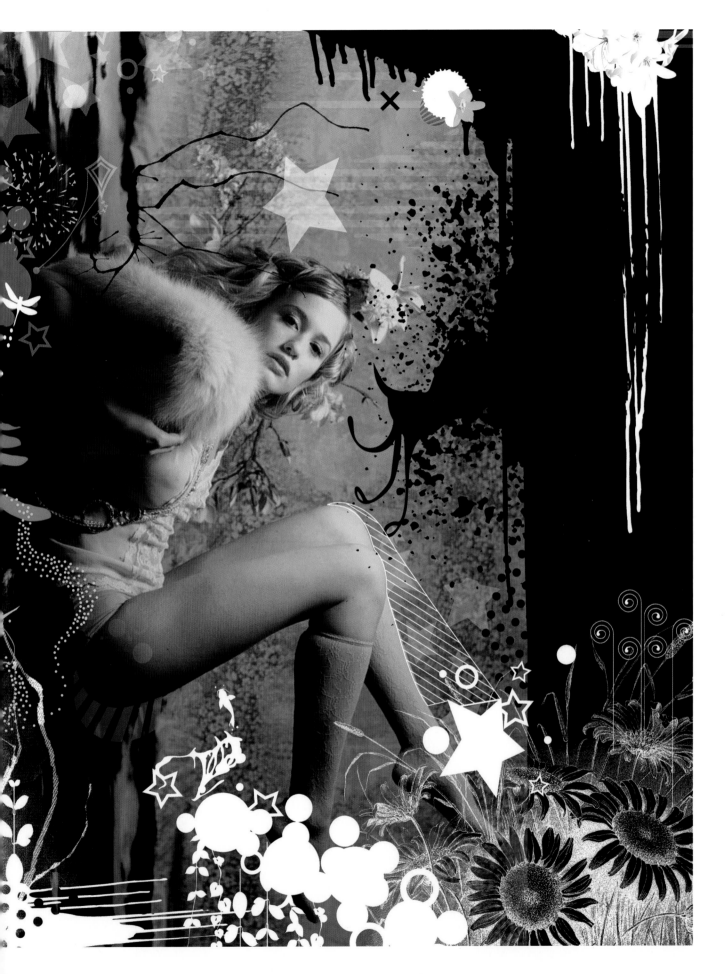

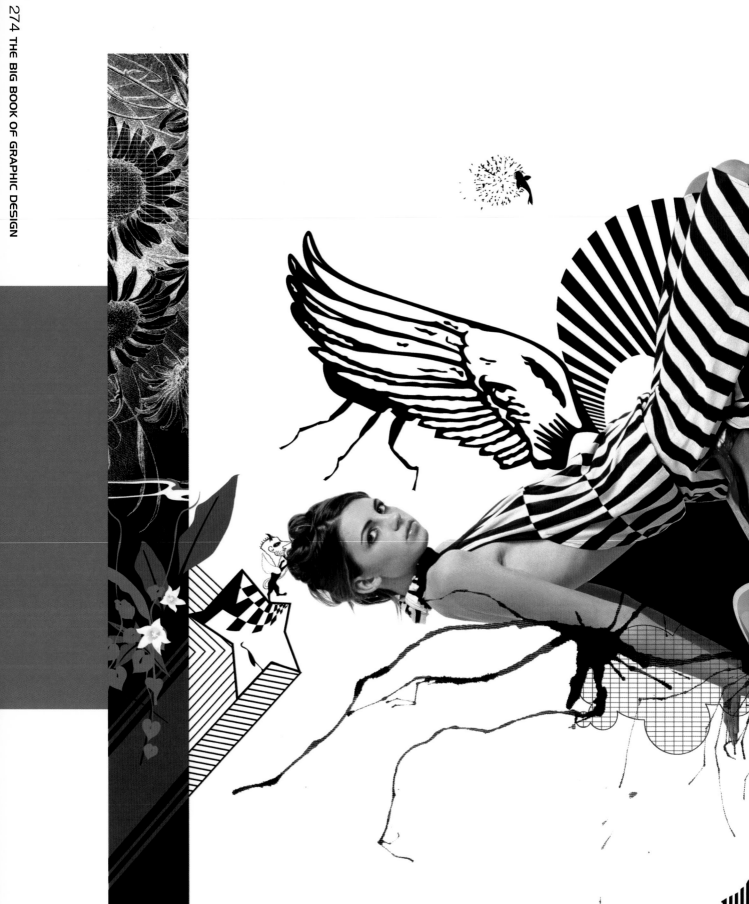

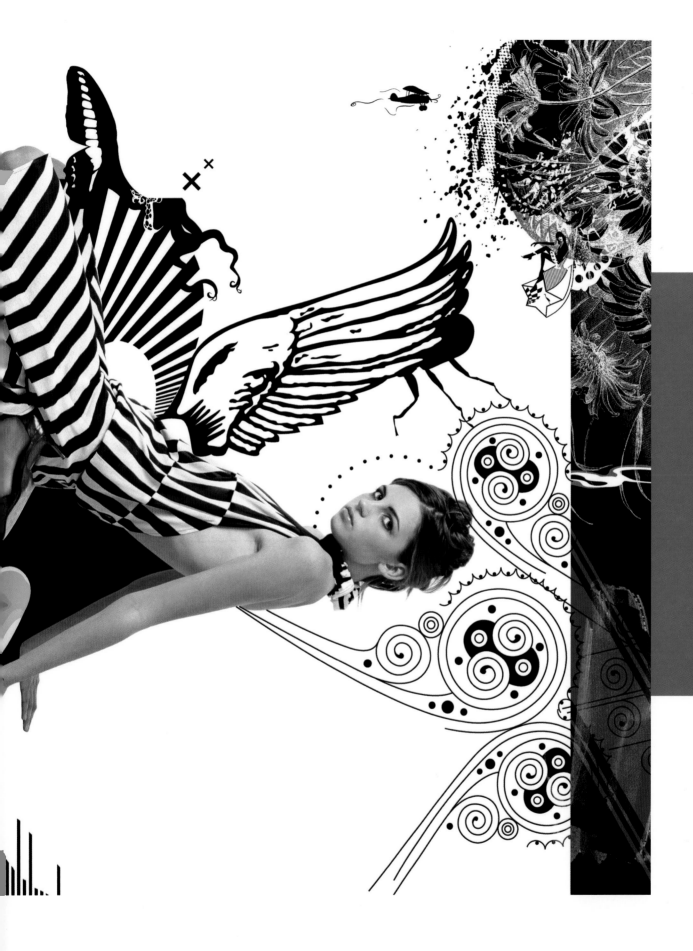

Vault49NewYork

facing page

Vault 49 New York

dimensions 8 ¹/₂ x 11 in 216 x 280 mm

description Vault 49 stationery artwork.

designers John Glasgow, Jonathan Kenyon

art direction Vault 49

design company Vault 49

country of origin USA

Je Vous Embrasse

dimensions 5 ³/₄ x 5 ³/₈ in 146 x 137 mm

description Mixed media artwork.

designer Linda Ketelhut

illustrator Linda Ketelhut

country of origin USA

facing page
Lace
dimensions 6 x 9 in 152 x 228 mm
description Gouache artwork, one in a
series of lingerie pieces.
designer Linda Ketelhut
illustrator Linda Ketelhut
country of origin USA

below
Le Maquillage
dimensions 8 x 6 ¼ in 203 x 159 mm
description Mixed media collage artwork.
designer Linda Ketelhut
illustrator Linda Ketelhut
country of origin USA

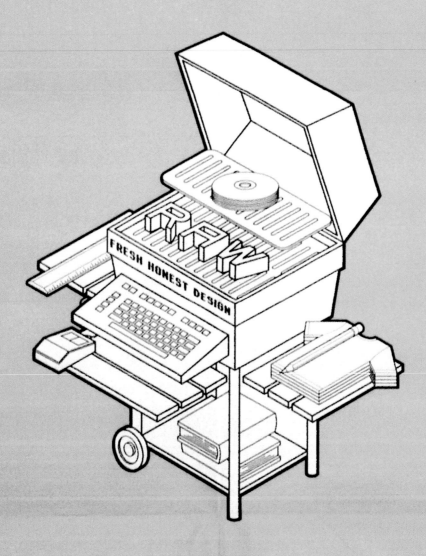

Services:
/Brand consultancy
/Corporate literature
/Web site and CD Rom design

/Photography
/Copywriting
/Print management
/Internet marketing

Contact
1 Bankfield Gardens
Leeds, LS4 2JB

Tel: +44 (0) 113 275 7773
Fax: +44 (0) 113 275 5214

www.rawdesignstudio.co.uk
info@rawdesignstudio.co.uk

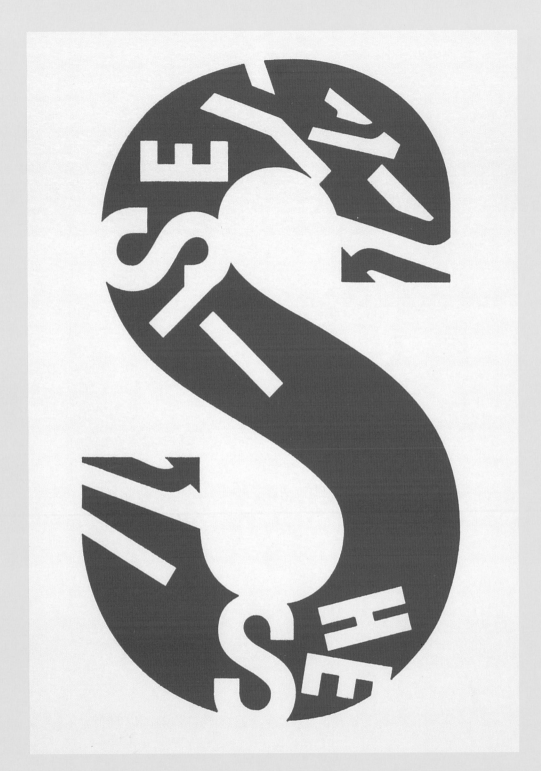

facing page

RAW Design Studio
dimensions 11 3/4 x 12 5/8 in 297 x 320 mm (A3)
description Self-promotional poster using the literal meaning of
"raw." The brand seeks to connect with the market and convey the
message that by working closely with clients and by "pooling their
raw talents," they will produce innovative and successful design.
designer Rob Watson
art director Rob Watson
design company Raw Design Studio
country of origin UK

above

Synaesthesia #1
dimensions 4 1/8 x 5 7/8 in 105 x 148 mm
description Typographic self-promotional
card, block-foiled on Colorplan.
designer Julian Morey
art director Julian Morey
design company Julian Morey Studio
country of origin UK

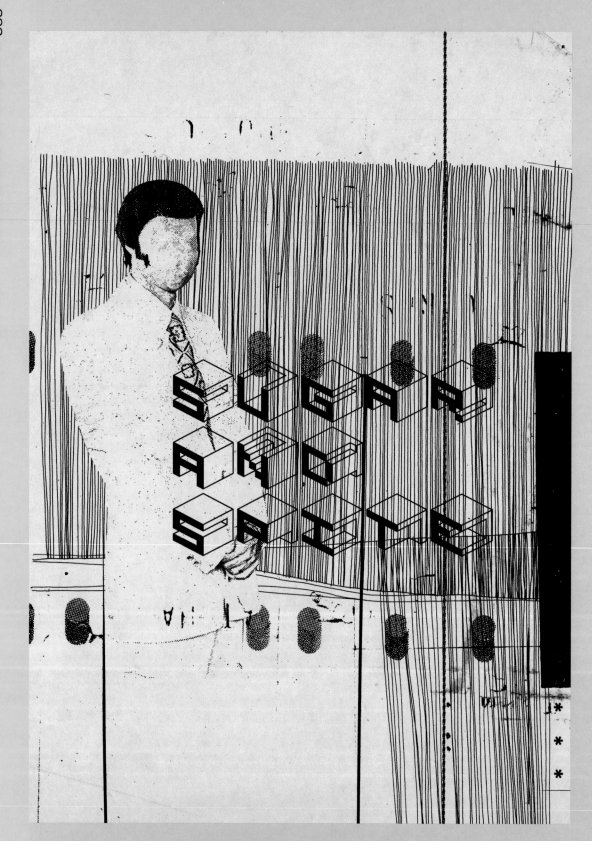

above
Sugar and Spite

right
I love God and Poker

overleaf, left
Love Is a Drug

description A selection of self-promotional prints for the 2005 4wall illustration exhibition in London.
designer Kerry Roper
illustrator Kerry Roper
art director Kerry Roper
design company Beautiful
country of origin UK

overleaf, right
Sleep

description Poster for the "if you could do anything tomorrow—what would it be?" project.
designer Kerry Roper
illustrator Kerry Roper
art director Kerry Roper
design company Beautiful
country of origin UK

Tatami City Animation
description Frames out of a 3-D animation with the Büro Destruct font Tatami.
designer Heiwid
company Büro Destruct
country of origin Switzerland

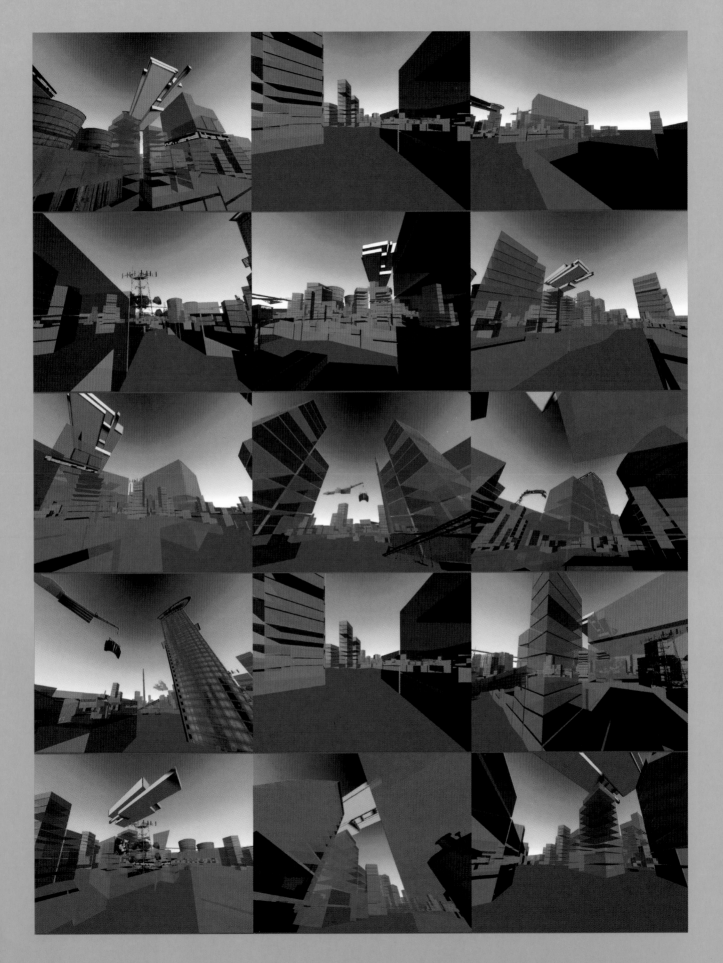

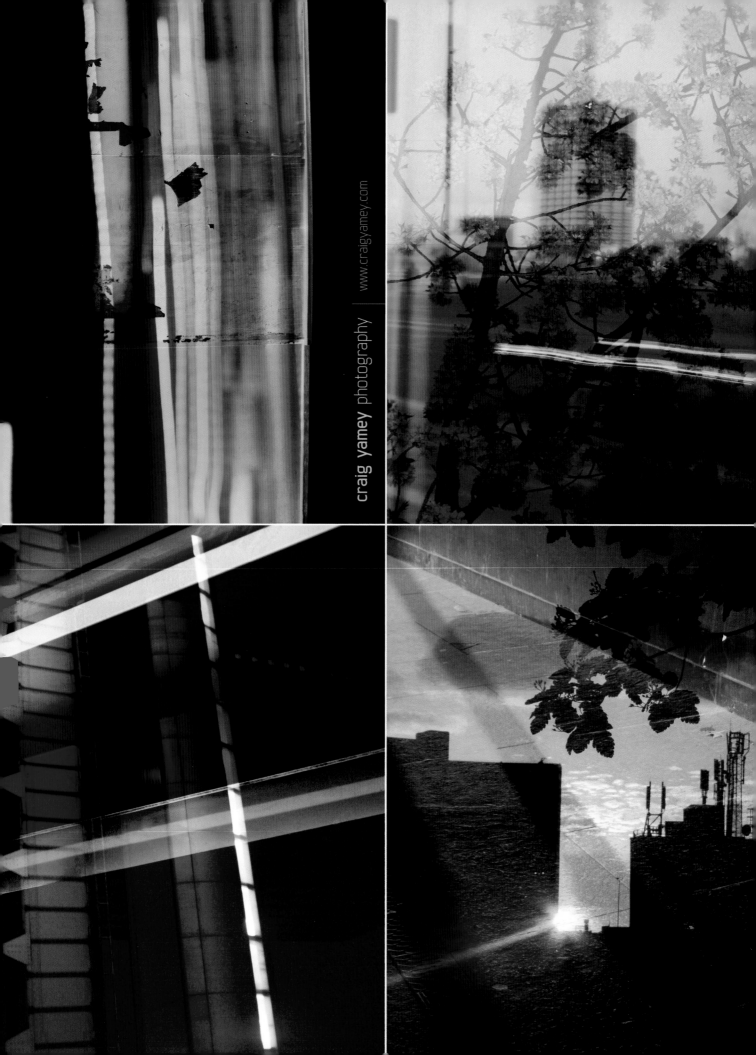

facing page
Yam Photography Poster
dimensions 16 ½ x 23 ⅜ in 420 x 594 mm (A2)
description Foldout poster promoting
Craig Yamey as a freelance photographer.
designer Craig Yamey
photographer Craig Yamey
art director Craig Yamey
design company Yam
country of origin UK

below
Yam Self-Promotional Postcards
dimensions 5 ⅞ x 6 ⅞ in 148 x 176 mm
description One in a series of self-promotional
postcards, using photographic collage and
featuring contact details on the reverse.
designer Craig Yamey
photographer Craig Yamey
art director Craig Yamey
design company Yam
country of origin UK

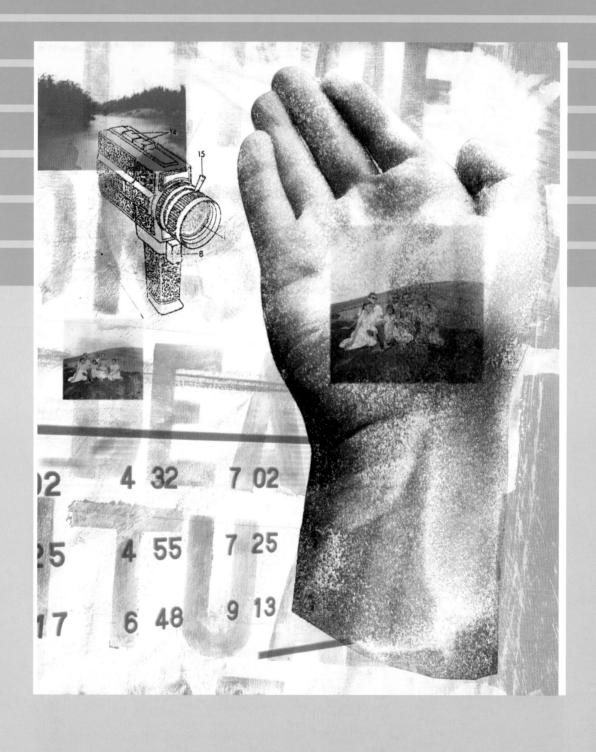

voicedesign.net
description Website design for Australian
design company Voice.
designers Scott Carslake, Anthony Deleo,
Ron Woods
art directors Scott Carslake, Anthony Deleo
design company Voice
country of origin Australia

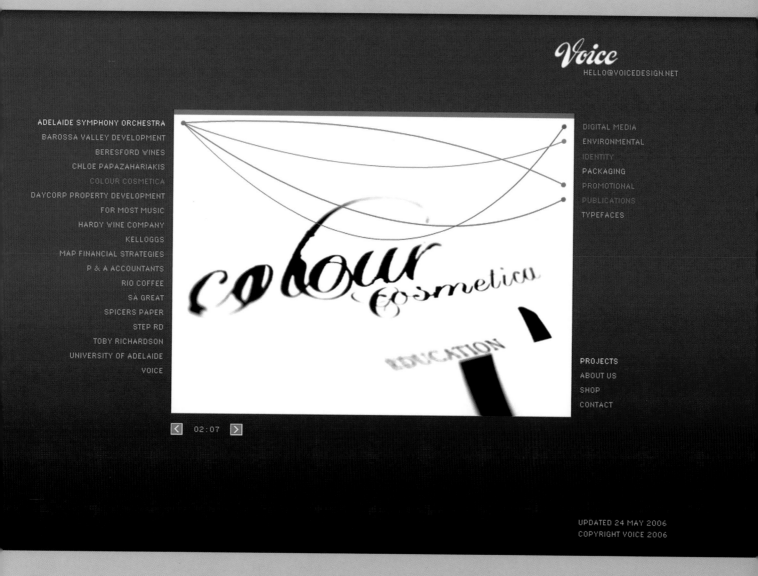

The designers wanted users to know what services they provide (such as identity, packaging, publications, digital media, etc.) and specifically to which clients they have provided each service. They created an interactive system interface with clients on the left and services on the right: users scroll over either category and curved lines appear linking a particular client with services or vice versa.

VOICE DESIGN

Untitled
description Stills from video projected artwork,
created for the opening of the Arc Biennial.
design company Inkahoots
country of origin Australia

We use a soft focus arc of 200° peripheral vision when we look at any building, with only a fraction being in focus. The Cities typeface echoes this (...) by allowing only 200° of each character to be visible. The arc is rotated through the alphabet in 26 stages of a 360° turn, as if spinning to find a bearing as to where one is in relation to the surrounding cityscape.

MALCOM CLARKE

Cities 200° Typeface

dimensions 23 3/8 x 33 1/8 in 594 x 841 mm (A1)
description Typeface design. Poster printed photographically in black and white, and screen-printed over the printed photograph. Background created through pinhole photography.
designer Malcom Clarke
art college London College of Communication
country of origin UK

Perspective

large poster 23 ³/₈ x 33 ¹/₈ in 594 x 841 mm (A1)
poster 16 ¹/₂ x 23 ³/₈ in 420 x 594 mm (A2)
description Photographic compositions of type in black
and white. Hand-printed, then screen-printed on top.
designer Malcom Clarke
art college London College of Communication
country of origin UK

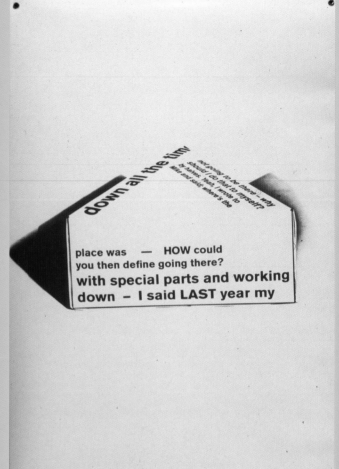

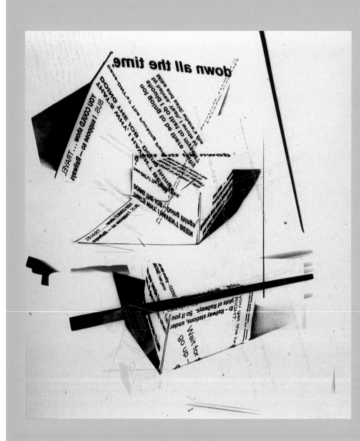

I recorded nine conversations simultaneously with a group of friends around Elephant & Castle, a hub of communication in south London. The 30-second conversation recordings were all located at different points vertically as well as horizontally on a 180° plane. The concept was to treat the typography in a sensitive way to suggest the positioning of the conversations with respect to one another as well as display the simultaneous nature of the dialogs.

MALCOM CLARKE

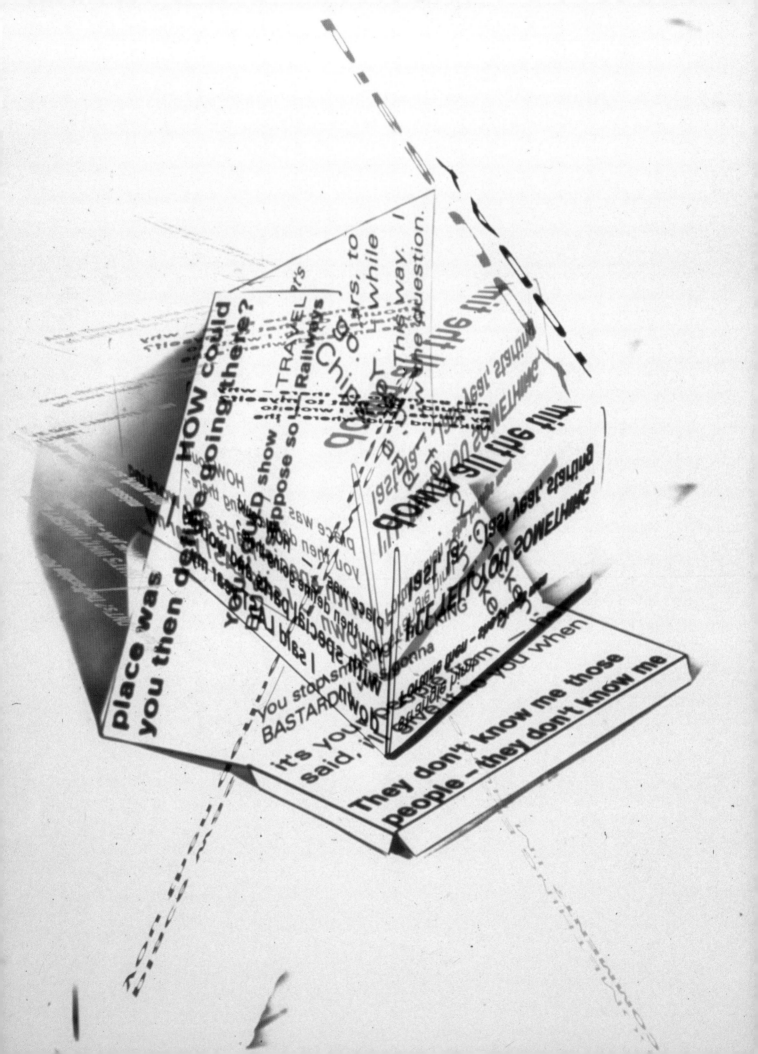

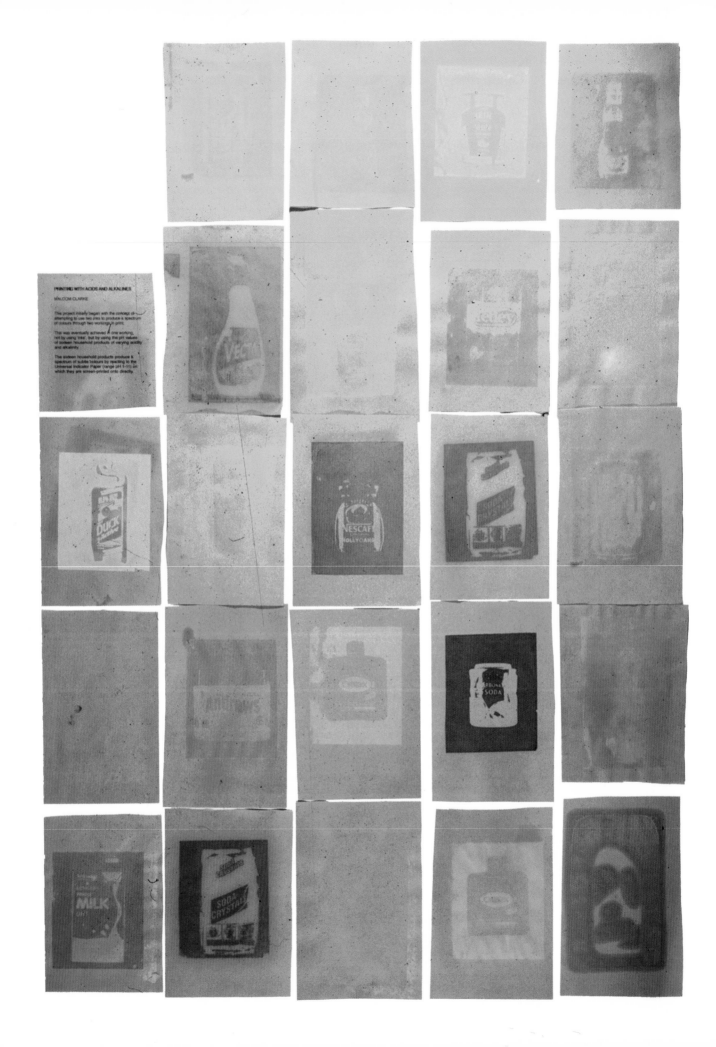

PRINTING WITH ACIDS AND ALKALINES

MALCOM CLARKE

This project initially began with the concept of attempting to use two inks to produce a spectrum of colours through two workings in print.

This was eventually achieved in one working, not by using 'inks', but by using the pH values of sixteen household products of varying acidity and alkalinity.

The sixteen household products produce a spectrum of subtle colours by reacting to the Universal Indicator Paper (range pH 1-11) on which they are screen-printed onto directly.

The concept was to produce a print that created a range of colors using no "inks" at all. This was achieved by utilizing the pH values of 16 household substances and printing them directly onto reactive paper, in the image of themselves. For example, the soda crystals piece is created by printing alkaline soda crystals onto the paper.

MALCOLM CLARKE

Acid Printing

dimensions approx. 5 7/8 x 8 1/4 in 148 x 210 mm
(per section)
description Screen-printed artwork. Printed on
universal indicator paper using the product pictured.
Exhibited as part of a group show at the Royal
College of Art, London.
designer Malcom Clarke
art college London College of Communication
country of origin UK

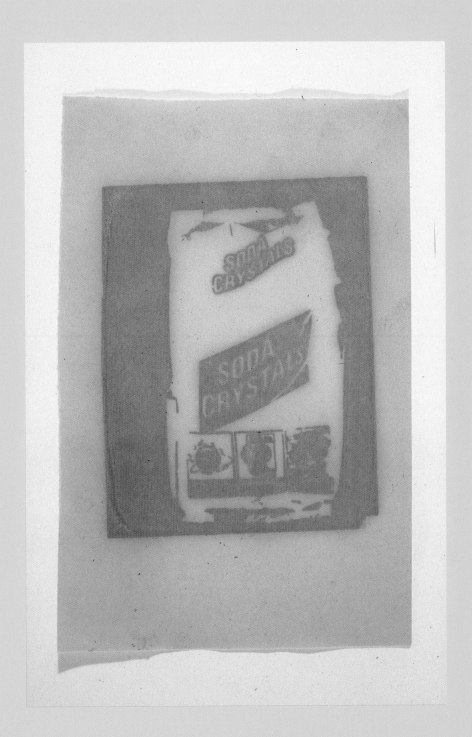

this page and overleaf
Pigeon Typeface
large poster 23 3/8 x 33 1/8 in 594 x 841 mm (A1)
description Self-initiated environmental typography
project, creating a "pigeon typeface" by feeding
London pigeons from Trafalgar Square.
designer Malcom Clarke
art college London College of Communication.
country of origin UK

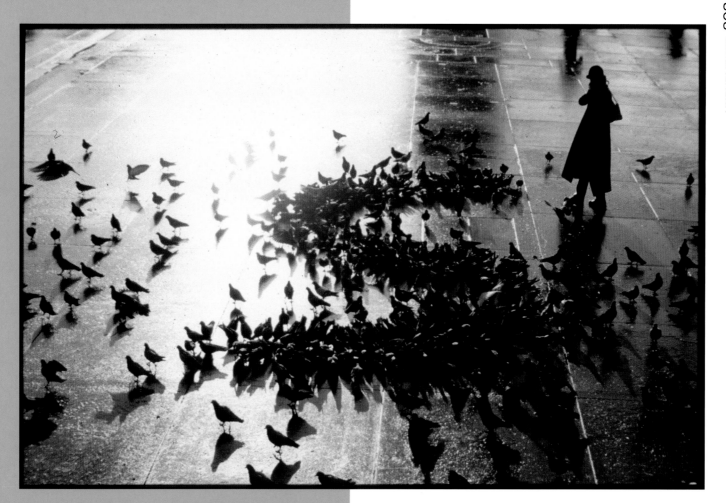

In Trafalgar Square, I manipulated the pigeons directly, as the proposed author of the message, to form language that communicated to the human public. The new politics of bird-feeding seemed like a very good opportunity to develop my project. The pigeons' message became: "Please bring back Bernard Rayor—Mayor Livingstone* is killing us."

MALCOLM CLARKE

* London's Mayor Livingstone has forbidden the feeding of pigeons in Trafalgar Square.

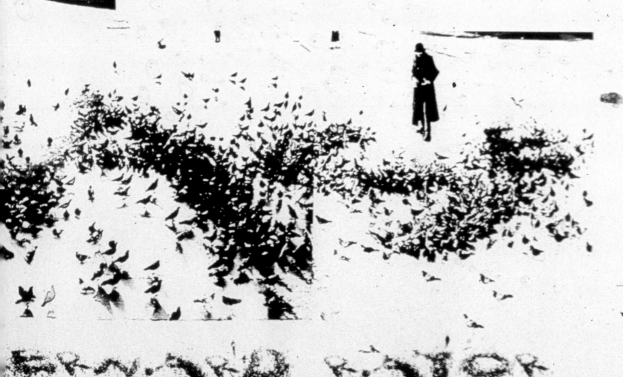

My final project for North Carolina State University's Master of Graphic Design program, the magazine TURN, deals with how the Religious Right's representation of Christianity in the media has formed stereotypes and schemas about Christianity. The goal of TURN is to represent these perspectives in a visual form in order to subvert them.

DAVID KASPAREK

overleaf
In and Out of Love
dimensions 10 x 12 in 255 x 305 mm
description Digital LED portfolio prints (personal work).
designer Paul Maye
art director Paul Maye
photographer Paul Maye
country of origin Ireland

TURN Magazine

dimensions 8 x 10 ½ in 203 x 267 mm
description An unpublished project, TURN takes the
form of a 48-page magazine that represents alternative
perspectives of Christianity—both visually and textually.
designer David Kasparek
illustrators David Kasparek, John Ritter
photographer David Kasparek
art college North Carolina State University
country of origin USA

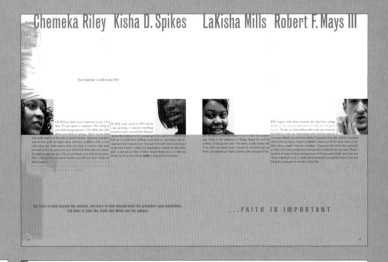

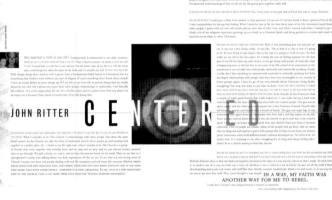

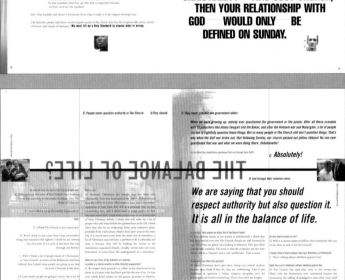

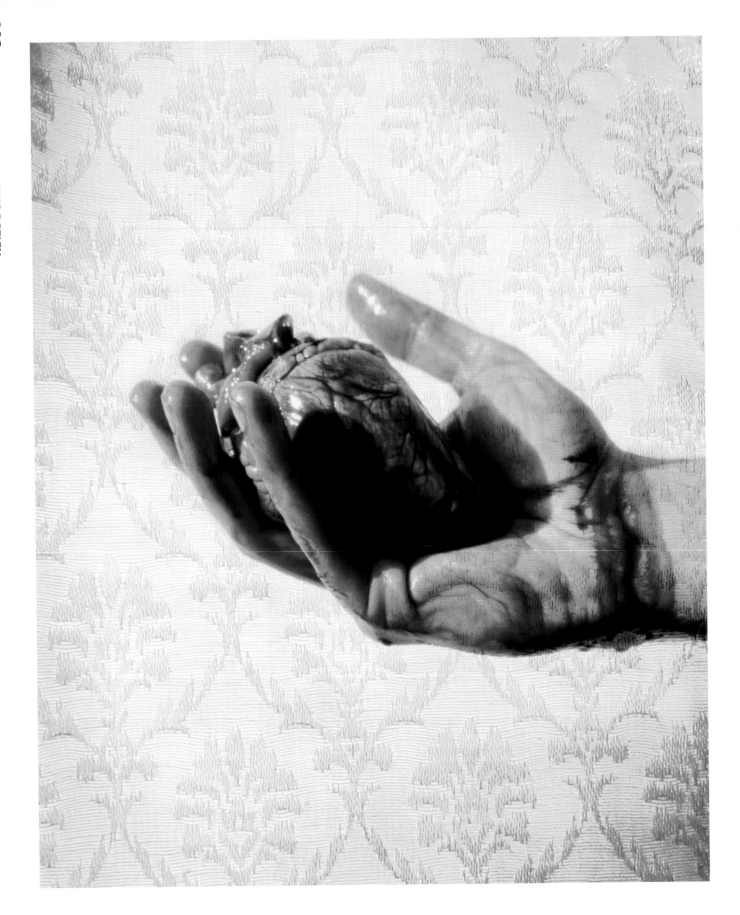

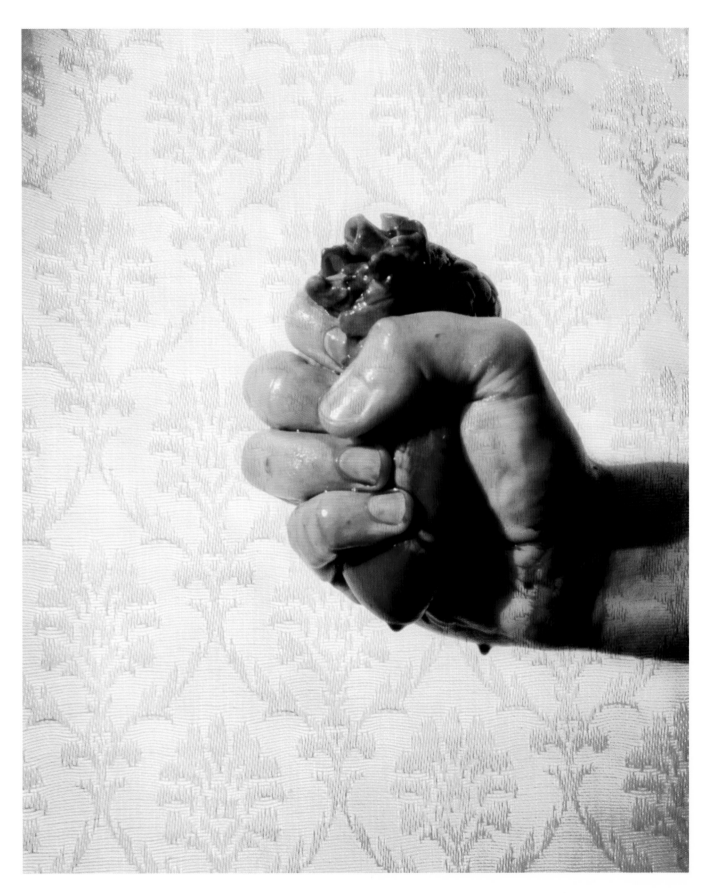

Cuts that won't heal
dimensions 10 x 12 in 255 x 305 mm
description Digital LED portfolio prints
(personal work).
designer Paul Maye
art director Paul Maye
photographer Paul Maye
country of origin Ireland

below
Untitled
dimensions 8 x 6 7/8 in 203 x 175 mm
description Digital artwork.
designer Linda Ketelhut
illustrator Linda Ketelhut
country of origin USA

above
Frankincense
dimensions 4 x 5 in 102 x 127 mm

above, right
Lavender Oil
dimensions 4 x 5 in 102 x 127 mm

right
Aromatic Medicine Shelf/Juniper Oil
dimensions 4 x 5 in 102 x 127 mm

facing page
Ancient Aromatherapy
dimensions 5 x 7 in 127 x 178 mm

description A series of aromatherapy
artwork in mixed media.
designer Linda Ketelhut
illustrator Linda Ketelhut
country of origin USA

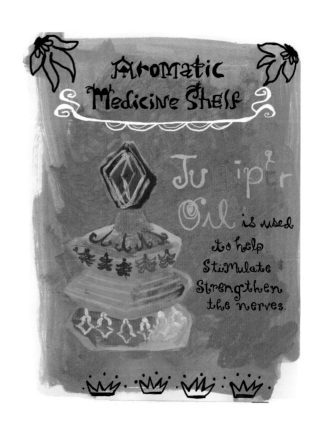

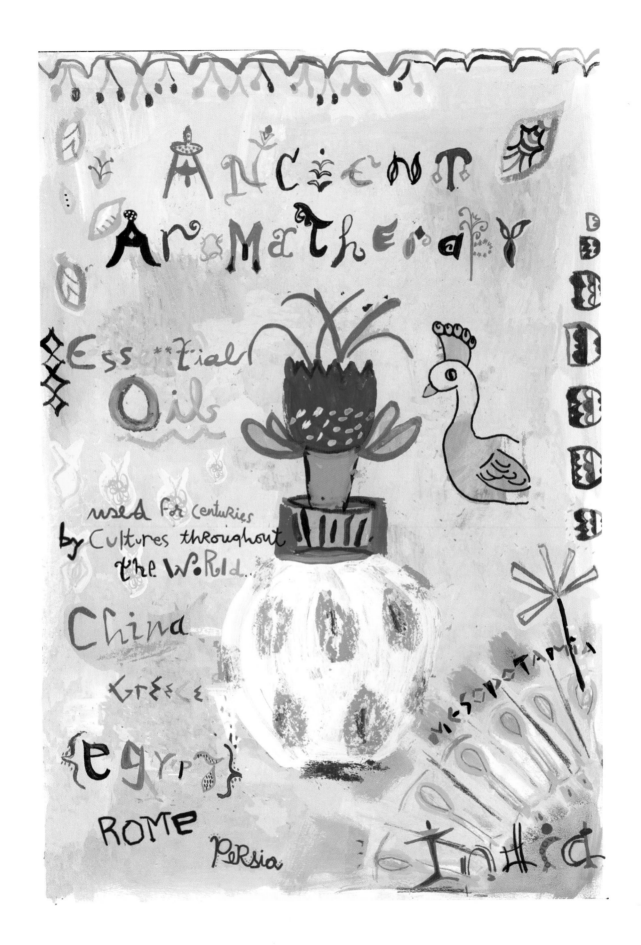

ANCIENT
Aromatherapy

Essential Oils

used for centuries by Cultures throughout the World...

China

Greece

{Egypt}

ROME

Persia

MESOPOTAMIA

India

What's Inside Dreams

dimensions 17 3/4 x 10 5/8 in 450 x 270 mm
description Unpublished proposed spreads for
Plus 81 Magazine. The theme was based on the
unconscious dreaming mind and the struggle
between light and dark, nightmare and dream.
designer Douglas Henderson
photographer Lucy Johnson
art college Cumbria Institute of the Arts
country of origin UK

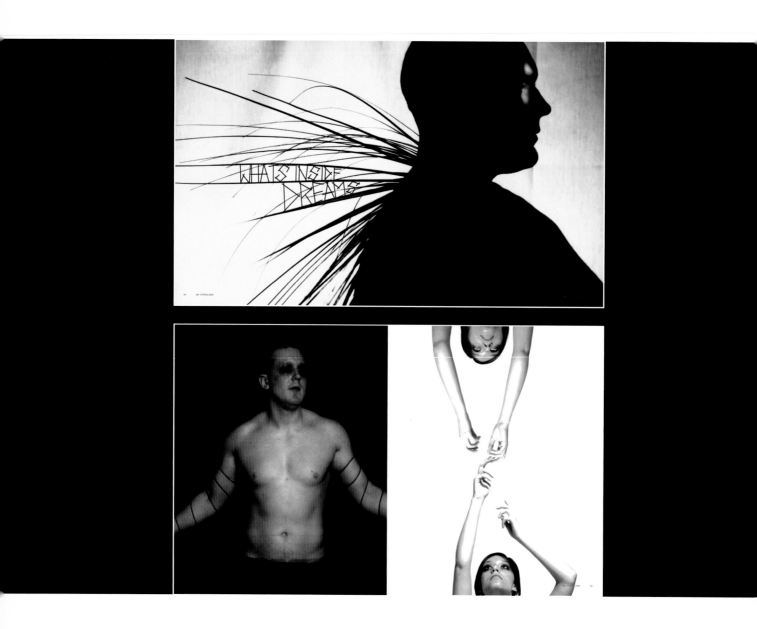

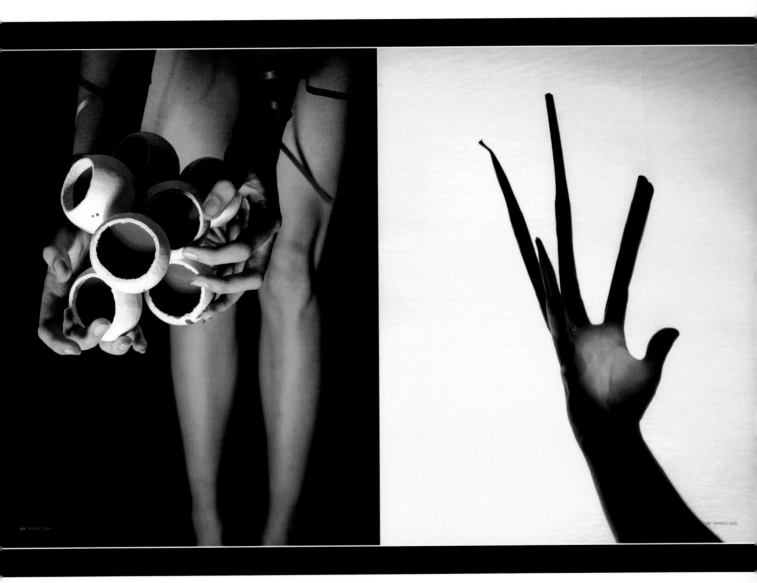

this page and overleaf

Immaterial

dimensions 15 x 7 ½ in 381 x 190 mm

description A university project—a book that captures
the process of six ideas from concept to execution.
This work is based on world poverty statistics.

designer Douglas Henderson

art college Cumbria Institute of the Arts

country of origin UK

ONE

I decided on a statistic that started at the earliest stage
of life. Every country has an I.M.R (Infant Mortality Rate); this
rate is gauged as deaths per thousand live births. Angola is
ranked number one with a staggering 191.19 per 1000 live
births for the recent year of 2005. This number is more
daunting when compared to Singapore and their rate that
is almost two hundred times lower at 2.29 per 1000 live births.

07

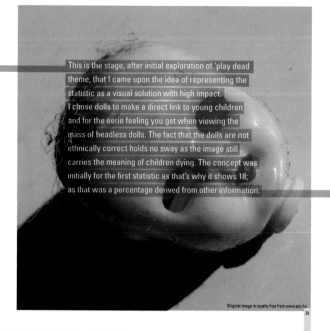

This is the stage, after initial exploration of 'play dead'
theme, that I came upon the idea of representing the
statistic as a visual solution with high impact.
I chose dolls to make a direct link to young children
and for the eerie feeling you get when viewing the
mass of headless dolls. The fact that the dolls are not
ethnically correct holds no sway as the image still
carries the meaning of children dying. The concept was
initially for the first statistic as that's why it shows 18;
as that was a percentage derived from other information.

Original image is royalty free from www.sxc.hu

20

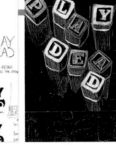

I 'toyed' with the concept of having the main image based solely on the phrase 'play dead' and used learning blocks as a means to make it relevant to children. The dark inverted version with gritty texture is meant to reflect the sinister nature of the statistic. I chose not to go forward with this idea as it did not show scale.

The process was one of duplication and patience. I Chose to stay with the grey background as it contrasts with the tones of the dolls plastic surface, that's the reason for using concrete surfaces. I added layers of texture until the desired effect was attained. Last step in process was adding information.

15 MILLION CHILDREN ARE ORPHANED DUE TO **HIV/AIDS** YEARLY. THATS MORE THAN THE TOTAL POPULATION OF CHILDREN IN SOME COUNTRIES.

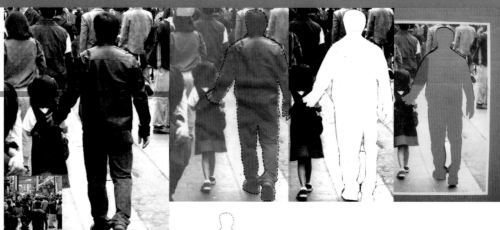

This statistic proved the hardest to show as comparing the numbers was not working or adding any value. I was prompted to think about what it's like to be an orphan and not just a statistic. Soon the idea came about having that parent missing, gone forever, cut -out.
Original image from sxc.hu. Many thanks.

FOUR

This section still deals with the child sector though this statistic deals with a far larger number. The United Nations estimates that there are 150 million street children worldwide. Other research has shown that 40% of these children are homeless while the other 60% work on the streets to support their family.

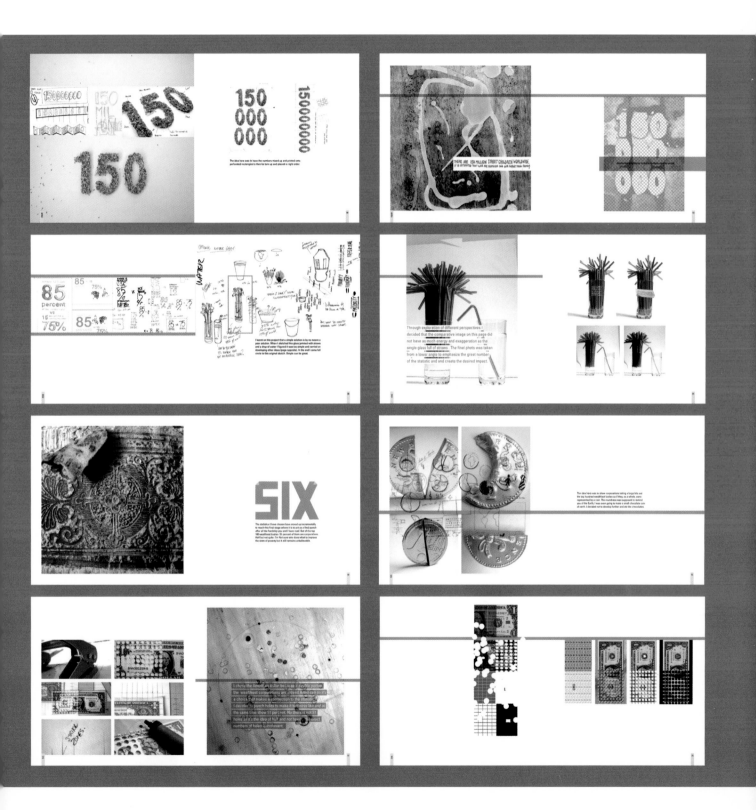

index

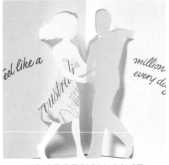

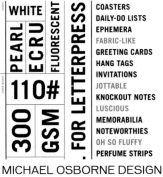

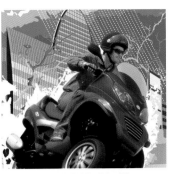

VAULT49 46-47

VAULT49 48-49

BRAND NEW SCHOOL 50-51

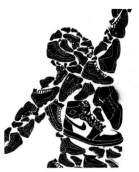

BEAUTIFUL 52-53

KITTEN CHOPS 54-55

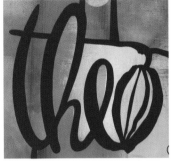

KITTEN CHOPS 56-57

YAM 58

YAM 59

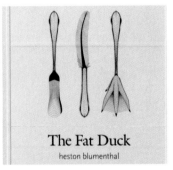

MALVERN PRESS 60-61

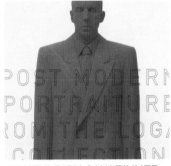

AUFULDISH & WARINNER 64-65

AUFULDISH & WARINNER 66-67

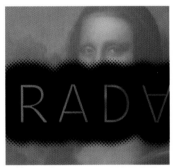

AUFULDISH & WARINNER 68-69

AUFULDISH & WARINNER 70-71

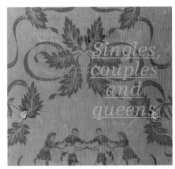

VOICE DESIGN 72-77

MARIAN BANTJES 78

MARIAN BANTJES 79

SOULENGINEER 81-82

ALEX WILLIAMSON 83-84

ATELIER: DOPPELPUNKT 84

RINA DONNERSMARCK 85

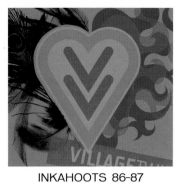

INKAHOOTS 86-87

FLUID DESIGN 88-89

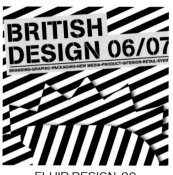

FLUID DESIGN 90

FLUID DESIGN 91

FLUID DESIGN 92

FLUID DESIGN 93

INKAHOOTS 94

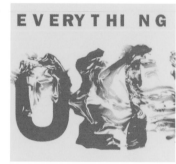

INKAHOOTS 95

INKAHOOTS 96

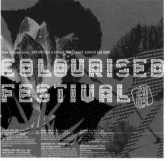

INKAHOOTS 97

ATELIER: DOPPELPUNKT
98-99

YAM 100-101

PENTAGRAM 102-107

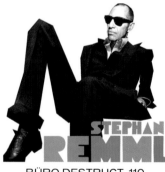

BÜRO DESTRUCT 110

BÜRO DESTRUCT 111

SUBSTANCE ® 112-113

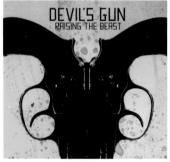

BEAUTIFUL 114-115

BEAUTIFUL 116

BEAUTIFUL 117

PETER MAYBURY STUDIO
118

PETER MAYBURY STUDIO
119

YAM 120

VISUALMENTALSTIMULI 121

BEAUTIFUL 122

YAM 123

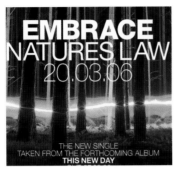

YACHT ASSOCIATES 124–125

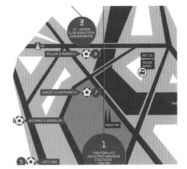

BÜRO DESTRUCT 126

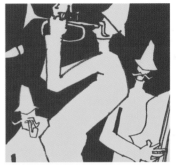

BÜRO DESTRUCT 127

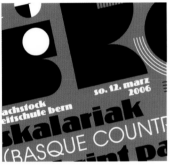

BÜRO DESTRUCT 128

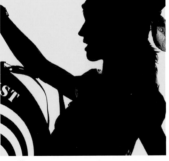

BÜRO DESTRUCT 128–129

BÜRO DESTRUCT 129

PETER MAYBURY STUDIO
130

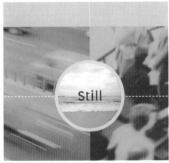

VISUALMENTALSTIMULI 131

BÜRO DESTRUCT 132–133

AUDIOWHORES
BEAUTIFUL 134

scrambler
BEAUTIFUL 134

BEAUTIFUL 135

YAM 136

YAM 137

RINA DONNERSMARCK
138–139

RINA DONNERSMARCK
140–141

INKAHOOTS 144

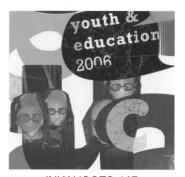

INKAHOOTS 145

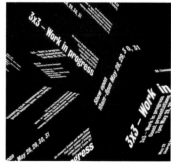

MALCOM CLARKE 146–147

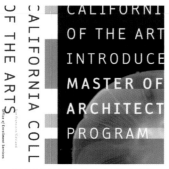

AUFULDISH & WARINNER
148

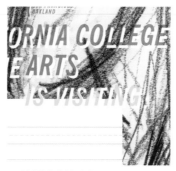

AUFULDISH & WARINNER
149

AUFULDISH & WARINNER
150–151

AUFULDISH & WARINNER
152–153

AUFULDISH & WARINNER
154–155

DANIELLE FOUSHÉE 156–159

AUFULDISH & WARINNER
160–161

AUFULDISH & WARINNER
162–163

AUFULDISH & WARINNER
164–167

AUFULDISH & WARINNER
168

AUFULDISH & WARINNER
169

AUFULDISH & WARINNER
170–171

SEGURA, INC. 174–179

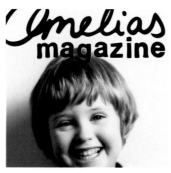

AMELIA'S MAGAZINE
180–185

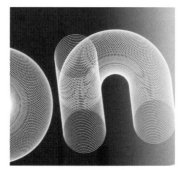

FROST DESIGN 186–187

FROST DESIGN 188–189

FROST DESIGN 190–191

FROST DESIGN 192–193

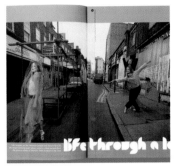

FROST DESIGN 194–195

FROST DESIGN 196–197

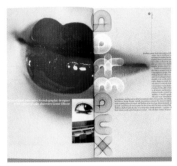

FROST DESIGN 198–199

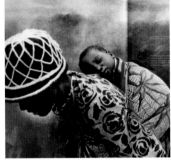

SEGURA, INC. 200–207

PETER MAYBURY STUDIO
208–213

FROST DESIGN 214–215

MARIAN BANTJES 216–217

VAULT49 218–219

PETER MAYBURY STUDIO
220–221

SIGN KOMMUNIKATION 222

SIGN KOMMUNIKATION
223–231

SIGN KOMMUNIKATION 232

GENERAL WORKING GROUP
233–241

FROST DESIGN 244–247

YACHT ASSOCIATES 248–9

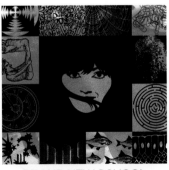

BRAND NEW SCHOOL
250–251

BRAND NEW SCHOOL
252–253

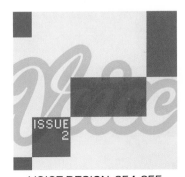

VOICE DESIGN 254–255

FLUID DESIGN 256–257

RINA DONNERSMARCK 258

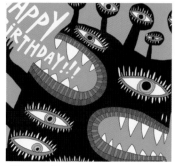

RINA DONNERSMARCK 259

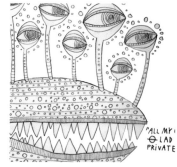

RINA DONNERSMARCK
260–261

SOULENGINEER 262

SOULENGINEER 262

SOULENGINEER 263

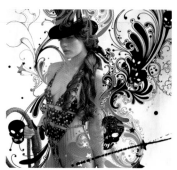

VAULT49 264–265

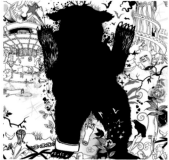

VAULT49 266–267

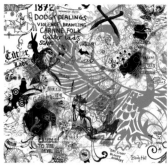

VAULT49 268–269

VAULT49 270–271

VAULT49 272–273

VAULT49 274–275

VAULT49 276

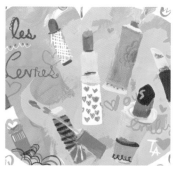

LINDA KETELHUT 277

LINDA KETELHUT 278

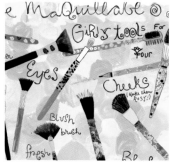

LINDA KETELHUT 279

RAW DESIGN STUDIO 280

JULIAN MOREY STUDIO 281

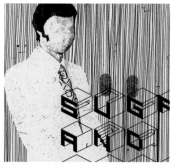

BEAUTIFUL 282

BEAUTIFUL 283

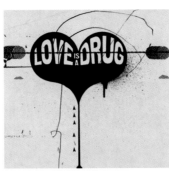

BEAUTIFUL 284

BEAUTIFUL 285

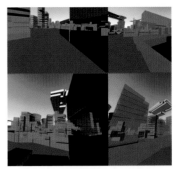

BÜRO DESTRUCT 286–287

YAM 288

YAM 289

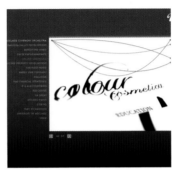

VOICE DESIGN 290–291

INKAHOOTS 292–293

MALCOM CLARKE 296–297

MALCOM CLARKE 298–299

MALCOM CLARKE 300–301

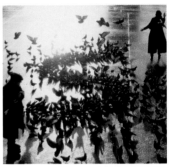

MALCOM CLARKE 302–305

VISUALMENTALSTIMULI
306–307

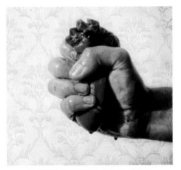

PAUL MAYE 308–309

PAUL MAYE 310

LINDA KETELHUT 311

LINDA KETELHUT 312

LINDA KETELHUT 313

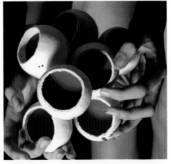

DOUGLAS HENDERSON
314–315

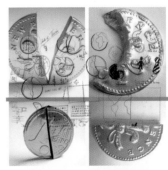

DOUGLAS HENDERSON
316–319

alphabetical index
& contact details

A

Adolfsen, Eric
see Brand New School **50–51**

AMELIA'S MAGAZINE 180–185
United Kingdom
info@ameliasmagazine.com
www.ameliasmagazine.com

Anstey, Brian
see Vault 49 **218**

Asciak, Marianne (Industrial Strange)
see Vault 49 **46–47**

ATELIER: DOPPELPUNKT 84, 98–99
Lehrter Strasse 57
10557 Berlin
Germany
TEL +49 3039063930
FAX +49 3039063940
atelier@doppelpunkt.com
www.doppelpunkt.com

AUFULDISH & WARINNER 64–71, 148–155, 160–171
183 The Alameda
San Anselmo
California 94960
USA
TEL +1 415 7217921
TEL +1 415 7217920
FAX +1 415 7217965
bob@aufwar.com
www.aufwar.com

Aufuldish, Bob
see Aufuldish & Warinner **64–71, 148–155, 160–171**

B

Backhouse, Ben
see Frost Design **186–199**

BANTJES, MARIAN 32–33, 78–79, 216–217
Box X–15
1478 Tunstall Blvd.
Bowen Island, BC
V0N 1G0
Canada
TEL +1 6049479107
marian@quatrifolio.com
www.bantjes.com

Basford, Lee
see Fluid Design **88–89**

BEAUTIFUL 52–53, 114–117, 122, 134–135, 282–285
96 Stanstead Road
Forest Hill
London SE23 1BS
United Kingdom
TEL +44 7976774820
kerry@youarebeautiful.co.uk
www.youarebeautiful.co.uk

Bernet, Andy
see Brand New School **30–31**

BRAND NEW SCHOOL 30–31, 50–51, 250–253
2415 Michigan Avenue
Building H, Suite 100
Los Angeles
CA 90404
TEL +1 310 3159959
FAX +1 310 3159939
jens@brandnewschool.com
www.brandnewschool.com

Brook, Ian
see Brand New School **30–31**

Bull, Richard
see Yacht Associates **124–125, 248–249**

BÜRO DESTRUCT 110–111, 126–129, 132–133, 286–287
Wasserwerkgasse 7
Bern
3011
Switzerland
TEL +41 313126383
FAX +41 313126307
bd@burodestruct.net
www.burodestruct.net

C

Cannon, Jonathan
see Brand New School **250–251**

Carslake, Scott
see Voice Design **10–13, 22–27, 42–43, 72–77, 254–255, 290–291**

Chow, Dickson
see Brand New School **50–51**

CLARKE, MALCOM 146–147, 296–305
Studio MC
Unit C5/The Old Imperial Laundry
71-73 Warriner Gardens
Battersea
London SW11 4XW
United Kingdom
TEL +44 7888729650
mc@malcomclarke.com
www.malcomclarke.com

Close, Chuck
see Aufuldish & Warinner **170–171**

notes

THE BIG BOOK OF GRAPHIC DESIGN

HarperCollins books may be purchased for educational, business, or sales promotional use.
For information, please write to:
Special Markets Department
HarperCollins Publishers
10 East 53rd Street
New York, NY 10022.

First Edition

First published in 2007 by
Collins Design
An Imprint of HarperCollins*Publishers*
10 East 53rd Street
New York, NY 10022
Tel: (212) 207-7000
Fax: (212) 207-7654
collinsdesign@harpercollins.com
www.harpercollins.com

Distributed throughout the world by
HarperCollins*Publishers*
10 East 53rd Street
New York, NY 10022
Tel: (212) 207-7000
Fax: (212) 207-7654

Library of Congress Control Number: 2007927208

ISBN: 978-0-06-121524-7

Printed in Singapore by Imago
10 9 8 7 6 5 4 3 2 1

Conceived, created, and designed by
Duncan Baird Publishers, Ltd.
Sixth Floor, Castle House
75–76 Wells Street
London W1T 3QH
United Kingdom

Designer: Gabriella Le Grazie
Jacket Design: Lloyd Tilbury (Cobalt ID)
Editor: Julia Szczuka